Wisdom With
Understanding
is Better
Than Rubies

Lurine Karon Greenberg
Fine Arts Collection

# Fierce Friends

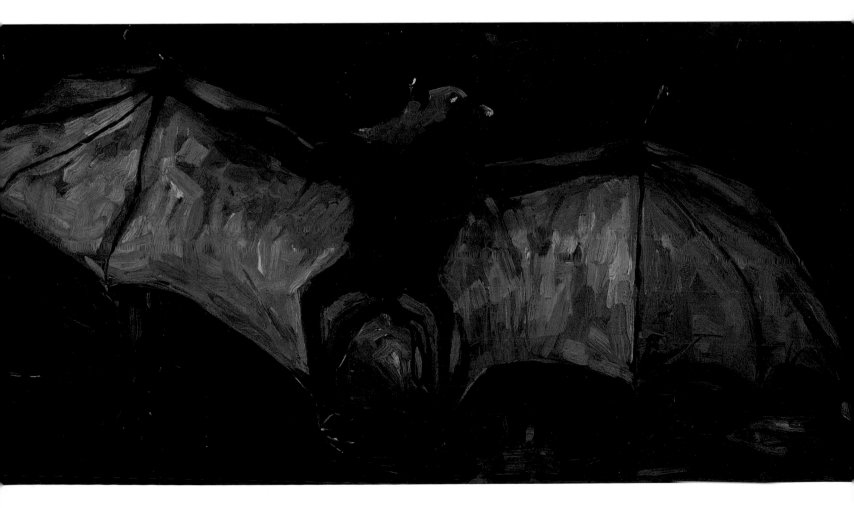

# Fierce Friends
## Artists and Animals, 1750–1900

LOUISE LIPPINCOTT and ANDREAS BLÜHM
Foreword by DESMOND MORRIS

VAN GOGH MUSEUM    CARNEGIE MUSEUM OF ART    in association with

MERRELL
LONDON · NEW YORK

First published 2005 by Merrell Publishers Limited

Head office
81 Southwark Street
London SE1 0HX

New York office
49 West 24th Street, 8th floor
New York, NY 10010

www.merrellpublishers.com

In association with

Van Gogh Museum
Paulus Potterstraat 7
1071 CX Amsterdam

www.vangoghmuseum.nl

Carnegie Museum of Art
4400 Forbes Avenue
Pittsburgh, PA 15228

www.cmoa.org

Published on the occasion of the exhibition
*Fierce Friends: Artists and Animals, 1750–1900*,
curated by Louise Lippincott and Andreas Blühm

**Exhibition itinerary**

Van Gogh Museum, Amsterdam
October 5, 2005 – February 5, 2006

Carnegie Museum of Art, Pittsburgh
March 25 – August 28, 2006

Publications Manager
Van Gogh Museum
Suzanne Bogman

Head of Publications
Carnegie Museum of Art
Arlene Sanderson

Produced by Merrell Publishers Limited
Designed by Maggi Smith
Edited by Christine Davis
Indexed by Christine Shuttleworth

Printed and bound in Italy

A catalog record for this book is available from the Library
of Congress

British Library Cataloging-in-Publication Data:
Lippincott, Louise, 1953–
Fierce friends : artists and animals, 1750–1900
1.Animals in art – Exhibitions 2.Human–animal relationships –
Exhibitions
I.Title II.Bluhm, Andreas III.Van Gogh Museum, Amsterdam
704.9'432

ISBN 1 85894 300 0 (hardcover)
ISBN 0 880 39 046 8 (softcover)

Jacket:
**Paul Meyerheim**
German, 1846–1915
*The Jealous Lioness*, c. 1880
Oil on canvas
49.8 x 69 cm (19½ x 27¼ in.)
Das Städel. Städelsches Kunstinstitut und
Städtische Galerie, Frankfurt am Main
(see pages 120–21)

Page 1:
**Vincent van Gogh**
Dutch, 1853–1890
*Flying Fox (Kalong)*, 1886
Oil on canvas
41 x 79 cm (16⅛ x 31⅛ in.)
Van Gogh Museum, Amsterdam
(Vincent van Gogh Foundation)

Page 2:
**Thomas Couture**
French, 1815–1879
*A Realist*, 1865
Oil on canvas
46 x 38 cm (18⅛ x 15 in.)
Van Gogh Museum, Amsterdam
(see page 119)

Pages 30–31:
**Georges Achille-Fould**
French, 1865–1951
*Rosa Bonheur in Her Studio*, 1893
Oil on canvas
91 x 124 cm (35¾ x 48¾ in.)
Musée des Beaux-Arts, Bordeaux
(see page 125)

# Contents

# Directors' Foreword

This book is published on the occasion of the exhibition *Fierce Friends: Artists and Animals, 1750–1900*, organized by our respective museums and presented in Amsterdam and Pittsburgh in 2005–2006. It is our second collaboration, following *Light! The Industrial Age 1750–1900, Art & Science, Technology & Society*, held in 2000–2001. These projects explore how artists represented the most common aspects of daily life in Western industrializing society. They highlight the continuities between then and now. We hope that our audiences come away from these exhibitions with a deeper understanding of our past, and a heightened awareness of the unique features of life today.

*Fierce Friends* presented our art museums with special challenges. In today's world, animals are extremely attractive and highly controversial. Everyone has an opinion about animals. They have become a focal point of international debates about the proper relationship between humankind and nature, and about definitions of humanity itself. At the same time, as pets and pests, they are involved intimately in our daily lives. Fortunately, we have been able to call on more experienced colleagues, especially at Carnegie Museum of Natural History, Pittsburgh, for advice and collaboration on promotion, presentation, and programs in each venue. They deserve much credit for the outcome of our project.

In museums, arrangements of objects express or provoke ideas. While we draw many items from our own collections, we ultimately depend on generous loans from institutions and individuals for the realization of our projects. We wish to thank all of our lenders for their willingness to share treasured *mirabilia*—wonders of art, science, and nature—with our visitors and readers; they are cited later in this publication.

Every new project places certain demands on museum staff, especially when we venture outside the boundaries of conventional art. We wish to thank the staff at our two museums for their skill, patience, and imagination in handling many new challenges, such as the shipping arrangements for a fossilized dinosaur bone, labeling a painting by a chimpanzee (does an ape have a nationality?), and identifying the genus and species of moth in a Van Gogh painting. Louise Lippincott and Andreas Blühm, exhibition curators, have produced an original and stimulating book and exhibition that continue the partnership launched with the creation of *Light!* five years ago.

Those funding our work have recognized the importance of animals, and the seriousness of our project, with major support. In Amsterdam, Rabobank, *promoting partner* of the Van Gogh Museum, took on the extra engagement of main sponsor. We are grateful to Jan Schinkelshoek, Vincent Pijpers, Ton Stek, and Yvonne Dorn. During the preparation of this project the Van Gogh Museum worked closely with the Dierenbescherming (Dutch Animal Protection Society), to promote each other's activities. The colleagues of the Dierenbescherming advised the curators on several issues of animal-protection history and on the contemporary display of animals.

In Pittsburgh, we wish to thank the Scaife Family Foundation for its essential initial grant for the exhibition. Generously, the Richard King Mellon Foundation has granted major funding for a Pittsburgh regional marketing initiative, *Pittsburgh Roars*. This grant substantially supports the Pittsburgh showing of *Fierce Friends*, while enabling other Pittsburgh regional organizations and attractions to participate in a broad marketing campaign to draw audiences to other collections, projects, and events organized around an animal theme. Two groups of loyal Carnegie Museum of Art friends, the Associates and the Fellows, responded to our request to support *Fierce Friends*. To the foundations and these individuals we extend our deepest thanks.

John Leighton
*Director*
*Van Gogh Museum*

Richard Armstrong
*The Henry J. Heinz II Director*
*Carnegie Museum of Art*

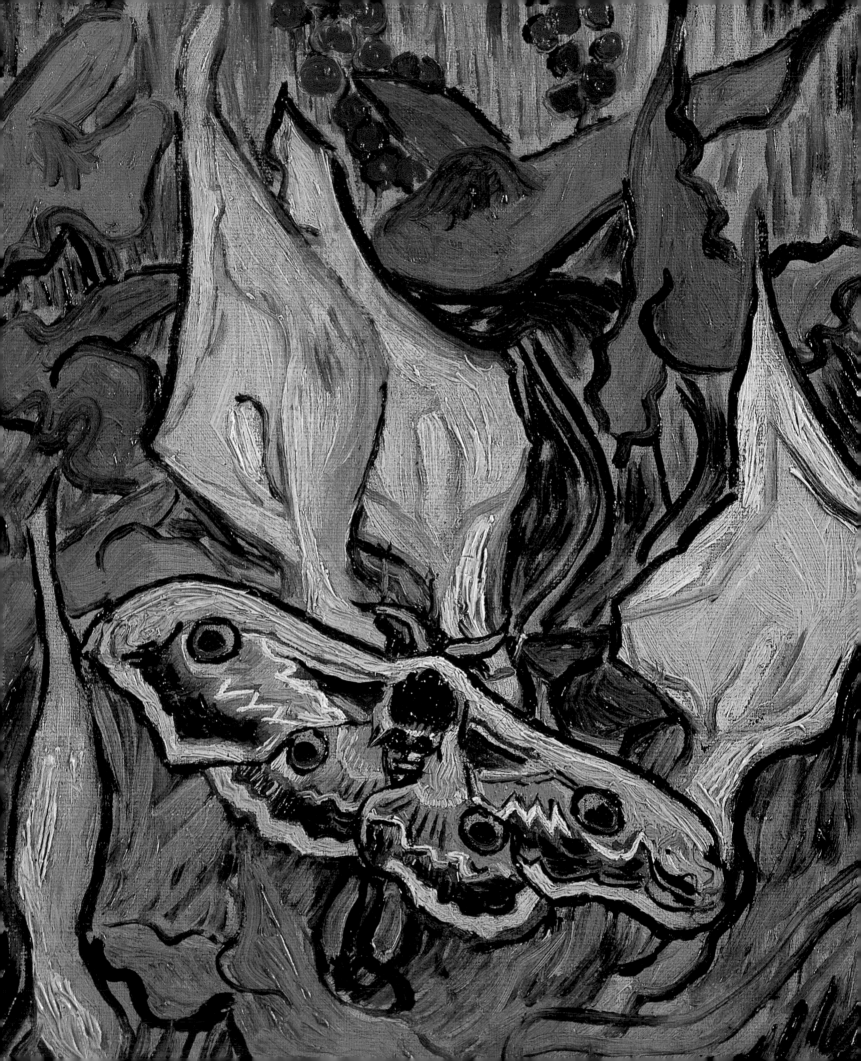

# Foreword

Desmond Morris

Animals have always played an important part in our lives, and it is fascinating to observe the way in which our attitudes toward other species have altered in recent centuries. This book traces the way in which such changes have been reflected in the visual arts of the eighteenth and nineteenth centuries—the period when "agricultural man" was becoming "industrial man," and when the new concept of evolution was challenging the old religious beliefs. In the world of the fine arts, this was a period of major upheaval. Gone were the set-piece compositions of devout religious scenes, and in their place came a wide variety of other themes, from the still life and the portrait to the landscape and, above all, to paintings in which animals moved in from the corners of canvases to take up central positions as the main subject.

Today, in the twenty-first century, we take it for granted that animals are accepted in their own right, on their own terms. We even view ourselves as animals—albeit extraordinary ones—and see ourselves as part of nature and not above it. We try to protect the environment and to encourage biodiversity, which means defending the cause of species other than our own. The conservation movement, which began as an oddity in the 1960s, is now widely accepted by young people as an essential part of life—a "given" concept that is not even questioned. Attitudes toward animal welfare and animal cruelty have also changed dramatically. Those who continue to hunt animals and those who train performing animals are looked on by many people as backward and uncouth. The exploitation of animals in circuses, films, zoos, factory farms, and even in laboratories is attacked by large segments of the population. There is a new mood spreading slowly through Western culture, that all animals deserve our respect and appreciation. The works of art carefully assembled for this book and exhibition show us clearly the first awakenings of this cultural mood, and the beginnings of this dramatic change of heart in our attitude toward our animal companions.

There are now six ways in which we approach other animals, but in prehistoric times there were only three: our primeval ancestors saw them simply as predators, prey, or pests. Today we have little to fear from animal predators. Apart from the occasional great white shark swallowing a surfer, there are few incidents of wild animals attacking human beings. Animals are still vastly important as prey, however, although they are farmed now rather than hunted. Animal pests are still with us, from mice and rats to bacteria and viruses, and our battle with them remains one of the central challenges for the medical profession.

In more modern times, three new approaches to animals have been added: the scientific, the aesthetic, and the symbolic. Scientific research—a discipline once despised by the religious because those involved refused to accept myths and miracles, and demanded that all statements should be tested and experimentally verified—has gained increasing momentum.

The aesthetic approach—which sees the potential for beauty in any species—has also grown alongside our increasing respect for animals. The "brute beasts of no understanding" are becoming a thing of the past. The final category—animals as symbols—still persists, but is also beginning to decline. Our greater understanding of the true character of animals makes it harder to attach crude, symbolic labels to them. Harder, but not impossible. The old symbolic labels often stick fast and are difficult to remove. We still call someone a "stupid pig," even though we now know how remarkably intelligent pigs are when tested scientifically. And we still accept the bald eagle as a suitable symbol of the United States, even through American scientists have discovered that it is, in reality, not a proud hunter but a messy scavenger. Symbols die hard. They have been with us since the totemic days of early civilizations and will probably always have a place in human thought, somehow managing to bypass scientific knowledge.

One huge area of human involvement with symbolic animals today concerns the special category we call animal pets. All pets are essentially substitutes for human companions. The majority are treated as symbolic children. There are millions of them worldwide, and they represent a major new obsession with species other than our own.

The shift in our approach to animals began in earnest in the eighteenth century—the Age of Enlightenment—when we first started to worry seriously about issues of animal cruelty. By the start of the nineteenth century, these worries had developed into the first animal-welfare organizations. Before long bull-baiting and dog-fighting were outlawed in many places and societies were being formed to stamp out other cruelties.

With the arrival of Darwin's bombshell in the middle of the nineteenth century, the scene was set for a dramatic increase in scientifically inspired animal subjects for the artists of the day. The exploration and investigation of the natural world was racing ahead all over the planet, and the aesthetic and scientific view of animals was coming more and more to the fore, leading to an increasingly precise representation of wildlife in paintings. Even where symbolism managed to survive—as in the work of Landseer, for example—the animals that were made to play symbolic roles (such as the dogs in *Dignity and Impudence,* see p. 103) were nevertheless depicted accurately, in deference to the pre-eminent importance placed on natural history by contemporaries. The paintings in this wonderfully organized, thematic exhibition reveal all these changes and force us to reconsider so much that we have forgotten or taken for granted.

My personal involvement with this exhibition concerns my loan of paintings and drawings by the chimpanzee "Congo." In the 1950s, I undertook a scientific investigation into the origins of art. Working with this one exceptional ape, I was able to study the way in which the chimpanzee, when faced with a blank sheet of paper, would make marks on it that were not randomly scattered, but visually controlled. Congo developed abstract designs —favorite patterns that he would repeat—and then started to vary these patterns, exploring different ways of filling the blank space in front of him. Although he never reached the stage of creating pictorial images, he did show that the ape brain was capable of thematic variation, compositional control, calligraphic differentiation, and visual balance.

In earlier centuries, several artists, including Goya, Watteau, Chardin, and Grandville, had painted satirical pictures in which monkeys or apes were shown creating works of art. The ape–artist who "apes" nature was a favorite theme for representation—in other words, one who can only slavishly copy what he sees before him and is incapable of painting from the imagination.

There is a great irony in this, since that was precisely the thing that Congo could not do. He could invent an abstract pattern, control it, vary it, and develop it, but he found it

impossible to copy the natural world. He could innovate but he could not imitate. How surprised Chardin and the others would have been to watch Congo hard at work, focusing all his brainpower on the joy of exploring visual pattern-making.

We have come a long way from the early days when animals were seen merely as victims or jokes, to be tormented in bear-pits, or laughed at in sideshows. This remarkable exhibition presents us with the main turning point in this shift of opinion, with the painted canvas as a barometer of the social upheaval that heralded a new awareness of the animal world.

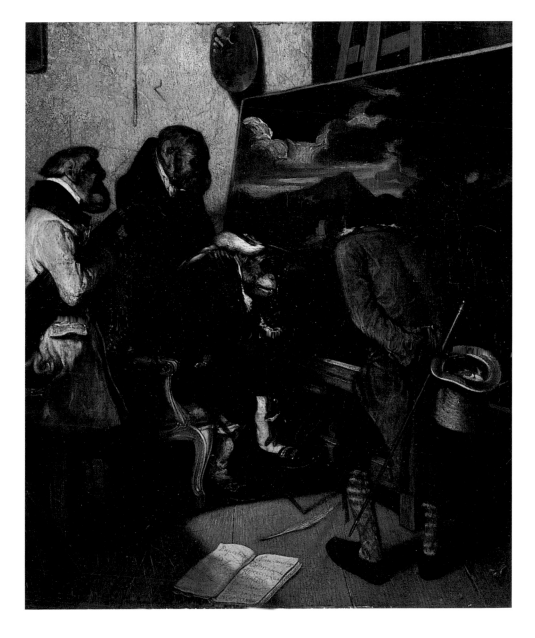

**Alexandre-Gabriel Decamps**
French, 1803–1860
*The Experts* (detail), 1837
Oil on canvas
46.4 x 64.1 cm (18¼ x 25¼ in.)
The Metropolitan Museum of Art,
New York, H.O. Havemeyer Collection

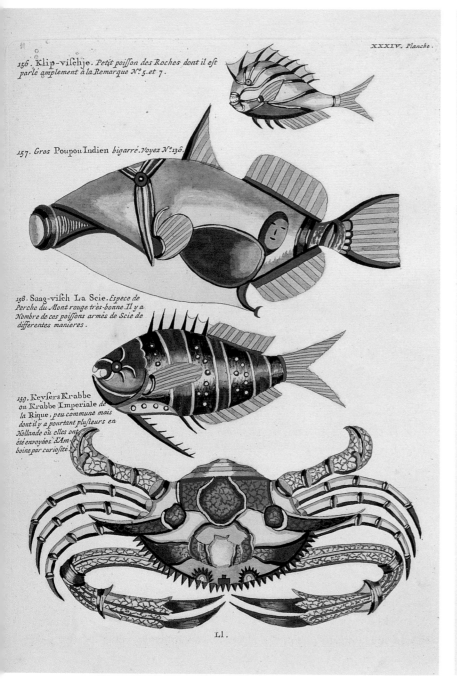

156. Klip-vischje. *Petit poisson des Roches dont il est parlé amplement à la Remarque N.°5.et 7.*

157. Gros Poupou Indien *bigarré.Voyez N.°136.*

158. Saag-visch La Scie. *Espece de Perche du Mont rouge très-bonne Il y a Nombre de ces poissons armés de Scie de differentes manieres.*

159. Keysers Krabbe ou Krabbe Imperiale de la Rique, *peu commune mais dont il y a pourtant plusieurs en Hollande où elles ont été envoyées d'Amboine par curiosité.*

LI.

1, CHIRONECTE BARBATULE, *Eydoux et Souleyet.* 2, CHIRONECTE À RÉSEAU, *Eydoux et Souleyet.* 3, CHIRONECTE LÉPREUX, *Eyd.*

4, GOBIE GRELÉ, *Eydoux et Souleyet.* 5, GOBIE À FILET, *Eydoux et Souleyet.*

Plate XXXIV in vol. II of Louis Renard, *Poissons, ecrevisses et crabes, de diverses couleurs et figures extraordinaires, que l'on trouve autour des Isles Moluques, et sur les côtes des terres australes: Peints d'après nature, etc.* (Fish, crayfish and crabs of diverse colors and extraordinary shapes, found in the vicinity of the Molucca Islands and the coasts of southern lands: painted from nature, etc.), Amsterdam (Reinier & Josué Ottens) 1754
Universiteit van Amsterdam, Artis Bibliotheek

*Poissons*, plate 5 of Fortuné Eydoux and Louis-François-Auguste Souleyet, *Voyage autour du monde exécuté pendant les années 1836 et 1837 sur la corvette La Bonité commandé par M. Vaillant Capitaine de Vaisseau* (Voyage around the world during the years 1836 and 1837 on the corvette La Bonité commanded by M. Vaillant, captain ...), atlas, Paris (Arthus Bertrand) 1841
Universiteit van Amsterdam, Artis Bibliotheek

# Looking at Animals: Vision and Evolution

Louise Lippincott and Andreas Blühm

This book is about the evolution of looking. In particular, how we look at nature, and how we look at a particular part of nature—namely, animals. In a period that witnessed revolutionary changes in political systems, methods of production, and technologies, what changed the most was our relationship with nature. We, representatives of *Homo sapiens*, got further away from it, less dependent on it, less aware of it. As a result, we now see nature very differently than we did 250 years ago.

How did we look at animals in 1750 or in 1900—and how do we look at them today? What has changed? Perhaps the most obvious difference is that today, although our scientists know much more about animals than they have at any time in the past, most of us no longer live or work with anything bigger than a dog or wilder than a parakeet. Our practical knowledge of animals—how to drive a horse, milk a cow, snare a rabbit, or track a fox—has diminished greatly. In fact, most of us no longer depend on animals for our livelihoods, nor do we think of them as useful in the way that cars, trucks, and supermarkets are now useful. In terms of our daily lives, animals function as luxuries. They serve as pets, as entertaining spectacles at the zoo and circus or on television, or as partners—both willing and unwilling—in recreational pastimes such as hunting, fishing, horse-riding, and dog-showing.

Emotional detachment as well as practical knowledge has always been necessary in order to train, hunt, work, sell, or slaughter an animal successfully. Farmers rarely give names to animals raised for food, for example. Today, the animals we live with are often the focus of passionate emotions—their owners dress them up, talk to them, sleep with them, and mourn their deaths with an intensity usually reserved for human members of the family. There seems to be a close correlation between our diminishing economic dependence on animals and our growing desire to relate to them emotionally.

Hand in hand with this goes a lack of understanding of the dangerous sides of animals. Few pedestrians today suffer attacks by wolves during a walk in the park. People who only take pony rides don't realize how easily a horse can kill a person. They are outraged when dogs bite, cows kick, deer eat the roses, and squirrels infest the roof. The true wildness of wild animals is underestimated; unbelievable as it may seem, it is fashionable in some circles to buy a lion cub as a child's pet. We no longer have to wake at sunrise to let the cow out to pasture. We romanticize horse-drawn carriages, while having no clue what city streets full of horse manure must have smelled like.

The greatest change in our perception of animals in recent years has been a growing recognition that animal life is essential to the long-term health and well-being of our planet, and that our actions are putting both of these at risk. This seems at first to be far removed from the traditional attitude that animals exist primarily to satisfy our nutritional, economic, and emotional needs. But in reality, we have simply taken exploitation to another level. We

still believe that human manipulation of nature is necessary for our survival. Today we undertake wildlife preservation in the name of biodiversity or DNA supplies, or ecotourism, as we recognize that ecologies that are out of alignment will ultimately kill people, too. In other words, the benefit to animals is still secondary.

There is more to the story than this, however. Set against our apparently innate tendency to exploit animals to satisfy our changing needs is another trend that also occurred between 1750 and 1900. This is the development of the understanding that humans are animals, too. At its root are some contentious questions: What is human? What is animal? Where and how does one draw a line between them? There have been some very different answers over the last three centuries—answers that seem to have little bearing on our daily routines, but are actually fundamental to religious belief, science, art, and culture. Long before Darwin wrote *The Origin of Species* (1859), philosophers, religious leaders, and naturalists had begun to recognize that animals display some of the physical and psychological characteristics of humans. We might say that after Darwin, philosophers, religious leaders, and scientists also had to accept the fact that humans display many of the physical and psychological characteristics of animals. So it was that at the beginning of the twentieth century, humanity finally rejoined the animal kingdom.

Over the last 250 years or so, the act of looking at animals has developed its own history, formed by our different ways of using animals and thinking about animals. Animal art reconnects us with the practices and ideas of the past, shows us how they have changed, and alerts us to the different ways we think and act now. We have tried in this book to step back in order to gain an overview of this fascinating and complex story. But we are mere art historians, connoisseurs of paintings, not creatures. Entering foreign territories—histories, of science, religion, culture—is risky, as the explorers of the past testify. However, if our adventurous naïveté can help others to regard art and animals with new interest, we will have achieved our goal.

We have tried to look at everything: not only paintings, sculptures, and photographs, but also natural history displays, zoos, taxidermy, and book illustration. The people who made these things based them not only on what they observed in animals, but also on what they knew, or believed they knew, or simply believed. In other words, we are looking at man-made animals.

Here, we examine what it has meant to look at animals over the last 250 years. Four themes emerge. The expansion of the animal world in the eighteenth century, primarily resulting from overseas exploration: Looking around. Our deepening knowledge of animal anatomy, physiology, and behavior in the early nineteenth century: Looking within. The impact of geology and the birth of paleontology in the mid-nineteenth century: Looking back. And the mind-boggling implications of Darwinian evolutionary theory after 1859: Looking in the mirror. In the remainder of the book, we examine particular artworks (generously defined) in detail. Our goal is to compare these visions from the past with what we see today. Animals may look the same as they did 250 years ago, but we see them differently.

## Looking around—the expansion of the animal world

In the eighteenth century, European explorers filled the empty spaces of their world map. Those vast wastelands that had been labeled "Here be dragons" turned out to contain buffalo, kangaroos, and gorillas instead. Animal specimens were treasures, like the metals, minerals, spices, porcelains, and other commodities and goods shipped back to Europe by the boatload.

What to do with these animals, if they survived the voyage? The economic solution was "acclimatization," trying to adapt desert, jungle, and savannah creatures to the European

climate, in hopes of developing new sources of food, leather, power, entertainment, medicines, and the like. The political solution was to use the animals to display wealth and power: My zoo is bigger than yours (because my empire is bigger, my navy is faster, my explorers more adventurous, and so on). The smaller, tamer animals become pets, markers of social status.

Many of these experiments in acclimatization failed. But every new animal added something to the Western world's growing body of knowledge about life on the planet. The old seventeenth-century cabinets of wonders could not cope with the expansion of riches: if by 1740 almost six hundred species of animal were known in total, one hundred years later four times as many *Ichneumonidae* (ichneumon flies) alone had been identified.[1] Slowly, collectors began to sort their treasures into groups. At first, they separated man-made wonders (works of art) from natural wonders (strange animals and minerals, freaks of nature). As the century progressed, these categories were subdivided further. Artworks were sorted by medium and by artist, by nationalities and centuries. Nature was divided into animal, vegetable, and mineral kingdoms, and then subdivided again.

The animal kingdom was sorted in many different ways, with an emphasis on quadrupeds and birds. Rigorous systems replaced the creative chaos. But for much of the century, each collector or scholar had a unique system for organizing and naming specimens. For scholars, the first problem was to name and identify the specimens in a uniform manner. The naming problem, which most people thought Adam had solved soon after Genesis, started to raise questions that we have still not solved completely. Is there an underlying order to nature that the human mind can grasp, put into language, and represent visually? Where does one draw the line between increasingly minute variations and distinctions between living things? What characteristics matter in these discriminations: color, shape, behavior, size, geographical origin, method of reproduction, usefulness to humans?

---

[1] Wolf Lepenies, *Das Ende der Naturgeschichte*, Frankfurt am Main (Suhrkamp) 1978, p. 17.

*Description abregée des planches, qui representent les cabinets & quelques-unes de curiosités, contenuës dans la theatro des morvgilles de la nature, de Levin Vincent* (Brief description of the plates representing the cabinets & several curiosities from the theatre of the wonders of nature of Levin Vincent), Haarlem (published by the author) 1719
Universiteit van Amsterdam, Artis Bibliotheek

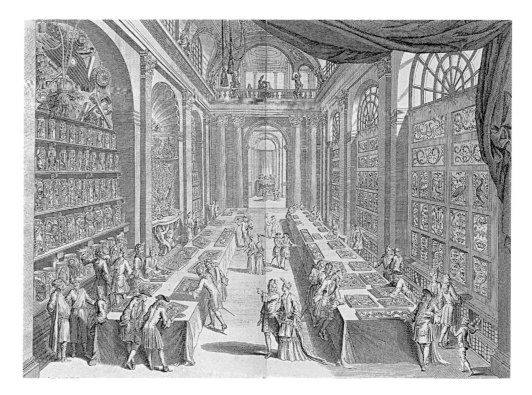

The Swede Carolus Linnaeus is credited as being the first person to summarize the natural world successfully. The tenth edition of his *Systema Naturae*, published in 1758, introduced the binomial system using Latin or Greek words to describe genus and species that is still valid today. But what was his distinguishing criterion to separate one animal from another? Linnaeus worked almost entirely from preserved specimens in the aristocratic collections of Europe, so, unsurprisingly, he looked at details of anatomy that survived primitive eighteenth-century preservation techniques and could be observed with the naked eye. Beginning with his work on plants, Linnaeus used the reproductive organs to sort and group his specimens into meaningful relationships. At that point in history, neither Linnaeus nor anyone else understood how sexual reproduction influenced evolution (a concept that would not even be introduced until the nineteenth century) and how it served to transform life-forms over time. Rather, Linnaeus's choice of criterion was based on minute observations of thousands of specimens and his own careful but somewhat arbitrary judgment.

The early emphasis of the systematizers was on accurate verbal descriptions and consistent nomenclature. Like many naturalists of the time, Linnaeus did not trust images. Most natural histories before 1750, if illustrated at all, made do with crude woodcuts, often copied without much care from other sources, and they were indeed inaccurate to the point of deception. Few artists were capable of depicting the anatomical minutiae critical to naturalists, and few naturalists could afford to pay for the lengthy and complex job of producing engravings for book illustration. In 1737, Linnaeus wrote: "I do not recommend the use of images for the determination of genera. I absolutely reject them—although I confess that they are more pleasing to children and those who have more of a head than a brain. I admit they offer something to the illiterate. … But who ever derived a firm argument from a picture?"[11]

Georges-Louis Leclerc, comte de Buffon, the other important eighteenth-century systematizer (a competitor of Linnaeus, and his critic), had also been reluctant to use images. His great work originated as a dry catalog or list of specimens in the French king's natural history collections. It expanded, however, into a description of nature as a whole, and to the usual terse descriptions and Latin names Buffon added anecdotal narratives, discussions of economic usefulness, occasional descriptions of internal anatomy and dissections, and citation of Classical sources. Furthermore, he added animal portraits. The irony is that the illustrations from his multi-volume *Histoire naturelle* are still admired and reproduced, while the text is hopelessly outdated and of interest to the specialized historian alone.

The two great encyclopedic books of the Enlightenment were Buffon's *Histoire naturelle* (1749–88) and Denis Diderot's *Encyclopédie* (1751–72). These extraordinary compilations were the first to gather large quantities of scattered information, systematize them into usable bodies of knowledge informed by radical but coherent world views, provide copious illustrations, and sell them to a wide public. They changed the way knowledge was organized and shared, and the way it was consumed. For the first time, books showed this new, scientifically organized world of nature to a large public that had never before had access in any way to the royal and aristocratic animal collections on which they were based. Because the ultimate purpose of these books was description, no expense was spared on the quality of engraving, the richness of the coloring, or the use of materials such as varnish, mica dust, or gilding to reproduce the brilliant tones and textures of feathers, fur, and insect wings.

What do we see in these books? It is interesting to watch how scientific illustration and eighteenth-century Neo-classical art complemented each other. Each valued clear outline, pure

---

11 Quoted in David Freedberg, *The Eye of the Lynx: Galileo, His Friends and the Beginnings of Modern Natural History*, Chicago and London (University of Chicago Press) 2002, pp. 412–13.

coloring, firm modeling, order and regularity, and precision. Because the main purpose of images was to record salient details for identification purposes and to permit comparisons over a distance, today they seem rigidly schematic. The profile view, fundamental to scientific illustration, was also a great favorite in Neo-classical portraiture. Profile reveals the greatest number of important characteristics simultaneously. Great attention is given to superficial details, such as markings, horns, and so on, which nevertheless aid in distinctions. On the other hand, poses are strictly conventional and often not at all lifelike, since so many renderings were made from skins, bones, or drawings instead of the living creature. Many of the exotic animals pose in the same way as horses, dogs, cats, or chickens, whose body types and motion were more familiar to artists. Sometimes, they are positioned on pedestals or among Antique ruins. Thus, these drawings, intentionally and unintentionally, show us the state of knowledge of animals at the time. They include the features that Enlightenment thinkers believed to be important.

The hallmarks of Enlightenment science—classification, hierarchy, systematization, collections, catalogs, and illustration—are also stamped on the visual arts. Modern art history, like modern natural history, grew out of collectors' attempts to name and order the contents of their cabinets. Unlike natural historians, connoisseurs did not have to make up names; the names could be taken instead from published sources like Giorgio Vasari's *Lives of the Painters* (1550). But the questions the connoisseurs asked were eerily similar. What mattered most when naming a drawing: Subject-matter? Quality? Technique? History? How does one distinguish an original from a copy, or a master from his pupil? Is there a universal standard for judgment? Can one trust images to provide information as well as to delight? Johann Joachim Winckelmann tried to establish a timeless canon based on a limited number of Greek statues, William Hogarth analyzed the principles of beauty, and Pierre Crozat and the comte de Caylus published illustrations of old master drawings in aristocratic collections. All other sciences know a parallel development.

Degrees of animality as measured by facial proportions, from a frog to the Pythian Apollo, plates 527, 528, 529 in vol. 9 of Johann Caspar Lavater, *L'art de connaître les hommes par la physiognomie* (The art of knowing mankind through physiognomy), Paris (Chez L. Prudhomme, ...) 1806–09 University of Pittsburgh, Health Sciences Library System, Falk Library

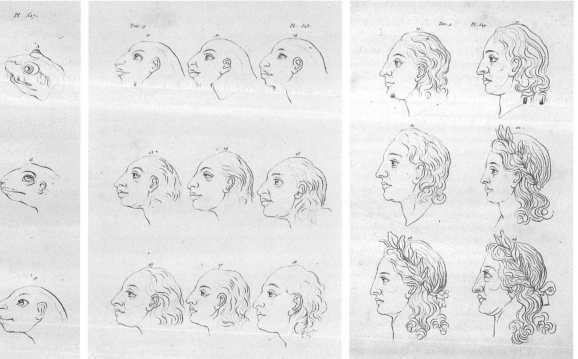

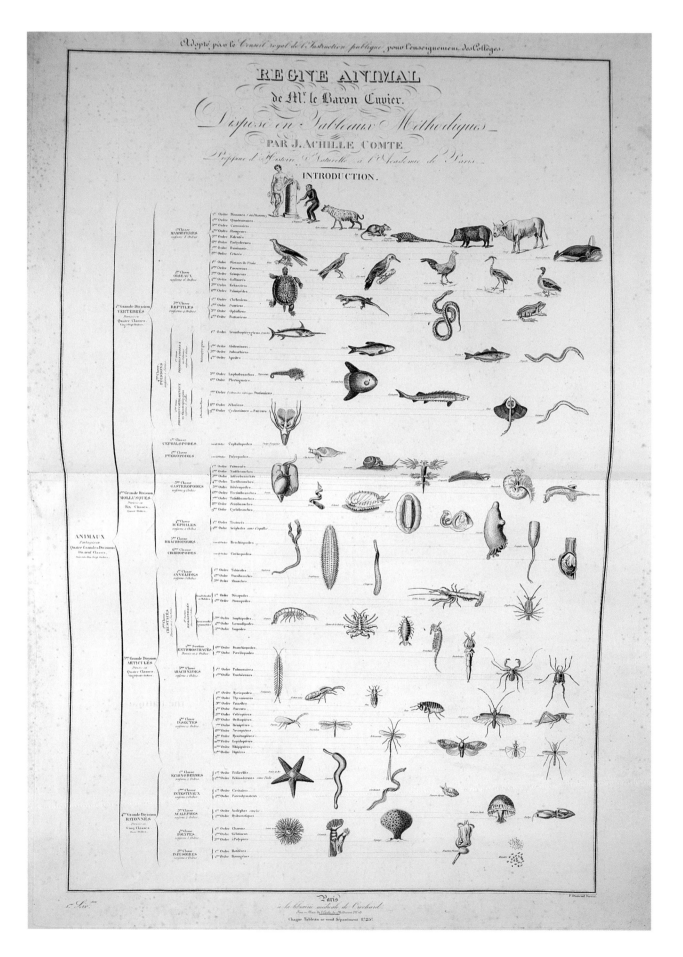

Despite its importance for recording and disseminating scientific information, animal art had little prestige during much of the eighteenth century. Its low status in the aesthetic hierarchy can be traced back to theories of creativity and moral value derived from the Book of Genesis. God's creation of the world, a six-day event, began with light and moved on to the lowest forms of nature—water, rocks, and the rest of the mineral world. He progressed to plants, animals, and finally mankind before resting on the seventh day. In philosophy, this sequence of events underlay the theory of the Great Chain of Being, an intellectual hierarchy of creation that organized nature in similar fashion, with minerals on the bottom, and ranks of vegetation, animal life, and mankind leading up through the higher orders of angels and culminating in God himself, pure spirit. It was argued that one's position within this ranking depended on one's share of the divine essence or spirit of God. Animals belonged somewhere near the middle, high enough to breathe and move and interact with their surroundings, but lacking the intellect, moral judgment, and spiritual awareness—that is, the soul—that distinguished the human creation from God's inferior works of the earlier days. As a result, the hardworking horse, sagacious elephant, and regal lion were placed at the top of the animal kingdom because they demonstrated features most akin to human virtues.

In art theory, the "hierarchy of the genres" functioned as the equivalent of the Great Chain of Being. Developed in the seventeenth century, the hierarchy placed history and religious painting at the top of its heap and the representation of lower forms of creation—animals, plants, and inanimate objects—at the bottom. The status of animal art rose and fell with the status of animals. And the status of animals was rising in the eighteenth century. The rare exotic creatures imported from new lands were valued sufficiently to become subjects of portraits. Enlightenment philosophers recognized that animals can inspire emotion in humans, and that they exhibit behaviors that seem to express primitive feelings—such as pain—that humans can recognize (although opinions varied on animals' ability to feel emotion themselves). In eighteenth-century animal art, we can trace the development of this new attention to feeling, from Oudry's detached portraits of animals as food or as exotic specimens to Greuze's sentimental image of a girl crying over her dead canary (see pp. 39, 53). Although the emphasis is on the feelings that looking at animals can arouse in humans—everything from admiration to hunger to fellow sympathy—the very admission of animals into the emotional lives of human beings represented a significant change of viewpoint.

## Looking within—comparative methods dig deep

By the end of the eighteenth century, it was clear that not only were there more animals to look at, but that there was also more in animals to see. In both the natural history and the art of animals that was produced between about 1780 and 1850, interest shifted away from the animal's external appearance. The new focuses for science and art became internal anatomy and emotional expression. At the same time, the comparative methods that were developing in both anatomical studies and art connoisseurship took on new refinement and sophistication. The three key figures in this new history of looking are the physiognomist Johann Caspar Lavater, the animal anatomist Georges Cuvier, and the anatomist and art connoisseur Giovanni Morelli.

Lavater's influential book *Physiognomische Fragmente, zur Beförderung der Menschenkenntnis und Menschenliebe* (Physiognomical fragments, for the promotion of knowledge and the love of mankind), first published in 1775–78, appeared in most European languages and countless editions in the later eighteenth and early nineteenth centuries. It drew on the work of the seventeenth-century artist Charles Lebrun, who had attempted to codify human facial

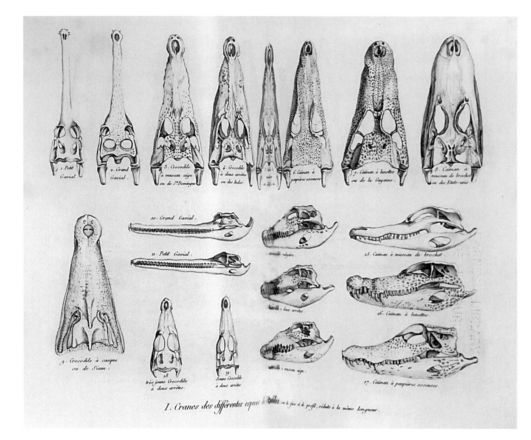

*Cranes des differentes espèces de crocodiles, vue de face et de profil, réduites à la même longeur* (Skulls of different species of crocodile, seen from above and in profile, reduced to equal length), plate 22 in vol. II of Georges Cuvier, *Recherches sur les ossemens fossils des quadrupèdes* (Researches on the fossil remains of quadrupeds), atlas, 4th edn, Paris (Edmond d'Ocagne) 1836 Carnegie Library of Pittsburgh, William R. Oliver Special Collection

expressions in a way that artists could use to depict common emotions in paintings. Lavater sought to prove that facial expressions reflected the passions of the soul, and he argued his point with carefully drawn portraits of famous humans. He correlated outstanding facial features, such as the shape of the chin, with aspects of personality, and he analyzed the relationship of common expressions—a frown, a sneer, a quizzical look—to internal emotions. The face reflected the soul. Lavater's work is important for our purpose because it contained a section on the expression of emotion in animals. Not only did he show that the character of a horse could be determined by the shape of its nose, the flare of its nostrils, and the set of its eyes, but he also implied that the origin of these expressions was to be found in the animal's soul. Lavater's ideas transformed the act of looking at animals at the end of the eighteenth century. After Lavater, one looked at an animal not only to assess its strength, durability, or nutritional value, but also for character, rapport, and communication. Thus looking at animals could be just like looking at humans, and the notion that animals could be compared to humans no longer seemed so far-fetched.

In fact, human and animal emotions became the central subject for nineteenth-century Romantic artists. This was the great age of the animal combat as a subject for art, the era of Alfred, Lord Tennyson's famous poetic description of "Nature, red in tooth and claw." These horrific images of violent conflict turn out to have been drawn mainly from Antique animal lore, staged menagerie acts, and the artists' hyperactive imaginations, but their origins and justification are to be found in Lavater. This is also the art in which animal subjects most often express human emotions or find themselves in situations that are more human than animal. Painters of animal emotion such as Landseer and Delacroix, or sculptors such as Barye, began to break down the traditional distinctions between lowly animal art and

superior history paintings by depicting animals on the same terms as humans, and vice versa (see pp. 79, 89, 95, 103). Zoos may also have played a decisive role in the development of these new modes of looking at and representing animals. Once one had seen a real tiger in action, however limited that action might be, a stuffed one on a pedestal—as in Buffon—could not satisfy the hunger for excitement anymore.

In contrast, nothing could be drier than comparative anatomy. Georges Cuvier served on the staff of the newly formed Muséum National d'Histoire Naturelle in Paris from 1795 until his death in 1832. He was a master of comparative anatomy; his *Recherches sur les ossemens fossils des quadrupèdes* (Researches on the fossil remains of quadrupeds) (1812) more or less invented the science of paleontology, and his *Règne animal* (Animal kingdom) of 1817 finally supplanted Buffon. Cuvier worked with the great French national collections, a magnet for rare and mysterious animal specimens from all over the world. Cuvier's method was simple and rigorous. His classifications of genus and species were based on thoroughgoing anatomical comparisons that extended deep below the skin of a creature to take into account its skeletal structure, internal organs, and physiology. The great Hall of Comparative Anatomy in the Jardin des Plantes in Paris—Cuvier's work—contains not skins nor mounts but skeletons. Cuvier's *Recherches* is illustrated with skeletons or individual bones, drawn meticulously to scale and laid out side by side so that the minutest differences in form are instantly apparent. By the 1820s, it was possible for advanced comparative anatomists to look at a single bone, perhaps a tooth or part of a leg, and describe the entire animal. And Cuvier's specimens included humans, whose bones are assembled in cases and displays, too.

The consequences of these comparative methods were enormous. Following Cuvier, the importance of detailed, scale illustrations was never again questioned. John James Audubon, Charles Willson Peale, and Carl Gustav Carus are among the most important of many fine artists with a scientific agenda. All insisted on the importance of quality drawings made directly from original specimens. The French explorer François Levaillant criticized earlier hand-colored bird illustrations because they were made after faded specimens.[III] And as both

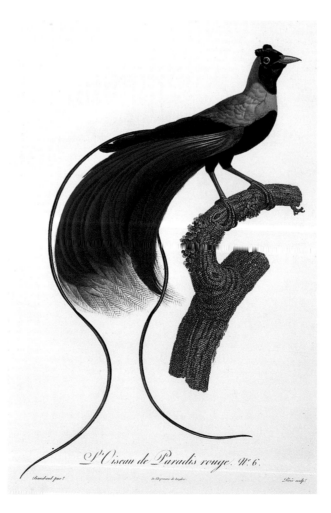

*L'Oiseau de Paradis rouge*, plate VI in vol. I of François Levaillant, *Histoire naturelle des oiseaux de paradis et des rolliers, etc.* (Natural history of birds of paradise and rollers, etc.), 3 vols., Paris (Denné le jeune and Perlet) 1806 Universiteit van Amsterdam, Artis Bibliotheek

*S'Oiseau de Paradis rouge. N°. 6.*

[III] Wolf Lepenies, *Das Ende der Naturgeschichte*, Frankfurt am Main (Suhrkamp) 1978, p. 73.

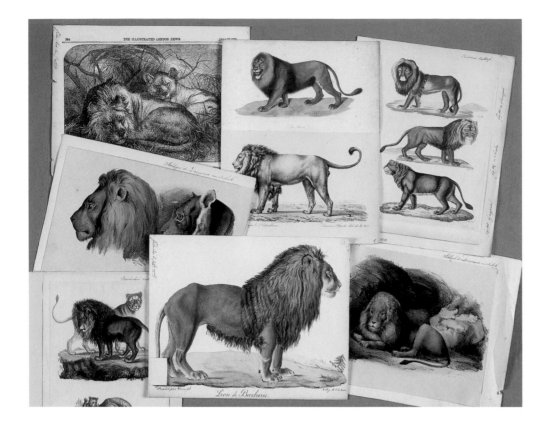

Images of lions, *c.* 1750–1850, from *Iconographia zoologica societatis regiae zoologicae Amstelodamensis Natura Artis Magistra, Carnivora I: Felis Leo* (Iconography of the zoological collections of the royal zoological society of Amsterdam Natura Artis Magistra, carnivores I: the lion) Universiteit van Amsterdam, Artis Bibliotheek

artists and scientists gained access to more and more specimens, through their own travels or as collectors on a grand scale, their work became more sophisticated, more penetrating, and less reliant on superficial detail and Classical lore.

When believing becomes a matter of seeing, the arts become a major vehicle in the fight for enlightenment, education, and science. The fight could only be won when things were shown and proven for everybody, things that nobody had ever seen: the eyes of a flea, the stomach of a frog, the skeleton of a walking tiger. George Stubbs dared to compare the last with the skeleton of a walking man. Down to the bone, everybody can see that a big cat and a human being have a lot in common (see p. 65). Enlightenment shed light on the subject, and tried to establish the human being as a self-conscious end of Creation—but the more the scientists researched, the more they found similarities with animals, not distinctions.

Looking at animals and looking at art evolved in parallel steps during the early nineteenth century. The first art museums and zoos, as heirs of the cabinets of curiosities and the royal menageries, retained much of the magic of exotic worlds, and they were fraught with similar problems of organization and identification of exhibits. The great art connoisseur Giovanni Morelli (1819–1891) lived generations after Lavater and was much younger than Cuvier. However, his methods of sorting and classifying works of art are the direct result of their research and ideas. Morelli was trained as a physician, but his great interest lay in comparative anatomy, and he was a dedicated student of Cuvier's writings. He applied Lavater's idea that outward expressions reflected the internal spirit or soul and Cuvier's belief that anatomical details could distinguish identities. But Morelli used these ideas for looking at art, not animals. He proposed that an artist would develop ways of handling anatomical details, such as ears or eyes or fingers, that would vary little from painting to painting. A connoisseur familiar with these details would be able to distinguish one artist from another (using ear shapes, perhaps) just as a comparative anatomist could tell one elephant from another (using skull formation, perhaps). Moreover, Morelli felt that the way an artist painted these details offered insights

into their creator's spirit, just as traditional anatomists believed that studying the details of nature offered insights into the mind of God.

Thanks to the comparative method, one could look at a lion's eyebrows, a strange bone, or a painted finger and expect to see deep into the souls of their creators. But spirit and creation were becoming problems.

## Looking back—new animals from the past

Although fossils had been found and recorded since medieval times, they were not recognized as the petrified remains of animals and plants until well into the eighteenth century. Even then, some people continued to believe that a mysterious generative power within the earth created fossils spontaneously from dirt and rock. Anatomists finally realized that a particularly common geometrically shaped fossil was a shark's tooth, and for believers in the Book of Genesis it has been all downhill from there.

The rapid expansion of mining and quarrying operations across Europe at the beginning of the Industrial Revolution exposed countless new fossil discoveries to the gaze of nineteenth-century geologists and anatomists. Explorations of increasingly remote territories produced more strange phenomena. Americans and Russians were finding giant elephant bones in swamps and frozen tundra, German miners excavating limestone for lithographic stones found evidence of birdlike creatures in the rock, and British beachcombers stumbled across the remains of giant sea monsters embedded in the coastline. These discoveries were profoundly exciting—and profoundly disturbing.

These masses of fossils posed two problems. The first was that many of these bones seemed to belong to creatures that no one had seen alive. It was just possible that sea monsters lived in deep waters and rarely approached shore; perhaps, as the American president Thomas Jefferson believed, herds of mastodons still wandered the unexplored Ohio plains; but what about the giant elk bones found in Ireland? There were no elk hiding on that populous island.

Plate XXIII in vol. I of Georg Wolfgang Knorr (ed.), *Sammlung von Merkwürdigkeiten der Natur und Alterthümern des Erdbodens* (A collection of natural curiosities and fossils), 6 vols., Nuremberg 1755–68
Universiteit van Amsterdam, Artis Bibliotheek

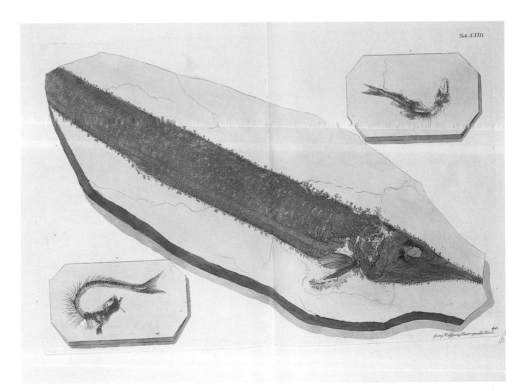

Georges Cuvier examined many of these finds, and in a series of papers and books pronounced that many of these animals were different from modern species and were extinct. It was also disturbing to recognize that many present-day animal varieties were missing from the geological layers. The second problem was the location of fossil remains. Marine fossils were found on mountaintops, for example. Other creatures were found within layers of rock that clearly had been laid down over successive eras with vastly different climates. Late eighteenth- and early nineteenth-century geologists gradually sorted these strata into sequences and began to develop theories of a history of the earth that encompassed a succession of radical changes in topography, climate, flora and fauna, and time spans of many thousands of years.

The scientists who made these discoveries and developed these ideas had been educated to believe that all of the earth's history had been described in the Bible. According to the Bible, earth was created in seven days, those seven days occurred just over 4000 years before the birth of Christ, and God's creation was perfect and immutable. Unsurprisingly, the first interpretations of fossils and extinct animals were based on the story of Noah's Flood. This global catastrophe, in which forty days and nights of rain drowned the earth's surface, explained the presence of shells on mountains, elephant bones in Siberia, and other anomalies. Some of the bigger bones were thought to belong to giants—mentioned in the Bible as early races of human—who must also have perished in the flood. It was grudgingly accepted that, contrary to the biblical narrative, Noah had not saved all the animals; a great many had missed the ark.

However, Noah's Flood could not explain the successive layers and successive waves of plant and animal life that differed in each layer. Cuvier developed a theory of "catastrophism," based on a series of Floodlike disasters that wiped out early creations and culminated in the final Creation recorded in the Bible. His ideas were disputed by numerous geologists, the most important being Charles Lyell, who argued that the geological record was produced by long, slow changes over hundreds of thousands of years. The implications of these discoveries and debates frightened many people. Religious leaders rejected most of them, or struggled mightily to reconcile them with Scripture. But they could not answer the growing numbers of questions. If God only made one Creation, where did all these other animals come from? How could God have gotten it wrong so many times? Why would he destroy his own handiwork? Or, could the Bible, source of all truth, be wrong about the prehistoric past?

The concept of extinction gave something new to animals: a history. The fossil record proved that animal life was as full of change as the human past. In fact, animal history was throwing into chaos most of the accepted facts of early human history. And these traumatic new ideas inspired some remarkable works of art. Human and divine history had traditionally dominated art theory's hierarchy of genres. Now, animals were thoroughly embroiled in both, and the great Romantic visionaries—from John Martin to J.M.W. Turner, dedicated painters of the most elevated histories—began to depict lowly animals (see pp. 99, 104). These were not the familiar creatures from the farm or the zoo, but Leviathan and Behemoth from the Bible, and ichthyosaurs and iguanodons from the remote past. Animals had reached the top of the intellectual heap in art.

Extinct animals also highlighted the role of the artistic imagination in the creation of both science and history. It was possible to make excruciatingly exact drawings of fossils and bones, but portraits of the extinct creatures themselves would have to be drawn from the imagination. Scientific illustrators worked, and still work today, under the close guidance of paleontologists, fleshing out the bones with information drawn from rigorous anatomical studies. Even so, none could claim to be producing anything but a human invention. It was not only scientific

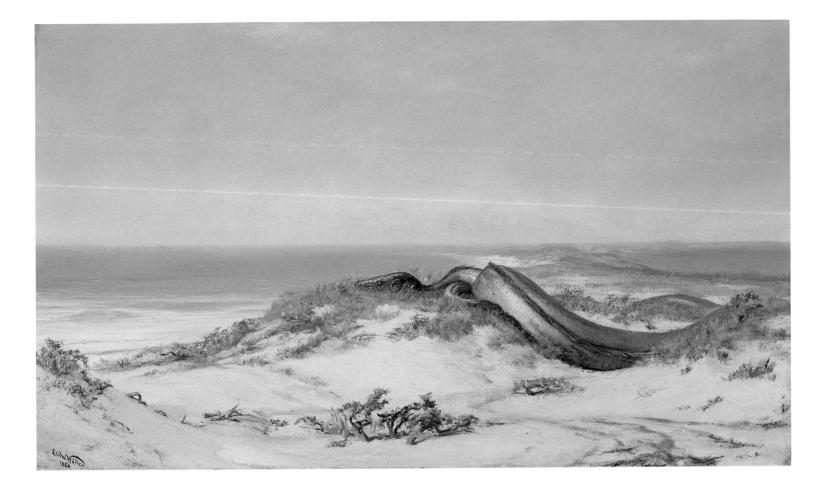

illustrators who were drawn to these extinct animals. Right from the start, the theme of monstrous creatures from the past appealed to visionary artists, who rose to the challenge of imagining worlds no human had ever seen. Not only did extinct animals take over the higher genres of traditional art, but they also stimulated the invention of new ones, such as science fiction.

### Looking in the mirror—the human relationship

The publication of Charles Darwin's *The Origin of Species* in 1859 was not only a landmark in biology and philosophy but also a turning point in the history of looking at animals. The result of decades of research became a non-fiction bestseller in its original English and very soon after in the major European languages. Darwin's theory synthesized the modes of looking described previously: around, within, and back. Darwin had looked around extensively, from the Galapagos Islands to his own backyard. He looked within while collaborating with Britain's most famous anatomists and natural historians in the examination, preservation, and publication of the specimens from his voyage on HMS *Beagle*. And as a skilled geologist himself, he was capable of looking back into many thousands and millions of years of animal history.

*The Origin of Species* argues that in a world of limited resources, all living things must compete and struggle to survive. Darwin derived this idea from the eighteenth-century economist Thomas Malthus, who had noticed that when human populations outgrew the available resources, those populations died out. Darwin took Malthus's ideas out of the field

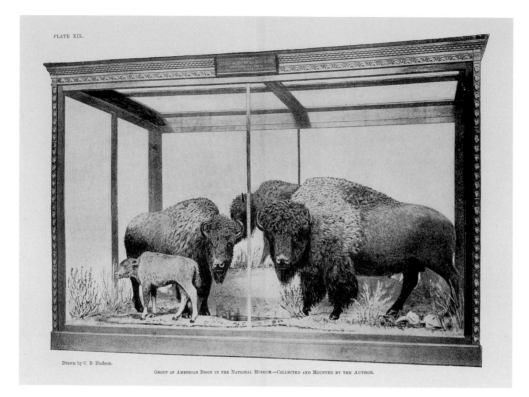

PLATE XIX.

Drawn by C. B. Hudson.

GROUP OF AMERICAN BISON IN THE NATIONAL MUSEUM.—COLLECTED AND MOUNTED BY THE AUTHOR.

Taxidermy display of buffalo family, from William T. Hornaday, *Taxidermy and Zoological Collecting: A complete handbook for the amateur taxidermist, collector, osteologist, museum-builder, sportsman, and traveller*, London (Kegan Paul, Trench, Trübner & Co.) 1891
Universiteit van Amsterdam, Artis Bibliotheek

of economics and applied them to zoology. He had learned from his observations of the specialized creatures on the Galapagos Islands that in isolation, over time, a species could develop characteristics that improved its chances for survival in a competitive environment. And, from his experience as a breeder of fancy pigeons, he realized that selective breeding could produce these characteristics relatively quickly. His final conclusion was that in nature, the early deaths of weak or poorly adapted animals ensured that stronger and better adapted members of the species would survive and breed. Over time, as adaptations multiplied and reinforced one another, different species would evolve. In his subsequent publications *The Descent of Man* (1871) and *The Expression of the Emotions in Man and Animals* (1873), Darwin extended his theory to show how humans descended from primate ancestors related to the apes, and how human and animal behavior and emotions, far from being expressions of the soul, were inherited adaptations enhancing survival.

Although based on the most careful observations of animals, *The Origin of Species* is one of the few science books requiring no illustrations. Darwin had published much of his visual evidence earlier in the lengthy and well-illustrated reports on the voyage of the *Beagle*. Moreover, he obviously believed in the superiority of good arguments and logic over diagrams and illustrations. But he ends *The Origin of Species* with a celebration of looking, which begins with an examination of the common, lowly life-forms on a grassy bank and leads to thoughts of cosmic laws and relationships. Darwin left it to others to visualize his new conception of nature.

Here we get at the heart of the interaction between science and culture. Darwinism did not change the way animals looked, of course. And yet, after 1859, people began to see and represent them differently. After Darwin, it was impossible to think about animals separately from their environments or their social and historical relationships. Both camouflage and extravagant plumage start making sense. Natural selection makes a creature part of a wider

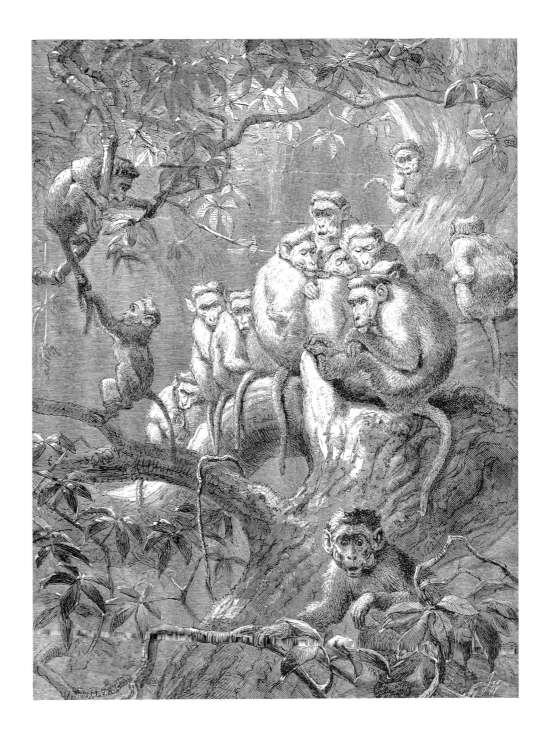

J.W. and E. Whymper
after Joseph Wolf
*Monkey Family*, from the Dutch edition
of Daniel G. Elliot, *The Life and Habits
of Wild Animals*, London (Macmillan)
1874 [Schetsen uit de dierenwereld,
Haarlem (Kruseman & Tjeenk Willink)
1874]
Universiteit van Amsterdam,
Artis Bibliotheek

natural environment. Buffon's isolated animals on pedestals suddenly appear distinctly odd. Paintings, zoos, and dioramas alike began to provide "natural" backdrops for their animal subjects and also sought to display them in herds, packs, families, and other forms of social organization. Paleontologists lined up fossil remains into entire genealogies. After Darwin, moral interpretations of animal behavior drop from sight. A big cat's behavior turns from mean to meaningful. A tiger is no longer cruel, it is simply hungry. Humans and animals cannot be thought of separately, either. They belong to the same kingdom and live by the same set of unforgiving laws: struggle for resources, survival of the best adapted, and servitude and death to the weak. The old ideas of hierarchy, traceable back to the Great Chain of Being, did not die easily, however. After Darwin, humans conceived a new "natural" order based on power and strength—"survival of the fittest"—rather than moral or spiritual values. This simple idea had a devastating impact on social, political, economic, and religious beliefs. *The Origin of Species*, a book about animals, changed humanity.

Before Darwin, monkeys and apes symbolized human stupidity. Dressed as a painter, the monkey represented mindless imitation (p. 36); dressed as a critic (p. 137), it symbolized blind incomprehension; looking in the mirror, even blinder vanity (opposite). In every case, this primitive ape looks, but it does not understand what it sees. It does not see what humans were supposed to see. After Darwin, monkeys and apes came to symbolize the most basic attributes of the human. Stupidity and incomprehension are still among them. However, as we have come to know our fellow primates better, we also recognize, in them, the origins of some of our prouder achievements, such as symbolic thinking, language, and tool use. We are now debating whether apes can make art, interpret signs, or recognize themselves in the mirror. We imagine that our understanding of apes is truer now than it was 250 years ago; in any

Anonymous
Russian (?)
Horse looking at its portrait,
c. 1900–10
Photograph
Reproduced in Rudy Kousbroek,
*Opgespoorde wonderen* (Rediscovered miracles), Amsterdam and Antwerp (Augustus) 2003, p. 31

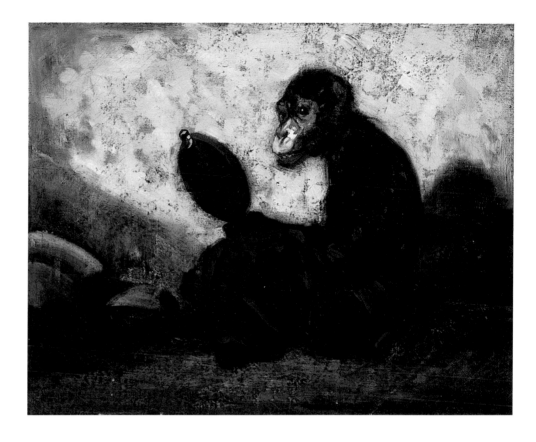

Alexandre-Gabriel Decamps
French, 1803–1860
*Monkey Looking at a Mirror* (detail),
before 1860
Oil on canvas
32 x 40.5 cm (12½ x 16 in.)
Museum of Fine Arts, Montreal

case, it has changed to accommodate our current views of the world and our place in it.

Looking in the mirror is a classic test of self-awareness or self-consciousness. A parakeet looks in the mirror in its cage and sees only another parakeet, which it treats as its best friend. On the opposite page we see a wonderful photograph of a horse laying back its ears to threaten the strange horse that appears in its own portrait. Monkeys and human infants do not seem to have a clue about who might be looking back at them from the mirror, but three-year-olds and chimpanzees probably do.

Today, we claim to look at nature objectively, assisted by the most advanced technology, sophisticated theory, and heightened awareness of our fragile, interdependent ecology. Artists are as actively engaged in this project as are scientists. But art and science have also proved that for even the most detached and objective of us, nature is also a mirror, and when we (imperfect monkeys that we are) look into it, we see mainly distortions of ourselves. Our abilities, limitations, experience, dreams, ideals, fears, and anxieties determine not only what we see, but also how we see it, especially in animals, the parts of nature that are most like us, the most mirrorlike. It seems to us as art historians, however, that there is still one more great project on which artists and scientists must collaborate—the creation of one more mirror. This would be a mirror that, when held up to nature, shows us not ourselves, but how the rest of creation looks at us. Then, perhaps, we might truly understand what it means to belong to the animal kingdom.

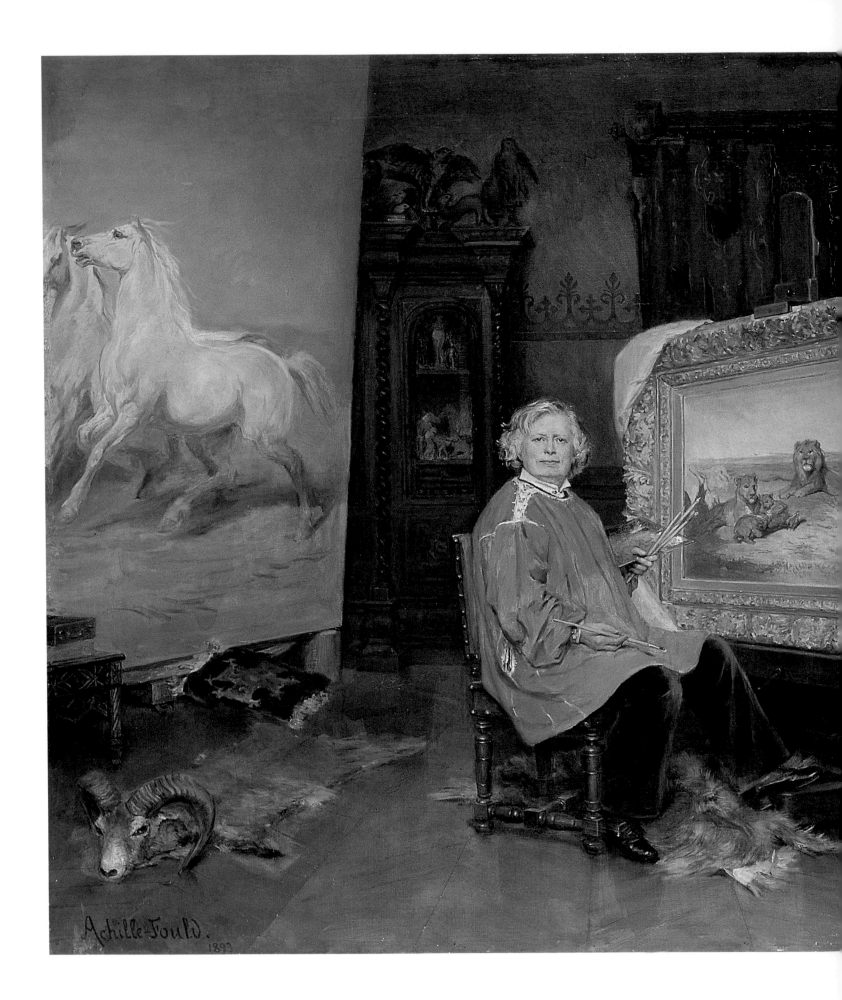

# Fierce Friends
## Artists and Animals, 1750–1900

# Ostrich, camel, roc

When Carle Vanloo painted *The Ostrich Hunt* for Louis XV of France in 1738, serious thinkers believed that ostriches were related to camels. They argued that ostriches and camels were both perfectly adapted to the arid deserts in Arabia and Africa. Ostriches did not fly, and their silky down resembled hair more than feathers, so they were unlikely to be birds. Also, ostrich skeletons were like camel skeletons because they lacked the keeled breastbone (anchor for wing muscles) that distinguishes birds from other creatures. It remained to be discovered whether ostriches were hybrid products of matings between camels and birds (as was the belief of the great naturalist Georges-Louis Leclerc, comte de Buffon) or if they constituted an intermediate form between birds and quadrupeds in the divinely ordained Great Chain of Being, which connected all of creation from the worm to Man. Thus Linnaeus gave the African ostrich its scientific name, *Struthius camelus,* in 1758.

Imported ostrich plumes had decorated European helmets and hats since the fifteenth century, and were finding a new vogue as ornaments on the burgeoning hairstyles of the eighteenth-century French court. Possibly, Vanloo saw live ostriches at the royal menagerie at Versailles, and he very probably had access to skeletons, feathers, and hides. His portrait of the bird is immediately recognizable. Its pink neck indicates that it belongs to an African species. However, this white bird could not have been based on a typical male, with black plumage, or on a sandy brown female. Unless the royal menagerie contained a rare albino specimen, Vanloo invented this one or copied it from another source.

As an actual hunt, this scene is implausible. It belongs to a suite of eight "Hunts in Foreign Lands" commissioned for the Petite Galerie du Roi at Versailles: the other hunts feature lions, tigers, a bear, a leopard, Chinese predators, a wild bull, and a crocodile. The hunters are exotic natives. Generic rocks and palm trees suggest Asian, African, and Middle Eastern locales. In fact, most of the scenes are modeled after seventeenth-century print and tapestry designs deemed suitable for the royal apartments. Vanloo and several other artists involved in the commission actually specialized in portraiture or genre painting, not animal art. Perhaps Vanloo's ostrich has been ambushed at an oasis—how else to explain the water in the foreground of this "desert" environment, and the presence of a hunter on foot who, in real life, could never have kept up with the bird's top speed of 50 miles (80 km) per hour?

One also wonders why, among the vicious predators in the hunts, the king wanted an ostrich. Perhaps its large size and dangerous kick made it sufficiently formidable, or perhaps its similarity to the roc, a giant bird of Arabian legend, glamorized it. The French believed they had discovered remains of the roc in Madagascar in the 1640s. (The gigantic bones and eggs—resembling those of an ostrich, but much larger—are now known to belong to the extinct bird *Aeypornis maximus.*) It was still just possible, in early eighteenth-century Europe, for a bird to be related to both a camel and a myth, and for an artist to paint an animal he had not seen, in a place he had never been to, on a hunt that could never have happened.

Carle Vanloo
French, 1705–1765
*The Ostrich Hunt*, 1738
Oil on canvas
183.3 x 128 cm (72⅛ x 50⅜ in.)
Musée de Picardie, Amiens

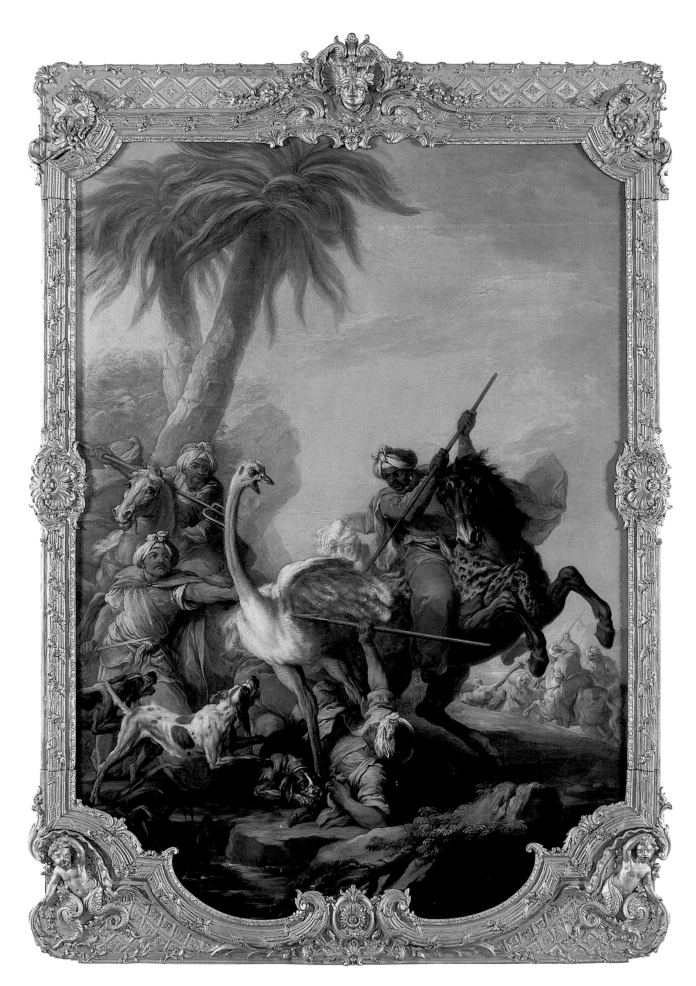

# Improving on nature

Jean-Baptiste Oudry
French, 1686–1755
*Antelope*, 1739
Oil on canvas
162 x 129 cm (63¾ x 50¾ in.)
Staatliches Museum Schwerin

In the eighteenth and nineteenth centuries, a woman expecting her first child often had her portrait painted. Death in childbirth was so common that families would commission this visual keepsake just in case. The same was true for exotic animals imported into Europe. If they survived the voyage (which was rare enough), the harsh climate or inadequate food supply usually killed them pretty quickly. It was imperative, therefore, to capture their likenesses as soon as possible. The inhabitants of the French royal menagerie at Versailles, including this antelope and hyena, were fortunate to pose for Jean-Baptiste Oudry, a brilliant animal painter who also painted humans. But even for an artist as great as Oudry, these rare specimens were a challenge. Not only did he have to record faithfully bizarre appearances, but he also had to figure out how to characterize the behavior and temperaments of animals few people had ever seen in action. Even when he had access to live specimens, he also studied other artists' work, as is the case with these sketches of leopards, made after a painting by the Flemish artist Pieter Boel (Charleville-Mézières, Musée Municipal).

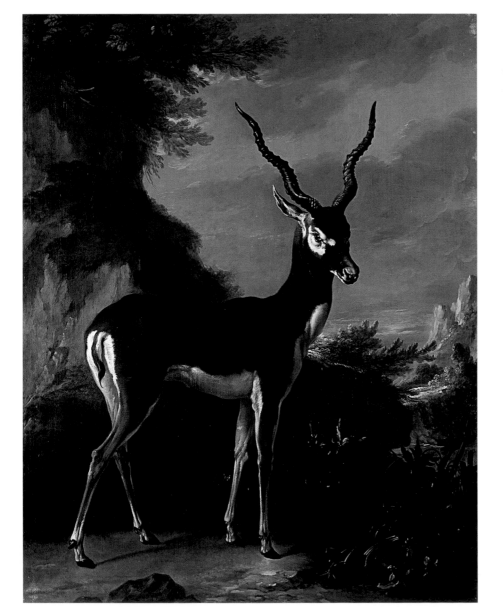

This painting of the Indian blackbuck antelope, which Oudry called a gazelle, deserves comparison with human portraiture. The animal appears life size and full length against a fanciful wilderness background that bears no resemblance to its natural environment. The blackbuck himself is beautifully observed. His rich brown coat turning black around the face and neck, the white underbelly and eye patches, the ridged and twisted horns—all are superbly depicted. Like many portraits, however, Oudry's improves on nature. His preliminary drawing (Stockholm, Nationalmuseum), probably made from life, shows a stockier animal with a shorter back and irregular markings. The head is carried almost perpendicular to the neck. In the finished painting the blackbuck is thinner, carries his neck almost vertically, and tucks in his chin. His physique and pose are more typical of a highly trained dressage horse than an antelope. His large, liquid eyes and docile manner show why "lovers and poets formerly thought it a compliment to the fair to say their eyes were as beautiful as the animals of that race [gazelles]."[1]

One of the goals of importing animals such as the blackbuck was to discover if they could be "acclimatized," that is, bred for adaptation to the European climate and domesticated for human use. Distantly related to sheep and goats, antelope are

---

[1] Mrs. Pilkington, *Goldsmith's Natural History Abridged for the Use of Schools*, 12th edn, Philadelphia (Thomas DeSilver) 1829.

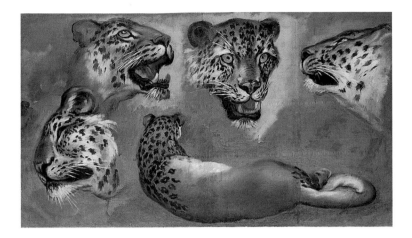

somewhat tamable, relatively easy to feed, and edible. However, they do not fare well in cold weather and have thrived only in hot desert areas such as their native India and Pakistan, and nowadays, Texas, where they are raised on ranches as prey for game hunters.

The hyena is quite another matter. It had the worst reputation of all mammals in the eighteenth century, and may still claim that honor today. (Hyenas are the principal villains of the Disney hit movie *The Lion King*.) In his magisterial encyclopedia of the animal kingdom, the comte de Buffon described the hyena as ferocious, untamable, unafraid of lions or men, and willing to dig up corpses for food. Its unusual genitalia laid it open to allegations of bisexuality, although Buffon discounts that idea along with other "ridiculous fables" derived from the ancients. Clearly the hyena was not an appropriate subject for a flattering portrait, and Oudry wisely turned to another genre, *animalier* painting, for his representation of this beastly beast (below). The obvious choice was an animal combat, pitting the striped hyena against two mastiff dogs. The bristling fur, glaring eyes, and bared teeth are enough to characterize the hyena's aggression, and the precarious situation of the dogs establishes its strength. But even here, the conventions of European art undermine the realism of the scene. Once again, the landscape is imaginary and the animal's pose is based on artistic formula, not observation. Oudry repeated the pose elsewhere—crouching animal with forepaw raised and head turned—to characterize the tender passion of a mother dog nursing her puppies (see p. 46).

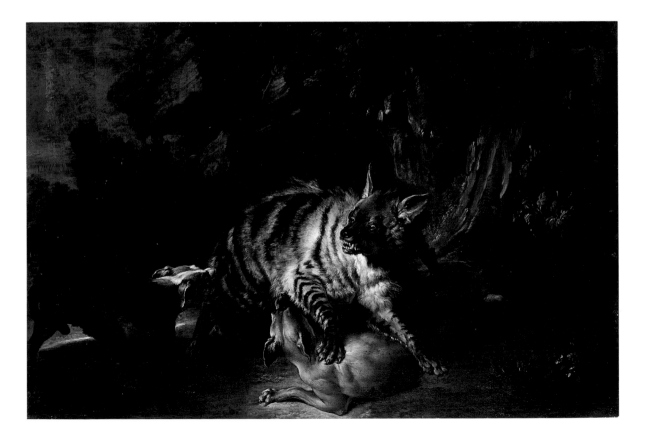

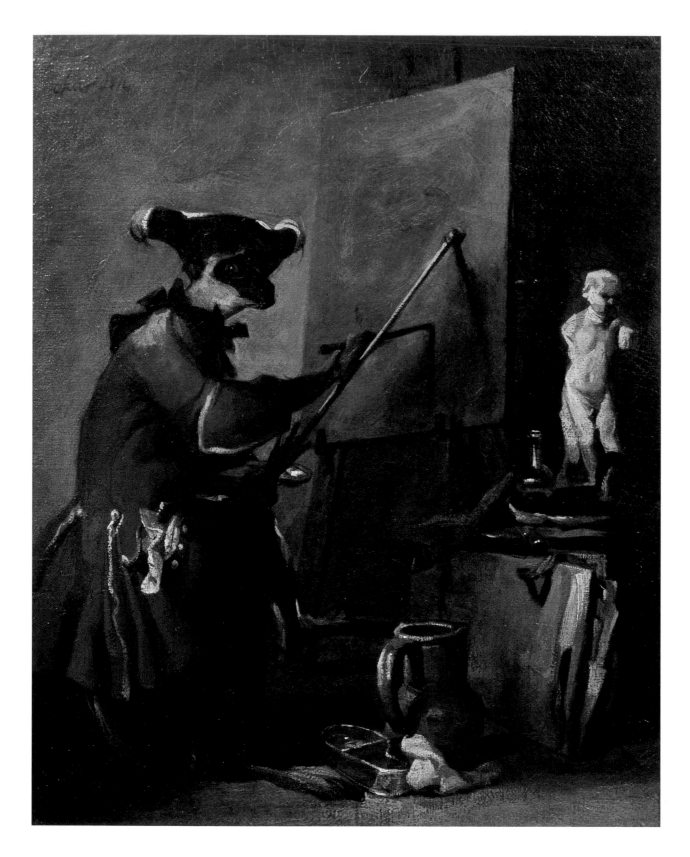

**Jean-Siméon Chardin**
French, 1699–1779
*The Monkey as Painter, c.* 1740
Oil on canvas
28.5 x 23.5 cm (11¼ x 9¼ in.)
Musée des Beaux-Arts, Chartres

# Monkey business I

When Chardin painted a painting monkey, he could not have imagined that biologists would one day experiment with … painting monkeys. From the early twentieth century onward, researchers were increasingly interested in animal behavior and human psychology, and in due course invited primates to take up the brush. Famous are the results of the chimpanzee Congo, who worked under the supervision of the celebrated zoologist Desmond Morris in the late 1950s. Congo's public success had much to do with popular reaction to the emergence of Abstract Expressionism, a style that led some people to believe that modern art is easy and could be executed by any brute, child, or insane person. Many people received Congo's paintings as a welcome support for their prejudices, but modern artists took the challenge with a sense of humor. Why should an ape not be creative? Why should one ape's talent not differ from the talent of another?

In Chardin's painting, we see a monkey in a studio, fully dressed, in front of an empty canvas. By using a monkey as a mirror for humans, Chardin followed a centuries-old prejudice that interpreted the monkey's imitations of human actions as silly. Such satirical images could be seen as an obvious criticism of human behavior. People looked at monkeys with bewilderment because they had humanlike features and yet behaved like animals—meaning, at this time, soulless machines that were deprived of any reason. Watching them, the beholder was confronted with an uncomfortable similarity. By dressing up monkeys and depicting them engaged in a human activity, the painter emphasizes this disturbing effect.

Apes or monkeys appear to humans as though they are imitating them; humans thus see themselves in a distorted mirror. "To ape" is a term that implies mindless imitative behavior. In Chardin's time, however, painters were taught first to imitate nature in order later to surpass it in their art. So what does Chardin want to tell us with a painting monkey? Does he want us to think that every painter is behaving like a monkey if he or she is just imitating nature?

When a real ape is painting, however, the result does not look remotely similar to what it has in front of it. Apes never ape. In front of a Congo painting, are we looking at the expressions of random motions, or is there some "free will" applied? When Pablo Picasso bought a painting by Congo the chimpanzee, he probably felt Congo's paintings to be direct expressions of emotions that had not been influenced in any way by education or civilization. Can we ever get closer to the origins of creativity?

**Paul Gauguin**
French, 1848–1903
Sketch for *Vincent van Gogh Painting Sunflowers*, 1888
Graphite on paper
Israel Museum, Jerusalem

**Paul Gauguin**
French, 1848–1903
*Vincent van Gogh Painting Sunflowers*, 1888
Oil on canvas
73 x 91 cm (28¾ x 35⅞ in.)
Van Gogh Museum, Amsterdam
(Vincent van Gogh Foundation)

**Congo**
Chimpanzee
*Split Fan with Central Blue Spot*, 1956–58
Gouache on paper
36 x 49 cm (14¼ x 19⅜ in.)
Collection Desmond Morris, Oxford

■ Paul Gauguin made a portrait of his friend Vincent van Gogh while they were staying together in Arles in 1888. The portrait was not meant to be flattering. If we look at the preparatory sketch it is evident that Gauguin gave Vincent apelike features. This drawing is part of a sketchbook full of animal studies that Gauguin made during a visit to a traveling menagerie that was passing through Arles. Gauguin always criticized Van Gogh for being unable to paint without a model in front of him, and said that he should paint from memory and use his imagination. But the Dutchman refused, and his gaze here is indeed fixed on the sunflowers. In Gauguin's eyes, Van Gogh could only "ape" and thus could not achieve the higher ranks of art. ■

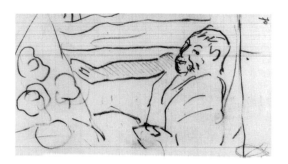

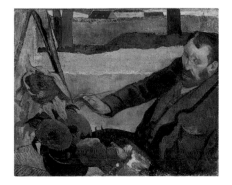

# From meat to metaphor

There is a drop of blood at the end of the dead hare's nose. The hare has been killed to make a meal. It is hanging, impaled through the leg, on a hook, along with the butchered hindquarters of a sheep, ready to be turned into a roast, a stew, a fricassee, or a soup. An unappetizing reminder that our meat is obtained from dead animals, such a painting would not be welcome in most dining rooms today. But in the eighteenth century, such scenes were the standard decor.

Jean-Baptiste Oudry's *Hare and Leg of Lamb* demonstrates how much eighteenth-century sensibilities about animals differed from those of today. In 1742, meat was a prestigious luxury available to aristocratic and wealthy elites; the bourgeoisie ate it occasionally, while peasants subsisted principally on bread. The hunting of game animals, such as the hare, was also restricted to élites, often by law. In the eighteenth century, meat could not be refrigerated, and packaging did not disguise its animal origin. Game was marketed with heads and paws and tails attached, so that a careful shopper could tell the difference between a skinned rabbit and, say, a cat substituted by an unscrupulous merchant. Eighteenth-century food presentation emphasized meat's animal origins with serving dishes shaped like the animals they contained, and roasts realistically presented with heads, feathers, and so on in the pose of the living creature. Eighteenth-century diners celebrated their opportunities to eat animals.

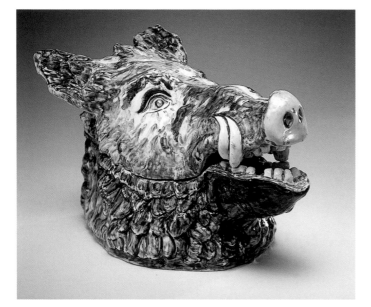

But Oudry's picture is about far more than gastronomy. Before its installation in his patron's dining room, Oudry sent *Hare and Leg of Lamb* to the Paris Salon, the annual state-sponsored art exhibition. There it took its place in a long and complex controversy about the purpose of art and the status of animals in God's creation and in art theory. The basic conflict revolved around subject-matter. According to one position, art elevates, educates, and pleases by depicting great moral themes from divine or human history. Animals in paintings should serve only as props for idealized human subjects (the hero's horse, or a symbolic dog). Art that featured animals was a "lower" genre, because animals were thought to belong to a separate and less elevated creation of beings that lacked the soul, intelligence, feeling, and moral judgment of humans. Painters, like Oudry, who specialized in animals were disdained for pandering to humanity's baser qualities, such as a love of eating or a childish delight in visual trickery.

The opposing view held that nature is God's greatest creation, and therefore its imitation must be the highest goal of art. Contemplation of nature, either directly or through art, was a means of contemplating the divine. Portrait, animal, and still-life painting enjoy a much higher status in this school of thought, and most animal artists espoused it enthusiastically. The emphasis on imitation inspired these painters to observe animals with unprecedented care and to paint them with a precision and detail that is rarely surpassed, even by photography. The staggering visual realism of *Hare and Leg of Lamb*, one of Oudry's masterpieces, tempts viewers to touch the canvas to confirm that it is truly a painting. Oudry, a mere mortal, could create only an illusion of nature. But his illusion arouses in us the same reactions—a desire to touch, or thoughts of dinner—as would the real hare and the real haunch of lamb. That places his achievement a little closer to God's.

JB oudry
1742

# China dogs

According to the venerable *Oxford English Dictionary*, the word "pug" entered English literature at the end of the sixteenth century as a term of endearment applicable to a person. In the seventeenth century, it commonly described a courtesan, mistress, or harlot; a bargeman; or, in servants' jargon, an upper servant. By 1660 "pug" could also denote a dwarf animal or imp—a small demon, a monkey or, seventy years later, a little, affectionate type of dog. With such connotations of love, femininity, dependence, intimacy, service, frivolous mischief, and portability, the word "pug" describes perfectly the enduring appeal of these weird little dogs.

From a cultural standpoint, pug dogs were part of the craze for chinoiserie that transformed Western European taste and aesthetics between about 1690 and 1770. For all but dog fanciers, the greatest innovation of the fad for Asian goods was the introduction of porcelain, the finely modeled, playfully decorated ceramic ware that launched European royals on a frenzied competition to reproduce it in their own state workshops. The opening of the first successful porcelain factory in Europe, at Meissen, was the eighteenth-century equivalent of the Apollo moon landing.

Pugs arrived with the porcelain. The type had been bred in the Chinese imperial court, where it was known as the Lo-Sze, and it first appeared in the West in Holland, Portugal, and other centers of trade between Europe and Asia. Holland's role as a center of diffusion of pugs (as well as porcelain) is suggested by the dog's earliest English name, "Dutch mastiff." The dogs quickly became ubiquitous accessories of the aristocracy and, soon, of the middle classes as well; the most famous pug of the era was probably "Trump," the alter ego of artist William Hogarth in his famous *Self-portrait with Trump* of 1749. Pugs also posed for Jean-Baptiste Oudry, Louis-François Roubiliac, and Francisco Goya.

This brings us to porcelain pugs. The dogs seen here are attributed to Meissen's most famous modeler, Johann Joachim Kändler, who was admired for his superbly crafted, sympathetically observed animal sculptures. He received many commissions for pugs, including requests for portraits of specific pets. Our pair supports a candy basket that probably belonged to an elaborate dessert service, a visual and gastronomical tabletop extravaganza. The dogs (female on the left, male on the right) direct their pleading gazes upward, toward the sugary treats just out of their reach.

Connoisseurs have suggested that this piece was assembled in the nineteenth century using eighteenth-century porcelain elements. (The dogs are eighteenth century because their ears are cropped, a fashion banned in the later nineteenth century.) Curiously, the revival of porcelain pugs coincided with new breakthroughs in East–West trade, a second craze for Asian porcelains (this time mainly Japanese), and a revival of the eighteenth-century Rococo style, echoing the conditions of the pug's first success. A new breeding pair imported from China in the 1860s, coinciding with the first dog shows and the first attempts to codify the breed, launched the modern craze for pugs that continues to this day.

Meissen Porcelain Factory
German, 1710–present
Johann Joachim Kändler, designer
German, 1706–1774
Sweetmeat basket with pug dogs,
c. 1745
Porcelain and gilt bronze
19.4 x 19.7 x 14.9 cm
(7⅝ x 7¾ x 5⅞ in.)
Carnegie Museum of Art, Pittsburgh,
Ailsa Mellon Bruce Collection

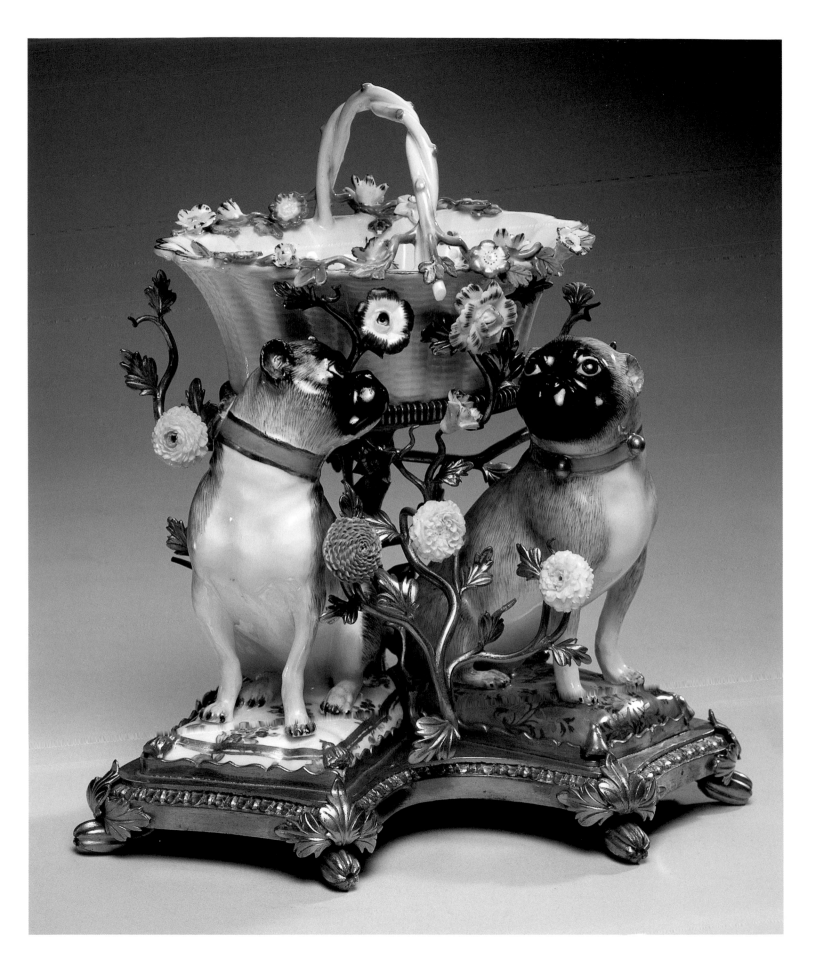

# Rhino in Venice

It is Carnival time in Venice, and what do you do to surprise these sophisticated urban folks who have seen everything? Show them something no one has seen in living memory: a real live monster! There surely could not be a stranger and more terrifying creature than a fully grown rhinoceros. When such a beast was brought to Venice on its tour through Europe, it was the first to appear on the continent for many decades. For those Venetians lucky enough to catch a glimpse, it must have been an astonishing sight.

And yet there is a definite lack of excitement in this picture. Rather than being moved by terror or joy, most spectators are portrayed with indifferent expressions. Only eight individuals are gathered around the animal, and some of them wear masks, hiding their identity. Seeing and being seen or, rather, not being seen—that is the real appeal of Carnival. So who are we actually looking at?

Pietro Longhi, a fashionable painter in Venice, was commissioned by local noblemen to record the event. He proudly announces in writing in the upper right that this painting is made after nature. What were his choices? He does not focus exclusively on the animal nor on the spectators' reaction. The space is evenly divided into two halves, the lower one for the animal, the upper one for the humans. The rhinoceros, with its huge, plump, and dark body, has little to no expression. It is reduced to basic vegetative activities, eating and defecating. Strangely enough, boredom seems also the overarching emotion of the audience.

The gentleman on the left is the animal handler. He is either the Dutchman Douwemout van der Meer, who brought the rhino from Indonesia to Leiden in 1741, or his assistant. Here he waves his right arm and points to the rhinoceros, as if such a gesture were necessary. His desperate efforts may have something to do with the fact that there is definitely something missing about the animal. The showman holds a whip and what seems to be the rhino's horn. How and why did it get off the animal's nose? It is recorded that the rhino lost its horn when rubbing it against its cage when in Rome. As the horn is the essential attribute for the rhino, like the trunk of an elephant or the feathers of a peacock, the handler must have been in considerable trouble. To the public a rhino without its horn must have looked like an animal deprived of its potential danger, almost as if castrated—even if this one is a female.

Was the public really unimpressed by what it saw, or did Longhi want to make a deliberate statement? By the mid-eighteenth century, the greatest days of the republic of Venice had come and gone: without its strong and dangerous fleet, which had controlled half of the Mediterranean Sea, it had lost its role as a major power. Although culture, art, and entertainment thrived, the republic was politically and economically on the decline. Perhaps Longhi was making a comparison between the disfigured rhinoceros and the decadence of his fellow Venetians.

Pietro Longhi
Italian, 1702–1783
*The Rhinoceros*, 1751
Oil on canvas
60.4 x 47 cm (23¾ x 18½ in.)
National Gallery, London

# Cruelty

The subject-matter may be anything but pleasing, but William Hogarth's engravings deserve a closer look, not only because they are filled with telling details but also because the artist wanted viewers to be moved by them in order to change their sinful life. Take your time.

It is quite unusual for an artist to be so clear about his intentions as Hogarth was in his *Autobiographical Notes*: "The Four Stages of Cruelty were done in hope of preventing in some degree that cruel treatment of poor animals which makes the streets of London more disagreeable to the human mind than anything what ever, the very describing of which gives pain." Hogarth wanted the prints to be simple and cheap so that they would reach their target group, the offenders themselves, whom Hogarth found among "the lower class of people."

These are stages One and Two out of a series of four. The sequence is a narrative, telling the story of a certain Tom Nero who, after torturing animals, goes on to kill a woman and finally finds his "reward" on the table of an anatomist at the Royal College of Physicians, who is seen dissecting his dead body. In the eighteenth century, doctors had to rely on executed criminals for the advancement of medical science. Did Hogarth have any success with his campaign? The public response is not recorded, and statistics concerning animal mistreatment were not made at that time. At least he can claim to have helped raise awareness. One well-known response to the prints was that of the German philosopher Immanuel Kant, who wrote:

> We can judge the heart of a man by his treatment of animals. Hogarth depicts this in his engravings. He shows how cruelty grows and develops. He shows the child's cruelty to animals, pinching the tail of a dog or a cat; he then depicts the grown man in his cart running over a child; and lastly, the culmination of cruelty in murder. He thus brings home to us in a terrible fashion the

**William Hogarth**
British, 1697–1764
*First Stage of Cruelty, Second Stage of Cruelty*, from "Four Stages of Cruelty,"
1751
Etching and engraving
33 x 38 cm (13 x 15 in.)
Rijksmuseum Amsterdam,
Rijksprentenkabinet

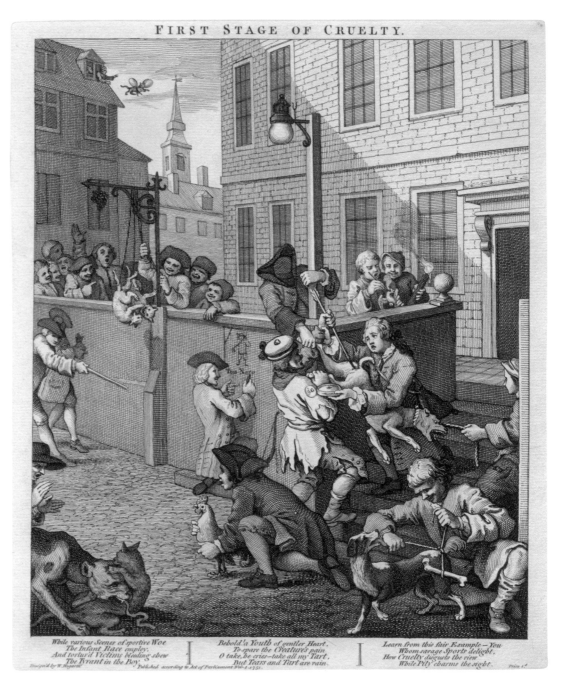

FIRST STAGE OF CRUELTY.

While various Scenes of sportive Woe
The Infant Race employ.
And tortur'd Victims bleeding shew
The Tyrant in the Boy.

Behold a Youth of gentler Heart,
To spare the Creature's pain
O take, he cries—take all my Tart,
But Tears and Tart are vain.

Learn from this fair Example—You
Whom savage Sports delight,
How Cruelty disgusts the view
While Pity charms the sight.

rewards of cruelty, and this should be an impressive lesson to children. The more we come in contact with animals and observe their behavior, the more we love them, for we see how great is their care for their young.[1]

What was—what is—more powerful: the prints of Hogarth, or the words of Kant? Do the Hogarths retain something of their convincing power? And, after 250 years, do we judge the quality of his prints by aesthetics or by morals? A comparison with today might help answer these questions. What do modern campaigners prefer if they want to move us to join the fight against the mistreatment of animals—text or image?

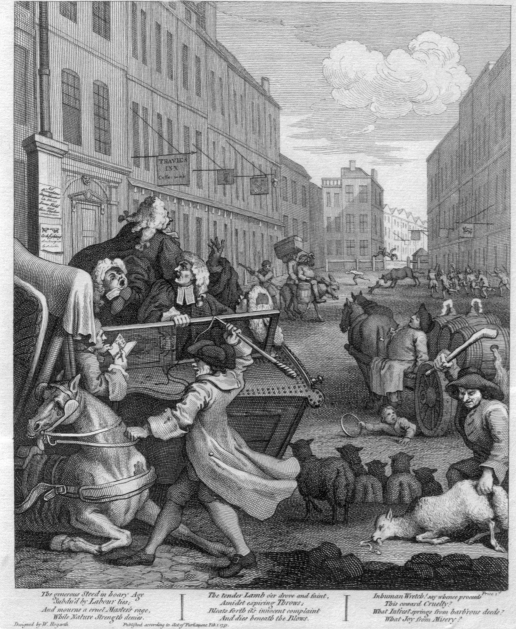

[1] Immanuel Kant, *Grundlegung zur Metaphysik der Sitten* (Lectures on ethics) [1785], trans. Louis Infield, New York (Harper & Row) 1963.

**Jean-Baptiste Oudry**
French, 1686–1755
*Bitch Hound Nursing Her Puppies*,
1752
Oil on canvas
103 x 132 cm (40½ x 52 in.)
Musée de la Chasse et de la
Nature, Paris

# Motherly love

It is hard to imagine that this painting of a bitch nursing her puppies would gain any recognition at the 1753 Salon. With hundreds of works of art displayed for the first time, these art exhibitions were the most important cultural events of the year in Paris. It was difficult enough to get the attention of the critics at such a fair, but to get a positive response was even harder. The great philosophers of the Enlightenment were regular visitors, and often wrote detailed comments of the art on view. In 1753, it seems that they were unanimously heralding this painting as one of the best on display. As Denis Diderot reported, however, its reception was not one of love at first sight. It was only when the canvas was acquired by the young Baron d'Holbach, a German-born nobleman, that everybody began talking about it. At his home, d'Holbach played host to the intellectual elite of Paris. Visitors offered him twice the price that he had paid for the painting. D'Holbach asked Oudry if he would allow him to sell it, telling him he would profit from the deal. The painter, however, declined, stating that he wanted his best work owned by someone who really appreciated its value.

How can we explain the acclaim the painting received? Oudry was by this time a well-established court painter who specialized in animal subjects. Most of his works are showpieces that depict exotic animals or hunting scenes; the intimacy of a bitch nursing her puppies is an exception to the rule. If we look back through the history of art to find a painting with similar subject-matter, we will draw a blank. Why would Oudry then choose this novel subject? If we consider contemporary views on animals, we might find a clue.

A hundred years after the death of René Descartes, the French philosopher's view that animals were mere automatons was still widely held. For Descartes, animals' inability to speak meant that they must lack the quality of reason, and this was the main way in which they were differentiated from humans. Some people interpreted this as meaning that animals possessed neither feelings nor a "soul"—a welcome justification for all sorts of exploitation or even mistreatment. There had always been people who disagreed with Descartes, but only recently had the opponents of cruelty to animals raised their voices in greater number and in public.

Jean-Baptiste Oudry had watched animals closely for many decades. For him, it must have been the most natural thing to give his subjects expression, and thus emotion. His animals have eyes that make them look, if not necessarily like humans, at least like creatures with their own will and emotion. Regarding them as automatons would have been an absurd assumption to him or to anyone who lived close to or with animals. This painting is a kind of manifesto for those who believed in the animal soul. The public understood the message and admired the painting as the first to reflect motherly love in the animal kingdom. Some went so far as to compare it with scenes of the Holy Family, a daring statement inspired in part by the humble environment and the bed of straw.

By acquiring the painting, Baron d'Holbach confirmed his position within the ranks of Enlightenment circles in Paris. A few years earlier he had made the acquaintance of Diderot, the founder of the *Encyclopédie*. D'Holbach not only became one of the financiers of this multi-volume enterprise, but he also wrote at least four hundred entries for it. Later he became one of the most fervent critics of the clergy, and espoused a radical mechanistic world view. Although placing humans in an entirely different category of nature than animals, d'Holbach stressed that we are not alone in possessing a free will. Oudry's bitch nursing her puppies may have inspired his thinking—a thinking that would eventually lead to the French Revolution.

# Precious pests

A traditional English Christmas song begins: "On the first day of Christmas my true love sent to me / A partridge in a pear tree." The charming verse calls to mind a plump, downy bird nestled in a tree richly loaded with fruit. The sad reality, of course, is that in December there would be no fruit, and the hungry partridge, normally a ground-dweller, would be dining on the succulent buds. A wise farmer would eat the partridge in order to ensure a fine harvest of pears. These small porcelain specimens, rudely interrupted while foraging in a field of ripe wheat, are also pests—or targets. Gentlemen farmers hunted them with guns and dogs, and the birds were delicious roasted.

Why would a mid-eighteenth-century British connoisseur collect statuettes of agricultural pests? For starters, there was a craze for porcelain. The materials and technique had been a Chinese trade secret for centuries, and only in 1710 had European manufactories begun to make viable imitations. These figures would have been valued as rare, precious, and refined objets d'art, regardless of their subject-matter. As bird portraits, they are not especially accurate. (The black cap on the bird's head, for example, is wrong.) Eighteenth-century artists and manufacturers almost never worked with living animals. Dead game appears in still-life paintings and portraits of sportsmen. Even the lively partridges depicted here were modeled after a book illustration, which reproduced a drawing in Sir Hans Sloane's collection, made from a stuffed skin of a bird that had been shot in the distant Hudson's Bay Colony (now Canada).

The illustration appeared in George Edwards's *Natural History of Uncommon Birds* (London, 1743–47) along with a text about the "White Partridge." Like most eighteenth-century ornithologists and artists, Edwards worked from skins and verbal reports from observers. He included a common pest in his "uncommon" birds because it represented a scientific challenge. The bird's seasonal color changes made it easy to misclassify winter and summer skins as being from different species. (Things were easier for the porcelain-makers, however, who painted the same pair of models reddish brown for summer and white for winter.) Moreover, Norwegian, British, and American specimens were sometimes classified separately out of nationalistic pride. And the bird had many names. Edwards called it a "White Partridge" while admitting that it was actually not a partridge at all. He listed other names, such as the rigorously scientific *Lagopus avis* (rabbit-footed bird) and the extremely vague "heath game," which could just as easily describe a fox. Today, the bird is called a ptarmigan.

In the struggle to describe, define, and name the exotic creatures pouring into Europe from all parts of the globe, natural historians sometimes seem to have missed the point. For example, despite their elaborate descriptions of the partridge/ptarmigans' seasonal plumages, no one pointed out that they adapted the bird for survival in snowy northern climates. In fact, the terms "adaptation" and "survival" were not yet part of the scientific vocabulary at all. The question, "What is it?" came first.

**Chelsea Porcelain Factory**
British, *c.* 1745–1784
Winter and summer ptarmigans,
*c.* 1750–55
Porcelain
15.2 x 10 x 7.9 cm (6 x 3¹⁵⁄₁₆ x 3⅛ in.)
14.3 x 12.5 x 7.9 cm (5⅝ x 4¹⁵⁄₁₆ x 3⅛ in.)
Carnegie Museum of Art, Pittsburgh,
Ailsa Mellon Bruce Collection

49

## *Mirabilia* and mutations

King Louis XV of France was an obsessive hunter and collector of trophies. He commissioned first Jean-Baptiste Oudry and then, after Oudry's death, Jean-Jacques Bachelier to record the most extraordinary antlers of a shot deer. The inscription on Bachelier's painting records further details of the event. Why make a painting of a trophy? Did the king think that a painting of a trophy adds to its status? Would the illusionism of a painting help the object gain more credibility? Whatever the answers, the painting is proof of the fact that nature and art were regarded as complementing each other. It helped that they were both in the service of the king's glory.

The king did not ask Bachelier to paint a "normal" pair of antlers. There was more at stake. These antlers show rare deformations, something that would trigger the curiosity and certainly look good in any cabinet of curiosities. This fascination with abnormal phenomena can easily be understood. We tend to remember the exception, rather than the rule; and once we see something special, we want a visual record and want to show it off. Today, of course, convincing explanations for these oddities have been found. But what did eighteenth-century hunters and farmers make of abnormal antlers, two-headed cows, and other peculiarities before any theory of evolution emerged and genetics provided the clue?

Abnormalities had solicited intense interest since ancient times. Until the Age of Enlightenment, these freaks of nature were interpreted as signs of God's power or wrath. By the mid-eighteenth century, such ideas still lingered on, since a convincing natural explanation was still lacking. Things started to change only with the French naturalist Etienne Geoffroy Saint-Hilaire, who developed a scientific approach to what was called teratology, the science of monstrosities.

The term "mutation" was introduced only in 1900, when the Dutch botanist Hugo de Vries presented his research. Defined as sudden and inheritable changes in an individual organism, mutations helped further support the theory of evolution. De Vries was also one of the people who discovered the writings of Gregor Mendel, the pioneer of genetics. Mendel's work broke new ground a long time after his death in 1884. But this is all far ahead of the time of Bachelier and Louis XV. During that period and before it, such abnormal antlers would fit into the category of *mirabilia*, marvels that inspire wonder and were collected with passion. Corals, bezoar stones, and narwhal tusks belonged to the same category, and found their way into the fashionable cabinets of curiosities of the time (see pp. 56–57).

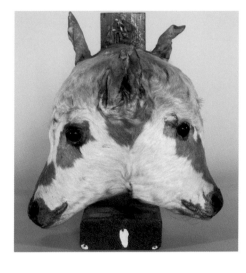

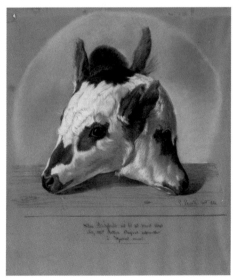

**Anonymous**
French
*Heads of a Two-headed Calf*, 1841
Watercolor
55 x 52.7 cm (21½ x 20¾ in.)
Musée Fragonard, Ecole Nationale
Vétérinaire d'Alfort, Maisons Alfort

■ This is a rare case in which an original object and painted views of the same object are still together in one place. Here the fascination with freaks of nature coincides with the beginnings of modern scientific investigation. While the causes of such peculiar features were still unknown in the mid-nineteenth century, the painter is trying to come to grips with this phenomenon. ■

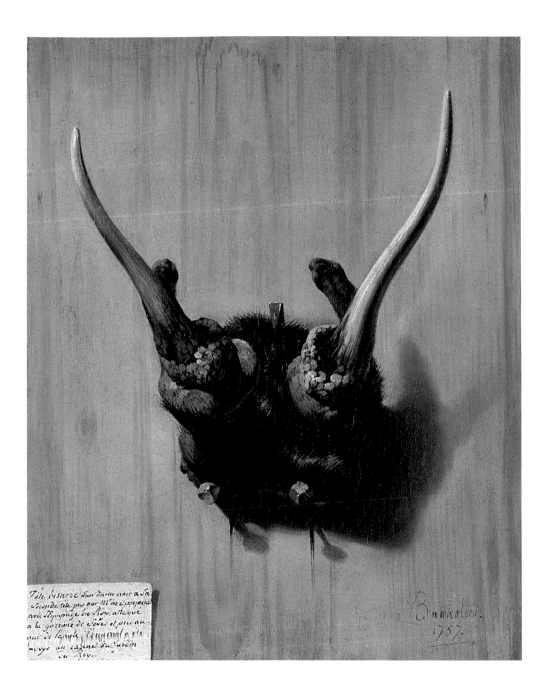

**Jean-Jacques Bachelier**
French, 1724–1806
*Bizarre Antlers, Seen from the Front*
1757
Oil on canvas
40.5 x 32.5 cm (16 x 12⅞ in.)
Musée de la Chasse et de la
Nature, Paris

**Johann Elias Ridinger**
German, 1698–1767
*Fox with Two Tails*, from
*The Strangest Deer and Other
Animals*, 1744
Etching and engraving
34.4 x 25.5 cm (13½ x 10 in.)
Rijksmuseum Amsterdam,
Rijksprentenkabinet

■ One of the most successful printmakers of his time, Johann Elias Ridinger specialized in the representation of animals. As such he was employed by the German noblemen who loved both hunting and Ridinger's images of the local wildlife. He is also regarded as a precursor of the French Romantics in his animated scenes that show an early interest in the natural environment. One of his many series of etchings and engravings, *The Strangest Deer and Other Animals* focuses on mutations. The descriptions underneath each engraving give a detailed account of the circumstances of the sighting. This fox with two tails was shot on February 14, 1734, 4 miles (6.4 km) outside Berlin. The fur was kept in the natural history cabinet of the Prussian king, because of its "rarity." ■

# Love birds

Are birds lovable? Our interpretation of this painting depends on the answer. Small birds have been kept as pets for centuries, and we know of one, at least, that inspired affection over two thousand years ago. The bird in question belonged to Lesbia, the lover of the Roman poet Catullus. He memorialized her bird's passing thus:

> Cry, Graces, companions of beautiful Venus, cry little Amors, and everyone of sentiment in this world. My darling's sparrow, which she loved more than her own eyes, is dead. He was sweeter than honey to her, and he knew her as well as she knew her mother. He never wandered far, but dashing here and there in little hops, he would only come to sing before his good mistress. Now he is off on a dark road from which he will never return. You should be ashamed of yourselves, unhappy shades of Pluto who devour all beautiful things. You have deprived me of the most wonderful sparrow in the world. Oh misfortune, oh unfortunate sparrow: it is for love of you that the eyes of my darling are swollen from crying.[1]

Clearly the girl loved the sparrow, and the poet loved the girl, but the sparrow's feelings are unknown. Catullus's poem is so close in sentiment to Greuze's painting that scholars have suggested it served as the artist's original inspiration. The poem may also have influenced a famous critical essay penned by the Enlightenment philosopher Denis Diderot after viewing *Young Girl* at the Paris Salon of 1765. Diderot believed that birds were most certainly not lovable, so he constructed an elaborate fantasy about the "real" cause of the girl's tears. Diderot imagined that a young man has given her the bird; she welcomes his visit in her mother's absence; he seduces her and leaves; the returning mother cannot understand why her daughter weeps; the girl, preoccupied by love and fears of abandonment, neglects the bird; the bird dies. Overcome by sympathy for the imaginary girl's distress—and perhaps half in love with her himself—Diderot wrote a sentimental masterpiece that has determined readings of the painting ever since.

Diderot's interpretation is based on eighteenth-century conventions regarding pet birds. Wild songbirds were captured for the market with traps or lime (a sticky substance spread on trees that would glue the bird in place until it could be collected). Exotic species, such as canaries, were bred or imported (most eighteenth-century French canaries came from Germany, according to Buffon), and were sold in large cities. Bird-catching and bird-giving became metaphors for seduction, perhaps because both birds and boyfriends charm their mistresses with song. (Think of Mozart's lovelorn Papageno from the 1791 opera *The Magic Flute*, luring women as well as birds with his music.) A bird in a cage then came to represent a woman captured by her lover.

Why is this girl mourning her dead bird? Is it a beloved pet? Is it a stand-in for an absent lover? Or is it just a symbol of lost love and innocence? Any of these interpretations was possible during the Enlightenment, when controversy raged about the existence of emotion in animals. A blockbuster painting about a mere bird's ability to arouse human affection (even if only in emotional teenage girls) signified that spiritual relationships between humans and animals finally were receiving attention.

---

[1] *Les Poésies de Catulle de Vérone, de la traduction de M.D.M.* [1653], quoted in *Jean-Baptiste Greuze/1725–1805*, exhib. cat. by Edgar Munhall, Hartford CT, Wadsworth Atheneum Museum of Art, and others, 1976–77, p. 104 (author's translation).

**Jean-Baptiste Greuze**
French, 1725–1805
*A Young Girl Mourning Her Dead Bird,*
*c.* 1765
Oil on canvas
52 x 45.6 cm (20½ x 18 in.)
National Gallery of Scotland, Edinburgh

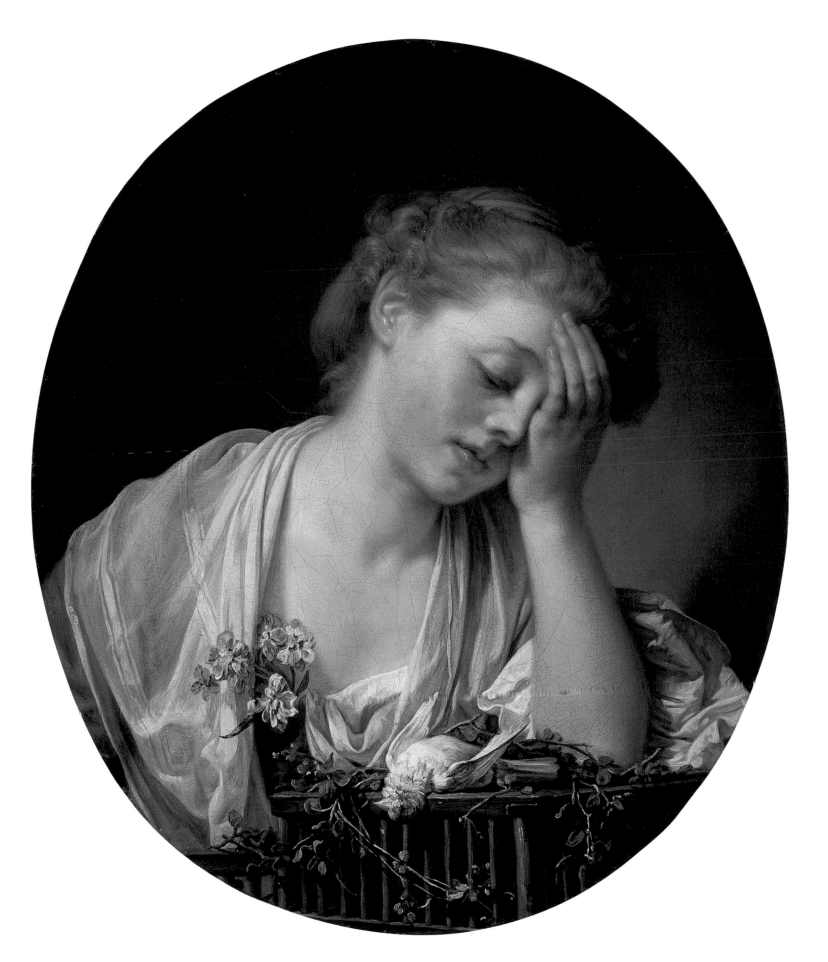

# Family affairs

Since when have humans and apes been part of the same family? Forever, biologically speaking, but in the perception of Western civilization, the relationship is somewhat more recent. Humans did not join the primate family until the mid-eighteenth century, when the Swedish naturalist Carolus Linnaeus lumped humans, apes, and monkeys into the same genealogical grouping, to the consternation of all.

Here we are presented with a family tree with many branches and seventeen monkeys. A family tree is the visual representation of a genealogy, implying that generations follow each other. The chain of being is thus visualized by a well-established method of explaining ancestry. It is surprising to see such a visualization of family roots applied to monkeys and apes, especially since it was only the nobility who had a real use for such reminders of their bloodline. In the thinking of the mid-eighteenth century, or even one hundred years later, creating a genealogical tree of monkeys could be regarded as a provocation.

The painting is based on the work of Georges-Louis Leclerc, later the comte de Buffon (1707–1788). The great French naturalist was the author of one of the first attempts to systematize the order of nature. He was also a great popularizer, who helped promote interest in the natural world across a broad spectrum. His groundbreaking *Histoire naturelle* (Natural history) was published in thirty-six volumes from 1749 to 1788. The illustrations were widely distributed and played a major role in disseminating the new view on the animal world (see pp. 16, 62).

Buffon was trying to put some order in the ape family. It was a task with which he had great trouble, however, admitting the difficulties involved and the impossibility of making any definite conclusions. In his *Nomenclature des singes* (Nomenclature of apes; 1766) he struggled with the division of families and races, and carefully avoided making overly close comparisons with humans. The orangutan, however, was the most disturbing reminder of the apes' close relation to us.

The tree has to be "read" from top to bottom. The lower down it is, the "higher" the position of the animal. On the ground stand two apes (orangutans), one of which is leaning on a stick. This was a traditional way of representing anthropoid apes (see p. 37). The erect position could be interpreted as humanlike, but the stick is a sign that the animal is not a primitive form of man. Unlike humans, the ape needs the stick to stay upright. (The stick has nothing to do with the debate about the use of tools among chimpanzees, which is of a much more recent date.)

Buffon and most of his contemporaries still rejected any family relationship between humans and apes. Only when comparative anatomy gained recognition did the evidence of skeletons bring us closer together. Today, genetics has replaced traditional anatomy when it comes to comparing animals and finding connections. It is more difficult, however, to visualize the new method. A DNA chain does not make pretty pictures. The general public is now pushed back to its old role: we cannot believe what we see, but have to believe what we are being told.

**Tethard Philip Christian Haag**
German, active in The Netherlands, 1737–1812
*Orangutan*, 1777
Oil on canvas
174 x 110.5 cm (68½ x 43½ in.)
Paleis Het Loo National Museum, Apeldoorn (longterm loan from the Royal Cabinet of Paintings, Mauritshuis, The Hague)

■ One of the most famous cabinets of (natural) curiosities was that owned by Prince William V of Orange, in The Hague. When a wealthy merchant donated a living orangutan, scientists were eager to find the answer to the question of whether the animal was related to humans. The orangutan is depicted in an erect posture, making it appear more humanlike than any animal. But the odd pose may also have to do with the fact that the painting was executed after the ape's death. Once in Holland, the orangutan did not long survive the inadequate nourishment and the harsh conditions of his first winter, dying on January 22, 1777, only about six months after his arrival. His skeleton was given to the Dutch doctor Petrus Camper, who became one of the founders of comparative anatomy. Camper compared the skulls of monkeys, apes, and humans, finding many shared characteristics. ■

**Anonymous**
French
*Genealogical Tree of Monkeys*,
according to Buffon's *Nomenclature
des singes* (*Histoire naturelle*, vol. XIV,
1766), after 1766
Oil on canvas
106 x 44 cm (41¾ x 17¾ in.)
Musée-Site-Buffon, Montbard

"Dragon" preserved in alcohol
17th–18th centuries
Zeeuws Museum, Het Koninklijk
Zeeuwsch Genootschap der
Wetenschappen, Middelburg

# All the wonders of the world

Before there were public museums, art galleries, and zoos, there were so-called cabinets of curiosities. In German they are called "*Wunderkammern*," which can be translated as "cabinets of wonders"—perhaps an even more appropriate term. Agents supplied rulers, noblemen, and bourgeois citizens who were curious and wealthy enough with strange objects from all over the world. They collected them for private pleasure and for study, as well as to show off. Objects of art and of natural history were often combined in the same collection: a strict division in disciplines was only introduced much later.

The fashion for such cabinets began during the Renaissance. The arrangement may look merely decorative to our eyes, but the order of things reflected contemporary views on cosmology. The world in miniature (microcosm) stood for the wider world (macrocosm); such cabinets thus represented the wider world. In the eighteenth century, when the drive to systematize just about everything took the upper hand, the "*Wunderkammern*" lost their relevance. The contents were cataloged according to the latest taxonomic principles. The focus was no longer on exceptions but rather on common characteristics. Finally, in the nineteenth century, most cabinets were disassembled, and their contents ended up in museums, where "art" and "nature" were strictly separated. This so-called progress is not necessarily the end of the story, however. Taxonomies and museum displays are inextricably linked with ideas about the order of the world and are far from static, even in our time.

Today, we look at these cabinets of curiosities with awed fascination. We are puzzled by the chaos of their arrangement or by the decorative displays that go completely against our understanding of the laws of nature. In recent years, both historians and artists seem to have rediscovered the power of seemingly chaotic arrangements. The boundaries of our thinking about nature are continuously shifting, and a cabinet of curiosities frees the thoughts from the limits of preconceptions and ideology.

■ This creature is a fake made from the skin of rays. In the early days of natural history, from the Renaissance onward, modern science and superstition often overlapped. Ancient stories still held much authority, and the new urge to learn about nature's secrets was applied to prove even the most improbable claims. The rage for collecting strange objects was so strong that many people found themselves the victims of hoaxes. This "dragon" is one of many similar artifacts that seemed to confirm the existence of creatures that had previously been the province only of imaginative illustrators. If you wanted to believe in dragons, mermaids, and unicorns, then there was somebody who would provide you with evidence. And as one often sees what one wants to see, people were only too ready to be fooled. This object may no longer prove the existence of dragons, but it does prove the power of images and the possibility of manipulation with imagery, both then and now. ■

■ Countries with strong overseas trading links were able to benefit from the traffic in exotic goods. The Netherlands was a particularly important arrival point for many objects from overseas, both natural and man-made. The Koninklijk Zeeuwsch Genootschap der Wetenschappen (Royal Zeeland Society of Sciences) in Middelburg, the capital of the Dutch province of Zeeland, commissioned several cabinets of curiosities. The objects shown here provide a telling example of how, no less than 250 years ago, a small community of interested and learned people was able to assemble the products of nature and culture on an almost global scale. The horns, shells, skeletons, and stuffed animals in this cabinet come from practically every corner of the planet. ■

Objects from a cabinet of curiosities
18th century
Zeeuws Museum, Het Koninklijk
Zeeuwsch Genootschap der
Wetenschappen, Middelburg

Wilhelm Friederich Freiherr
von Gleichen, genannt Rußworm
*Geschichte der gemeinen Stubenfliege*
(History of the common housefly), ed.
Johann Christoph Keller, Nuremberg
(Raspische Buchhandlung) 1790
Universiteit van Amsterdam,
Artis Bibliotheek

■ This loving study of the housefly was first
published in 1764. It inspired wonderment but also
wry amusement. People started to make fun of
researchers who could spend years studying the
minutest details of the most common insects. ■

# Insect fun

While the telescope brought the stars closer to our eyes, the microscope allowed for an equally fascinating expansion of our visual vocabulary. The early books on microscopy, despite their claims to serious scientific purpose, rarely resist the temptation of amusing their readers with illustrations of details of insects, human hair, or crystals. Ledermüller and Winterschmidt's illustrated book does not hide its wish to entertain: the Dutch edition's title "*vermaaklykheden*," and the French edition's "*amusement microscopique*," translate the original German "*Gemüths- und Augen-Ergötzung*" of the first edition (1763). A more literal English translation would be "a pleasure for the eye and the soul." The authors emphasized the useful and agreeable nature of the pastime ("*zum nützlichen und angenehmen Zeitvertreib*") and even spoke of "insect fun" ("*Insectenbelustigungen*").

Looking at a flea in detail was thus considered a pleasure. Even if we do not go so far as to attribute any aesthetic qualities to the insect itself, we can derive "pleasure" from the exciting novelty of the image and the frisson of terror caused by magnifying the tiny pest. (This frisson has not disappeared: fleas and other microscopic animals remain the principal source for the monsters that appear in modern films. Unwelcome even when tiny, they appeal to our primal fears when exaggerated.)

When we talk to scientists, we are often puzzled by the excitement with which they describe the beauty of the kinds of animals that make most people tremble in fear—from snakes to scorpions, from spiders to ticks. Specialists would have it that these are among the most beautiful creatures in the universe. Beauty and disgust are definitely in the eyes of the beholder, and publications such as that by Ledermüller and Winterschmidt have broadened the range of what is seen as pleasing. Perhaps knowing more about a flea also helps one to appreciate the animal's functional design. Making the microscopic world visible has had a great impact on our concept of beauty.

When photography first appeared in 1839, the primary purpose of the new medium was meant to be scientific. As with microscopy, early experiments often combined the serious with the entertaining. With the marriage of camera and microscope, people were right to expect novel insights into all things minuscule, whether they were alive or not. But this time, viewers met with disappointment. Photography offers less detail, less information, and even less color than a well-executed drawing. Looking at both fleas, the "handmade" one from the eighteenth century and the mechanically reproduced one from the nineteenth, it is obvious which one allows us better to understand the mechanism of the creature's sophisticated body. The photograph remains flat, lacks contrast, and looks dead. The objectivity of the lens cannot match the experienced draftsman, who can both generalize and select in order to give the most insight into the structure and surface of the object. It would take many more decades before photography would find its place in the representation of the animal world. Only when the environment of an animal became part of the desired visual information could the photograph match the old-fashioned watercolor. Nevertheless, even today, science books often prefer the handmade illustration to the mechanically produced one.

Top:
**Martin Frobenius Ledermüller and Adam Wolfang Winterschmidt**
*Mikroskoopische vermaaklykheden, etc.* (Microscopic amusements, etc.),
vol. I, Amsterdam (Erven van F. Houttuyn) 1776, plate XX (image turned 90° to the right)
Universiteit van Amsterdam, Artis Bibliotheek

Above:
**Anonymous**
Active at Throop University, Pasadena, California, *c.* 1891 (now California Institute of Technology)
Microscopic photograph of a flea, 1892
Cyanotype
11.6 x 9 cm (4½ x 3½ in.)
Stephen White Collection II, Los Angeles

# Early birds

The Forsters were lucky, considering that their journey almost never took place. When the great explorer James Cook organized his second circumnavigation of the world, he assumed that the naturalist Joseph Banks, who had accompanied him on his first voyage, would join him again. Banks had to decline, however, and instead Cook took the Prussian naturalist Johann Reinhold Forster with him. Forster was generally considered a difficult personality, and not the first choice for company on a voyage that would last several years. Forster took his son Georg with him, who was only eighteen years of age at the time. On July 13, 1772, they set sail on HMS *Resolution*.

A discovery is of no use if nobody learns about it. It was thus of crucial importance to keep a detailed record of all encounters, adventures, and findings on the voyage. In the age before photography and film, those who embarked on such field trips either were trained draftsmen themselves or hired professionals to accompany them. In 1777, Georg published his own account of the trip, *A Voyage Around the World*. It turned out to be one of the most important travel books of the eighteenth century, and his future fame would put his father in the shade.

Georg's travel account does not mention much about birds. More exciting are the descriptions of encounters with indigenous peoples in the South Seas. John Francis Rigaud's painting suggests that father and son did embark on serious natural history research, however. Georg is seen making a drawing of a bird, supervised by his father, who apparently has just shot the poor creature for the sake of science. Other dead birds are gathered in the foreground. Earlier historians located the scene in Tahiti, but recently biologists have identified the bird in the father's hand as a New Zealand bellbird (*Anthornis melanura*). The other birds seen in the picture are also natives of New Zealand: the North Island kokako (*Callaeas cinerea*), the North Island saddleback (*Philesturnus carunculatus*), and the Tui (*Prosthemadera novaeseelandiae*). The exact location of the scene may be less important, however, than its representation of natural history in action. Georg did in fact make many drawings of birds on this trip.

Rigaud gives those who had to stay at home a visual record of the work that such an exploration into unknown territories entailed. He wants us to focus not on the glamour of the European voyager setting foot on distant shores, or the first encounter of a representative of Western civilization with "exotic" people, but rather on the discovery of natural specimens. What is important is that yet another strange and colorful bird is in the process of being registered and added to the visual vocabulary of mankind. The expansion of knowledge and the addition of another piece to the jigsaw puzzle of natural phenomena are the goals.

The international fame that young Georg acquired through his account of the journey led him to make the acquaintance of many of the important scientists of his time, such as the comte de Buffon and Benjamin Franklin. At the age of only twenty-four, he became Professor of Natural History in Kassel. On his trip around the world, he not only learned about animals and plants but also developed a great respect for the cultures of distant peoples. His enlightened vision of the world led him to become involved in political activities and finally to take the side of the French revolutionaries. Considered a traitor by many of his fellow countrymen, Georg Forster died in Paris in 1794, aged forty, poor, depressed, and lonely. But one bird will always stay loyal: the Emperor penguin (*Aptenodytes forsteri*).

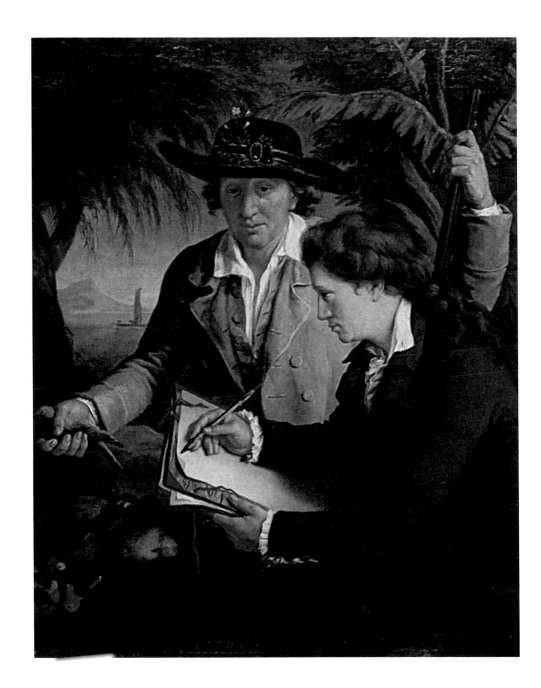

**John Francis Rigaud**
Swiss, active in Britain, 1742–1810
*Johann Reinhold and Georg Forster*
*Drawing a Bird*, 1780
Oil on canvas
126 x 102 cm (49⅝ x 40⅛ in.)
Private collection

# Royal birds and revolutionaries

At the height of the French Revolution, in December 1792, an Englishman named Sudell asked his Paris banker to order on his behalf a lavish porcelain dinner service from the royal porcelain factory at Sèvres. He asked for the "Buffon" pattern, with an elaborate gilded border, and he wanted his coat of arms in gold on each plate. This was one of the most expensive products of the Sèvres factory, and of the highest fashion among enlightened European aristocrats. With French society and its economy in chaos, this was, perhaps, the last opportunity to make an order.

A Buffon service is decorated with hand-painted vignettes of birds in naturalistic settings copied from the illustrations in a book, *Histoire naturelle des oiseaux* (The natural history of birds; 1770–1783), by Georges-Louis Leclerc, comte de Buffon. This huge compendium cataloged the ornithological section of the French royal natural history collections, and the count, a famous philosopher, was the king's curator. Owing to his position at the center of a major colonial empire, he had acquired on the king's behalf the most comprehensive and exotic collection of birds in the world. Buffon's books were European bestsellers thanks to their charming illustrations, sensational stories, and radical ideas. Buffon exposed the inadequacy of the Bible as history, encouraged the search for truth in the laws of nature, and advocated the unity of all living things, including mankind. Despite his social and intellectual status, the count had been suspected of atheism and freethinking.

The porcelain painter F.B. and the gilder Jean Chauvaux the Younger probably began working on the service in early 1793, around the same time that the Jacobins, taking control of the French government, executed Louis XVI. Our two dishes were made for serving the second course, primarily a meat course, for a lavish dinner. F.B. selected most of the birds from one volume of Buffon: a tanager, a sparrow, a wren, and an antbird for one; and a puffbird, a martin, a swallow, and a sparrow hawk (from an earlier volume) for the other. Following the model closely, he portrayed each bird in profile and wrote its name on the back of the dish, facilitating its recognition. The profile views, delicate craftsmanship, and use of antique ornamental swags also conformed to the highest standards of the Neo-classical taste, "style Louis XVI."

Work on the service was complete by July 1793, just as Robespierre established his dictatorship and instituted the guillotine in Paris. In the meantime, revolutionary crowds, motivated by politics and/or hunger, had overrun the royal menagerie at Versailles, killing and eating many specimens. The revolutionary government, fully aware of the significance of the royal collections as symbols of power, wealth, and empire, nationalized the remnants of the royal menagerie, the royal natural history collections including Buffon's birds, and the royal art collections. By establishing the Muséum National d'Histoire Naturelle, the Jardin des Plantes, and the Musée du Louvre in 1793–94, the revolutionaries completed Buffon's work of popularizing and sharing with the public the great national collections of both art and natural history.

The revolutionaries also took over the porcelain factory at Sèvres. Presumably Mr. Sudell received his china safely, although only a few scattered pieces of his service survive today.

**Manufacture Nationale de Sèvres**
French, established 1738
Pair of dishes, 1793
Hard paste porcelain
4 x 35.4 x 23.8 cm
(1½ x 13⅛ x 9⅜ in.) each
Carnegie Museum of Art, Pittsburgh,
Jonny B. and Lois E. Scaife Funds

# Mysteries of form and motion

In 1778, the distinguished Dutch anatomist Petrus Camper praised George Stubbs's engraved *Anatomy of the Horse* (1766) as the only accurate representation of an animal's musculature and skeleton available. And, he continued, "If such is the fate of the Horse, the Animal of greatest use to mankind, it is not difficult, Messieurs!, to imagine the state of affairs with skeletons of other Animals, who do not have a painter like Stubbs to give us the likeness."[1] Stubbs was drawing at a moment when artists and scientists contributed equally to the study of anatomy. Observational ability and manual dexterity were needed to make dissections and drawings, the basis of all anatomical work. Therefore, it is not surprising that one of the greatest animal artists of all time was also one of the great anatomists of the eighteenth century.

Following the critical success of *The Anatomy of the Horse*, Stubbs enjoyed a long and successful career as an animal painter. He excelled at horses but also painted dogs, cattle, exotic creatures (moose, kangaroo, zebra, tiger), and the occasional human. His dedication to animal painting, one of the "lower" genres of art, prevented his election to full membership into the prestigious Royal Academy of Arts, but he was immersed in the circle around the great British anatomists William and John Hunter.

Stubbs's acquaintance with Camper dated back to 1771, when Camper first suggested that Stubbs extend his anatomical studies to the rest of the animal kingdom. But it was not until he reached the age of seventy-one that Stubbs reconsidered Camper's proposal and began work on a fully fledged *Comparative Anatomy*. Today, over 125 elaborate drawings for the project survive, although Stubbs published only fifteen during his lifetime. Stubbs's drawings are in most respects so rigorously exact and so beautiful that their oddities and intellectual significance sometimes pass without remark. Having "done" the horse, Stubbs concentrated on humans,

**George Stubbs**
British, 1724–1806

*Tiger skeleton, lateral view*
Graphite on paper
28.2 x 41.7 cm (11⅛ x 16⅜ in.)

*Dorking hen skeleton, lateral view*
Graphite on paper
27.9 x 39.3 cm (11 x 15½ in.)

*Human skeleton, lateral view,
seen from the left, running*
Graphite on paper
54 x 40.6 cm (21¼ x 16 in.)

*Human skeleton, lateral view,
in crouching posture*
Graphite on paper
44.8 x 28.2 cm (17⅝ x 11⅛ in.)

All *c.* 1795–1806
Yale Center for British Art, New Haven CT

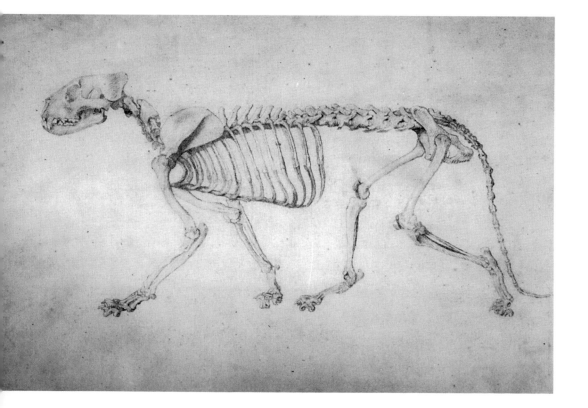

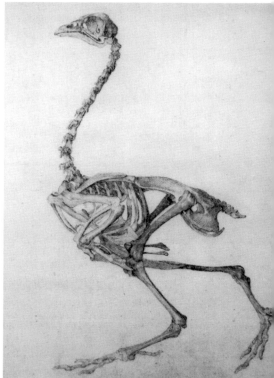

tigers, and chickens shown in comparable views (side, front, back) and poses (standing, running). As in the case of the horse, he emphasized the bones and muscles, of particular interest to artists wishing to portray animal forms and motion with accuracy. He probably selected a human, a tiger, and a chicken because they represented the three highest divisions of nature (humanity, quadrupeds, and birds) according to eighteenth-century science. His choice suggests that he was looking for organic relationships across the full span of the higher creation. Practicality also mattered: the chicken was small, common, and cheap. The tiger was sheer luck: a rare specimen had died in a local menagerie. Access to human cadavers was not so easy. Dissection of humans was illegal in the eighteenth century, with the exception of condemned criminals. Stubbs may have attended such a dissection at a London medical school or, like other anatomists of the time, he may have purchased bodies illicitly or even sponsored grave robbers.

What did Stubbs hope to accomplish? The goal of comparative anatomy is to discover relationships between creatures by looking at their similarities and differences. In the early eighteenth century, comparisons had been based on external appearances; by 1770 internal characteristics such as the skeleton, muscles, and internal organs were the focus. Today, we analyze genetic material. Stubbs's colleague Camper had compared horses to elephants, humans, ostriches, penguins, and fish in search of the basic laws of nature. He developed theories on animal body plans, proportions, and eating habits designed to inform the work of artists and scientists. In these drawings, Stubbs may also have been looking for the laws of nature, perhaps concerning the mechanics of animal motion.

_____

[1] Petrus Camper, *Discours prononcés par feû Mr. Pierre Camper en l'Academie de dessein d'Amsterdam*, Utrecht (B. Wild et N. Althéer) 1792, p. 43 (author's translation).

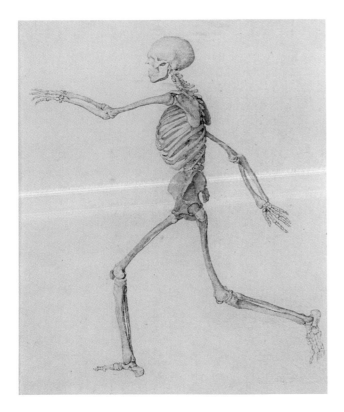
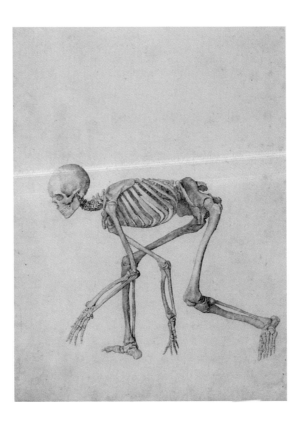

 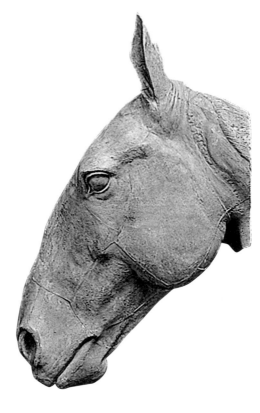

**Anonymous**
Dutch
*Superficial Muscle Layers of the Horse*,
1830
Oil on canvas
206 x 210 cm (81 x 82⅜ in.)
Universiteit Utrecht, Faculteit
Diergeneeskunde (Faculty of Veterinary
Medicine)

**Jacques-Nicolas Brunot**
French, 1763–1826
*Dissected Head of a Horse*, 1816
Plaster
69 x 19 x 41 cm (27⅛ x 7½ x 16 in.)
Private collection, courtesy Galerie
André Lemaire, Paris

■ This anatomical study was shown at the annual Salon exhibition of 1817, sanctioning the sculpture as a piece of art and not "just" a teaching tool. Brunot presents himself here as a precursor of the French school of *animaliers*. Unusual is the fact that only one side of the head is dissected. ■

■ This large painting was made for teaching purposes. The artistic ambition is limited: the prime aim is to create a clear and readable display of the horse's muscles. Pictures like this are not particularly marketable, and many came to be viewed as something of a nuisance. We can only imagine how many of these works may have been lost through neglect. This is a rare example that has survived because a veterinary faculty has understood the intrinsic value of such images, and how they can shed light on an institution's own history. ■

**Philippe Etienne Lafosse**
French, 1738–1820
*Cours d'hippiatrique, ou traité complet de la médecine des chevaux*,
(Veterinary studies, or complete treatise on equine medicine), Paris (Edme)
1772
Universiteit Utrecht,
Universiteitsbibliotheek

■ One of the earliest and most important veterinary books is Lafosse's treatise on the horse. The French were the first to provide regular university education in veterinary science, first in Lyon (1761) and later in Paris (1766). This book is lavishly illustrated, with many hand-colored engravings. No aspect of the horse's health is left untouched. The images do contain anatomical errors, however. Whether these are the result of inexperience or sloppiness on the part of the artist, we do not know. George Stubbs's anatomical drawings, by contrast, are convincing even to the critical eye of a modern animal anatomist. ■

# Buried treasure

The feat of making unknown animals knowable involves luck, financial risk, and backbreaking labor. But above all, it involves drawing as a means of recording new discoveries, sharing them with distant colleagues, and communicating with the public at large.

When the American artist, naturalist, and museum proprietor Charles Willson Peale began looking for mastodons in 1801, the mysterious mammothlike creatures were known only from tooth and bone fragments discovered in New York and the Ohio Territory. When the first gigantic teeth were discovered in the early eighteenth century, they were thought to belong to pre-Adamite giants. After more teeth turned up with giant tusks and bones, it was imagined that they must have belonged to a ferocious carnivore that tore its prey apart with sharp claws and downturned tusks. While these ideas may seem far-fetched today, at the time they were reasonable, indeed logical, deductions based on existing physical evidence and prevailing beliefs in the perfection of divinely created nature. (Since God's design must be perfect, extinction was thought to be impossible.) By 1800, however, the eminent French philosopher, skeptic, and natural historian the comte de Buffon had proposed that the mastodon was a degenerate and extinct variant of the European mammoth. Thomas Jefferson, meanwhile, staunchly defended the uniqueness and vigor of the fauna of his new nation by asserting that there might still be gigantic mastodons roaming the unexplored American continent.

Charles Willson Peale played a central role in the resolution of these opposing viewpoints. Peale had drawn isolated mastodon bones from an earlier discovery in 1784. His brother-in-law's response to the bones—"I would have gone twenty miles to behold such a collection. Doubtless, there are many men like myself who would prefer seeing such articles of curiosity than any paintings whatever"[1]—inspired Peale to found his own museum of art and natural history in Philadelphia in 1787 and to search for mastodons for display there. Peale was able to extract two nearly intact skeletons from a site in New York in the summer of 1801. In this painting, Peale shows us his excavation, with a man-powered treadmill lifting water, workmen laboring in the face of an oncoming thunderstorm, and genteel folk braving the mud to view the proceedings. Appropriately for this moment at the dawn of paleontology, all we see of the emerging mastodon is a few bones and an enormous drawing. Peale assembled the skeletons for display with the help of Philadelphia's distinguished anatomist Dr. Caspar Wistar and the sculptor Benjamin Rush. One was placed on view in winter 1801; the second was packed up for a European tour, but this was canceled when Britain declared war on France in 1803. However, Peale's elaborate drawings of the skeleton did reach the great French anatomist Georges Cuvier (1769–1832). Equipped with new and reliable visual evidence, Cuvier definitively pronounced the mastodon to be a unique species of elephant, now extinct. Although Peale and Cuvier never met, their collaboration marks the birth of modern paleontology. It is still the only science that needs art to reveal its discoveries.

---

[1] Quoted in Paul Semonin, *American Monster: How the Nation's First Prehistoric Creature Became a Symbol of National Identity*, New York and London (New York University Press) 2000, p. 195.

**Charles Willson Peale**
American, 1741–1827
*The Exhumation of the Mastodon*,
1806–08
Oil on canvas
127 x 58.8 cm (50 x 62½ in.)
The Maryland Historical Society, Baltimore

# Man or amphibian?

This fossil is about looking, and about the passage of time. It is a staggering twelve million years old. It was found 270 years ago by Johann Jakob Scheuchzer (1672–1733), doctor and Professor of Natural Sciences at Zurich University. Scheuchzer was interested in fossils and supported the idea that they represented animals that once had really lived—a view not widely held by the early 1700s. His favored explanation was that these fossils were the remainders of living creatures that had been wiped out by the Flood. Nobody, however, had ever seen the remains of a human who had died during that event. You can imagine the joy when Scheuchzer found the skeleton of a man in a rich fossil quarry in Öhningen, near Lake Constance in southern Germany. This human witness of the Flood, named "*Homo diluvii testis*," earned Scheuchzer international fame.

In 1726, Scheuchzer published his sensational find. His account describes all the bones and even identifies inner organs and muscles. According to his measurements, this human must have been 5 ft. 5 in. (166 cm) tall. The date of the account's publication is given as "4032 years after the Flood," a reflection of the still unchallenged power of the biblical story of the Creation, and a reference to the most recent attempt to date it. That was October 23, 4004 BC at 9 o'clock, according to the Irish bishop James Usher.

Scheuchzer's interpretation was challenged as early as 1752. Some saw the fossil as a catfish, others as a lizard. It was not until 1811 that the truth emerged, when the celebrated anatomist Georges Cuvier (see p. 21) identified the skeleton as belonging to a giant salamander. Live specimens of these animals were unknown in Europe until the first one was brought to Holland from Japan in 1830. How could the Swiss doctor have got it so wrong?

The answer lies in the way ideology, on the one hand, and the progress of science, on the other, can change the perception of one and the same object. Scheuchzer was looking for proof of the theory that fossils were a result of Noah's Flood. Others doubted the theory and therefore the validity of the evidence. It required an expert in comparative anatomy, someone who had seen more skeletons and fossils than anybody else and who would not be blinded by a preconceived opinion, to come up with the correct identification. Cuvier's identification is still valid. The Frenchman, however, shared Scheuchzer's old-fashioned belief in catastrophes as the causes of extinction.

**Fossil skull of a mosasaur**
Cretaceous period, Maastrichtian age,
74 to 65 million years old
Plaster cast of fossil, c. 1810
100 x 160 x 20 cm (39⅜ x 63 x 7⅞ in.)
Nationaal Natuurhistorisch
Museum Naturalis, Leiden,
Gift of Georges Cuvier

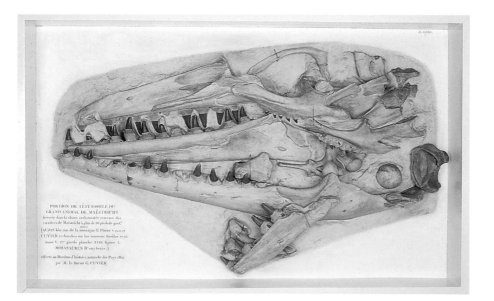

■ When this fossil was found in 1770 in a mine in the Sint Pietersberg area, near Maastricht in The Netherlands, naturalists were at a loss. Nobody could identify the animal, which looked like a crocodile or a toothed whale. Only sixty years later, the "Great unknown animal from the quarries of Maastricht," as it was called, was classified as a dinosaur and given a name, the mosasaur, derived from the place in which it was found. Georges Cuvier used the fossil as key evidence for the then new theory that animals could become extinct. Cuvier was able to study the fossil firsthand, as it had been looted by the French army in 1794 and brought to Paris. Looking at animals is like looking at art: you need the original to classify, attribute, or fully enjoy. In about 1810 Cuvier graciously gave the Dutch a plaster cast of the fossil. ■

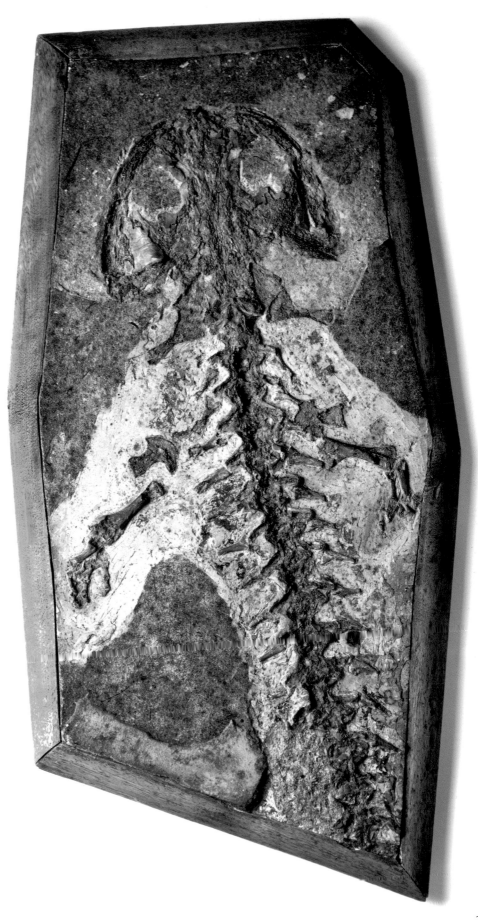

*Homo diluvii testis*
(*Andrias scheuchzeri*) or giant
salamander fossil
Miocene era, approx. 12 million
years old
Fossil
Teylers Museum, Haarlem

# Skeletons in the cabinet

Seashells, sponges, and corals are beautiful objects. They are richly yet delicately colored, they can be smooth as pearls, rough as bark, spiny, dense as a stone, or as translucent as mica. Their shapes seem to flow and twist like the currents of their watery environment. For sheer wonder, it is hard to surpass the exotic shells and corals of the East and West Indies.

These wonders started to make their way to Europe in the sixteenth century, arriving—like equally rare, precious, and beautiful porcelains—along the trade routes from India, Indonesia, China, and the Americas. Like the porcelains, too, they became treasured items in cabinets of curiosities, encyclopedic collections of the amazing and the bizarre. Corals, especially red corals like that in the lower right of Berjon's painting, were once thought to embrace all of nature's forms. Coral lived like an animal, looked like a plant, and hardened into a mineral substance after death. Sponges, too, seemed to blend the characteristics of animals and plants.

By the early eighteenth century, shell-collecting had developed into a popular craze. Trading ships carried shells as ballast, and sailors sold them for exorbitant sums. Shell-collecting and art-collecting went hand in hand in elite circles, as connoisseurs applied their skills of visual analysis to identify species of mollusks as well as the drawing styles of the old masters. As the century progressed, interest in shells moved steadily away from science and into the arts. Shells' elegantly curved and asymmetrical shapes inspired the ornamental forms of the mid-eighteenth-century Rococo style. Shell work—the craft of encrusting surfaces with real shells— was a fashionable hobby at the end of the eighteenth century, and some people went so far as to inlay entire garden grottoes with local or imported shells. By 1810, when Berjon painted this sumptuous still life, corals and shells were still valued as beautiful products of nature, just like the fruit and flowers that the artist featured in many of his other paintings. Shells were the province of the still-life painter.

We are so accustomed to viewing shells and corals as natural *objets d'art* that it is sometimes a shock to remember that they are really the external skeletons of marine animals. Almost nothing was known about these animals until modern times. The only authoritative book on the subject, *The Ambonese Curiosity Cabinet* by Georgius Everhardus Rumphius, had been published in 1705 and was still the best source on East Indian shells 150 years later. The dearth of scientific interest in mollusks is in sharp contrast to the explosive growth in zoology over the same time period. This inconsistency can be attributed to the difficulty of keeping marine mollusks alive before the invention of aquaria, electric pumps, and aerators, and the difficulty of preserving them after death. Modern technology, such as diving gear, submarines, and underwater photography, has finally made it possible for us to see marine life in its natural state. But perhaps we should also blame our own limited imaginations, which, it seems, can easily envision dinosaur families or animals in combat, but struggle with the thought of life with a single foot, dozens of eyes, a boneless body, water to breathe, and a portable house.

Antoine Berjon
French, 1754–1843
*Seashells and Corals*, 1810
Oil on canvas
75 x 56 cm (29½ x 22 in.)
Musée des Beaux-Arts, Lyon

**Théodore Géricault**
French, 1791–1824
*A Horse Frightened by Lightning,*
*c.* 1813–14
Oil on canvas
48.9 x 60.3 cm (19¼ x 23¾ in.)
National Gallery, London

# A horse frightened by lightning

Horse lovers know this, but the rest of us may be assured that the subject of this painting is not a Romantic invention: horses really do get scared by thunderstorms. This is not a trivial matter, as the "terms and conditions" of any stable with horses to rent will testify. During a thunderstorm, you ride a horse at your own risk. Note: This is not the only scared horse in this book (see p. 151).

The French Romantic painter *par excellence*, Théodore Géricault was one of the most knowledgeable connoisseurs of horses the history of art has known. Many anecdotes tell of his lifelong interest in these animals. In Paris, he was a frequent visitor to the Cirque Olympique de Franconi, an establishment famous for its equine performances. Géricault often engaged in discussions with the circus staff about the best way to treat horses. His contemporaries soon considered him the master of horse painting, and he was recognized as having surpassed the somewhat formal style of his teacher, Carle Vernet.

The racehorse, an English Thoroughbred, is pulling backward slightly as if interrupted in its movement. It raises its eyebrow and foams at the mouth. Experts attest to Géricault's success at rendering the horse's emotion realistically. The cause of the terror—the lightning—can only be seen in the far background. The black sky gives the scene an eerie character and also provides contrast with the shimmering skin of the horse. Géricault focuses on the animal and its movement without making it into an overly dramatic scene. It has been suggested that the painting might be an independent study for use at a later date within a larger composition. There is, however, no evidence for this theory. Whatever the work's purpose, the important aspect is the artist's focus on the creature's sensitivity. This is the first animal painting to show such acute observation.

The question thus arises as to why someone should start to look more carefully at an animal in 1813, compared with earlier generations. Humans have long had an intimate relationship with horses, and some—such as Géricault—have enjoyed particular empathy. There is no doubt, also, that horse owners can possess a deep understanding of their animal's feelings and can interpret the most subtle of signs. This work is particularly interesting not only because it provides visual evidence of this empathy between man and horse, but also because it was highly praised by contemporaries, was exhibited in public, and was kept for posterity. It would seem that Géricault's personal feeling for horses coincided with a new acceptance of animal emotion in society.

The painting may be of too early a date for us truly to see the effect of the new industrial age, when horsepower was being replaced by machines. But it is an acknowledged fact that, consciously or subconsciously, people start looking more closely at things when they are rare or threatened with extinction. Viewed in this light, Géricault's frightened horse is one of the earliest signs of a major cultural change.

# Variations on a theme

The theme of our story is variation in nature, as measured by stripes on horses. The story begins in 1821, when the Swiss artist/naturalist J.-L. Agasse received an unusual commission from The Royal College of Surgeons in London. He was to record the results of a surprising and controversial breeding experiment initiated by Lord Moreton around 1817. Lord Moreton owned a quagga, a South African equine highly prized for its coloring and stripes. Quaggas, like zebras, were completely untamable and extremely rare in captivity. It was hoped that crossbreeding them with horses might result in useful—and highly decorative—hybrids, like mules, which are products of horse–donkey matings. When Moreton bred his quagga stallion with a conventional mare, the result was an oddly shaped foal with zebra-style stripes on its shoulders and the backs of its fore- and hindlimbs, and a dark stripe down its back. Lord Moreton sold the mare, which was then bred on two occasions with a black Arabian stallion. Bizarrely, the foals from these two horse-to-horse breedings also bore stripes like those on their half-quagga half-sibling.

What did this mean? Lord Moreton reported the strange results to The Royal College of Surgeons and offered his own interpretation: somehow, the first mating with the quagga must have influenced the mare's subsequent offspring by different sires. However, another explanation was also possible: many pure horses show some stripes, and back ridge and shoulder stripes are common on donkeys and mules, which are more primitive equines. The stripes on the mare's second and third foals might be a normal variation well within the conventional range for horses. In that case, the quagga would have had nothing to do with the appearances of the second and third foals. Charles Darwin studied Agasse's paintings (there are six in all) and opted for the second explanation in *The Origin of Species* (1859). He proposed the now

generally accepted idea (the law of variation within species) that the early ancestor of today's horse, ass, and zebra was striped, and that from time to time "throwbacks" exhibiting primitive characteristics would result from certain matings. Unaware of Gregor Mendel's experiments, which showed the genetic causes of such variations, Darwin could not explain why they occurred. He argued, however, that reversion to primitive ancestral characteristics was a more logical interpretation of the facts than was the competing, biblically inspired theory that God had separately created numerous species with the inherent capacity to produce stripes at random.

Although the causes of striping in horses are no longer controversial, Agasse's painting of the quagga sire continues to be of the utmost scientific relevance. European settlers introducing sheep, cattle, and other ruminants into South Africa viewed quaggas as undesirable competitors for valuable grazing land. Quaggas were hunted rapidly to extinction, and the last one died in the Amsterdam zoo in 1883. Yet Darwin's law of variation within species may yet rescue the quagga from oblivion. In 1980, DNA testing of material from a preserved quagga skin proved that quaggas are a type of zebra, not an independent species. The Quagga Project now underway in South Africa is breeding carefully selected Plains zebras in the hope of producing animals that look like the extinct quagga. Would they actually be quaggas? The project's leader, Reinhold Rau, asserts, "The quagga is a quagga because of the way it looked, and if you produce animals that look that way, then they are quaggas. Finished."[1] In which case, Agasse's portrait sets the standard for success.

---

[1] Quoted in Don Boroughs, "New Life for a Vanished Zebra?" *International Wildlife*, March/April 1999, available at www.nwf.org/internationalwildlife/1998/quagga.html.

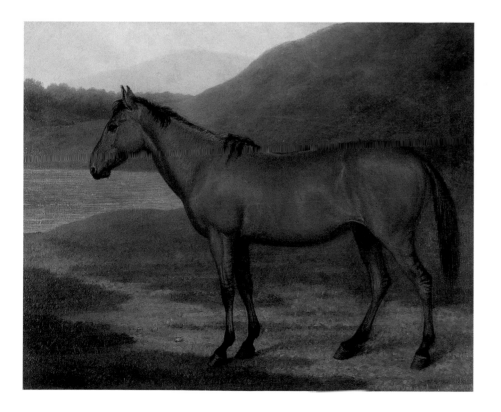

**Jacques-Laurent Agasse**
Swiss, 1767–1849

*A male quagga from Africa:
the first sire*, 1821
Oil on canvas
48 x 58.5 cm (19 x 23 in.)

*Black Arab stallion:
the second sire*, 1821
Oil on canvas
48 x 58.5 cm (19 x 23 in.)

*Hybrid foal, which the Arab mare bore
when sired by the Quagga*, 1821
Oil on canvas
48 x 58.5 cm (19 x 23 in.)

All: Hunterian Museum of The
Royal College of Surgeons
of England, London

# The death of a friend

On November 24, 2004, a memorial to animals that have perished in war was unveiled in London. The monument has been described as an "overdue tribute to the millions of conscripted animals that died in war." It is overdue indeed, not only because it finally recognizes the contribution of so many involuntary victims, but also because it consolidates the tributes to four-legged war victims made by artists almost two centuries earlier.

During the course of the eighteenth century, there was a growing recognition that animals deserved to be treated with dignity. Philosophers, scientists, and artists both inspired and reflected the spirit of the time by complaining about cruelty against animals (see pp. 44–45). However, cruelty against humans and animals was officially sanctioned in times of war.

Horses were the most common animals to be found on the battlefield. A strong cavalry remained a decisive element until the Napoleonic wars. After the Battle of Waterloo (1815), improvements in artillery design slowly but surely reduced the horses' importance. In the conflicts that followed, horses and riders could more easily be kept at a distance from the enemy, due to the longer range of the new firearms. Many animals and soldiers were killed or wounded before they could even take part in the fighting proper.

There have always been horses in battle paintings, of course, but it seems that—in parallel with a growing feeling of empathy—these terrible and "senseless" casualties of modern warfare served to direct the attention of artists to the fate of animals. The more the animals' suffering increased, the more prominent was the place given to them in the pictures.

A telling example is Eugène Delacroix's *Evening After the Battle*. Although it is quite small and the execution sketchy, we must note that it is not just a study for a larger composition. The painting is signed, and it stands as an independent work. Its subject is plain to see: two dead horses, with a barely visible cuirassier trapped under one of them. We do not know if Delacroix had any particular battle in mind. What we have in front of us is no less than a painting about the suffering of animals in war. The minor role given to the human soldier only emphasizes the focus on the animals.

Carlo Marochetti, a very successful sculptor and the author of important equestrian monuments in several countries, goes a step further than Delacroix. His bronze group with a dying horse and an Oriental soldier under a palm tree directly appeals to our emotions. With its title, "The Death of a Friend," Marochetti makes this scene very personal. He almost liberates the horse of its anonymity. The subject is the friendship between man and horse, and the deep sympathy the soldier feels for the suffering creature, whose head rests on his lap. The exotic setting adds to the sculpture's appeal. Orientalism was in fashion, and Marochetti reminds us of the special relationship between Arabs and their horses. A century earlier, the founder of French zoology, the comte de Buffon, had commented on this in his *Histoire naturelle* (1749–88): "Cruelty and severity are never practiced; for an Arab treats his horse as if it were a friend." In Marochetti's view, was it the

Carlo Marochetti
Italian, active in France, 1805–1868
*The Death of a Friend*, c. 1840–50
Bronze
52 x 46 x 26 cm
(20½ x 18 ⅛ x 10¼ in.)
Musée Girodet, Montargis

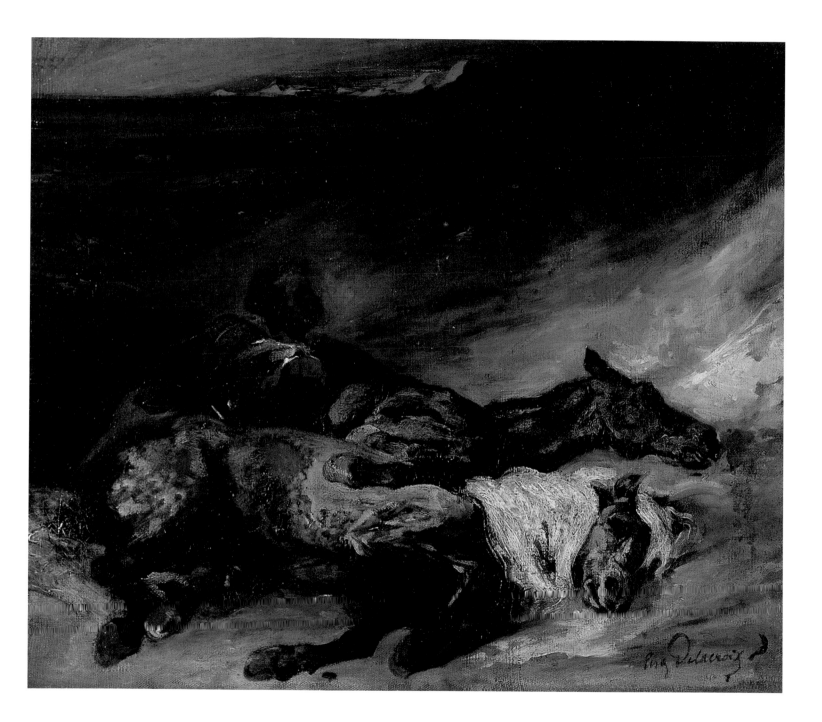

Eugène Delacroix
French, 1798–1863
*Evening After the Battle*, *c.* 1824–26
Oil on canvas
48 x 56 cm (19 x 22 in.)
Museum Mesdag, The Hague

nobility of the Arabian horse that inspired this special care, or did he see Arabs as living closer to nature than Europeans?

Another highly successful artist in his time, Ernest Meissonier, made this sculpture of a wounded horse. It is only the bronze cast of a study, but at least this time we know exactly which horse it is. The animal was owned by one Captain De Neverlée, a *franc-tireur* and hero of the Franco-Prussian War of 1870–71. We recognize the horse as that in Meissonier's painting *The Siege of Paris*, a strange allegory with detailed realistic elements (1870; Musée d'Orsay, Paris). In this work, which took the painter fourteen years to complete, Meissonier included a number of other famous individuals as well as the aforementioned captain. The horse is shown in the exact same pose as it is in this bronze, but seen from a difficult angle. Its position in the painting is very prominent, and the way it is shown trying to get back on its feet stresses the suffering it must be experiencing. The siege of Paris by Prussian troops, the subject of this painting, was a traumatic episode for the French, who were eventually forced to ask for an armistice. A way of coping with this defeat was to believe that individual soldiers fought heroically but were left to their fate by incompetent generals. Meissonier's meticulous preparation leaves no doubt that he wanted to assign to the horse an important role, and one that was worthy of being remembered.

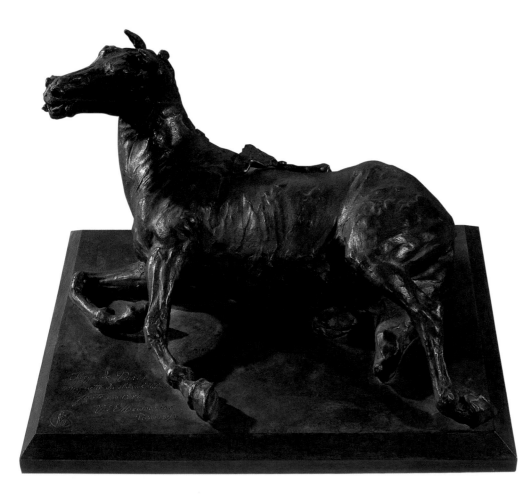

**Ernest Meissonier**
French, 1815–1891
*Wounded Horse*, 1884–93
Bronze
26.7 x 35 x 35.2 cm
(10½ x 13¾ x 13⅞ in.)
Musée des Beaux-Arts, Lyon

# Satirical laughter

The British humorist Richard Steele introduced the concept of the "horse laugh" in the British periodical *The Guardian* (no. 29) in 1713. His untitled essay on laughter compared ancient laughter, as cataloged by Greek and Roman authors, with its modern forms, such as the loud, coarse guffaw practiced by London coffeehouse debaters and rural hoydens, which he termed the horse laugh. In this drawing, Thomas Rowlandson makes direct reference to Steele's essay. He illustrates ancient laughter with heroic horses drawn from Antique models and modern laughter with caricatures of vulgar early nineteenth-century Britons. (The likely equine models are the Parthenon reliefs and Leonardo da Vinci's *Battle of Anghiari* sketches, both of which were in England, and famous, by the early nineteenth century.)

Nowhere does Steele suggest that horses actually laugh. In fact, he asserts that laughter is a distinguishing characteristic of human rationality. If a sense of humor is exclusive to humans, how can these horses be said to be laughing? Twentieth-century psychologists and anthropologists have pointed out that primates show their teeth in rage and laughter, and that there may be strong connections between humor and aggression in humans; it would be natural for an inexperienced primate to confuse the horse's rage with laughter (until he or she got bitten). Steele's choice of the word "horse" to describe human laughter probably is based on superficial resemblances between sounds (snorts and neighing) and appearances (exposed teeth, wrinkled noses, tossing heads), and their connotations of noisy vulgarity.

By comparing the ancient originals to their modern counterparts, Rowlandson also alludes to a European craze launched by Johann Caspar Lavater's *Essays on Physiognomy* (1775). These essays analyze anatomy and facial expressions in order to interpret character and facilitate love and understanding between humans and animals. Lavater illustrated his book with portraits of famous people and details from historic paintings of fictional humans and animals, just as Rowlandson does here. One wonders if Rowlandson intended the mismatched horses and humans in *The Horse Laugh* to satirize the superficiality of so many of Lavater's comparisons. Yet, however wrong-headed, Lavater drew attention to the relationships that exist between the anatomy and psychology of the animal and the human. He is credited today as a founder of the modern disciplines of comparative anatomy, physiognomy, and psychology. His analysis of character and expression in beasts inspired early believers in animal rights, vegetarianism, and mankind's unity with nature. Rowlandson's satire indicates the depth of his impact on popular thought at the time.

Thomas Rowlandson
British, 1756–1827
*The Horse Laugh*, c. 1825
Graphite, vermilion, and India ink on paper
22.2 x 17.8 cm (8¾ x 7 in.)
Carnegie Museum of Art, Pittsburgh,
Mr. and Mrs. William A. Meyer
Acquisition Fund

PLATE XXVI.

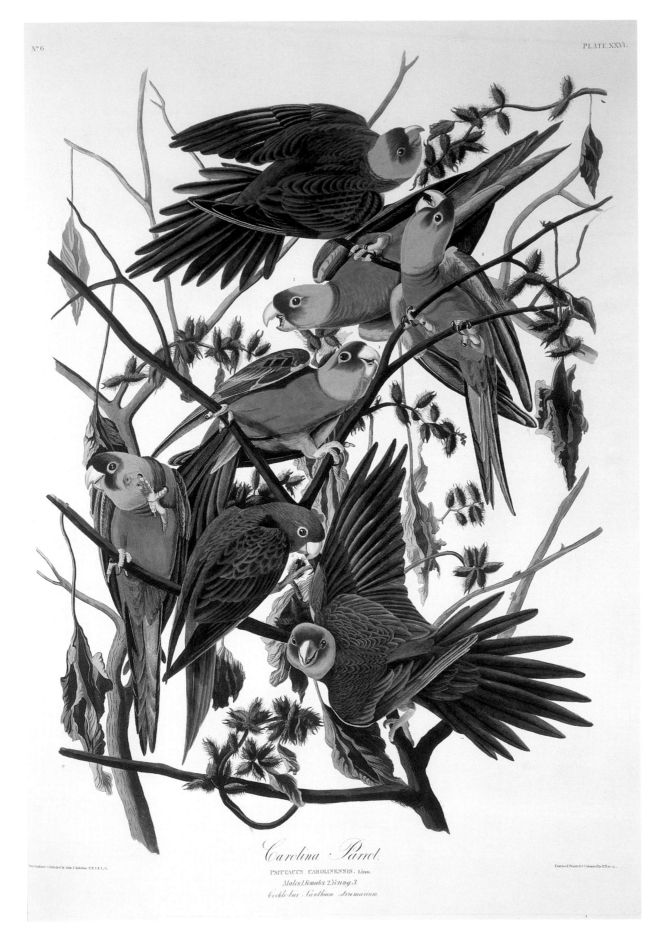

*Carolina Parrot.*

PSITTACUS CAROLINENSIS. *Linn.*

*Males 1. Females 2. Young 3.*

*Cockle-bur Xanthium Strumarium.*

Drawn from Nature & Published by John J. Audubon. F.R.S.E. M.S.    Engraved Printed & Coloured by R.Havell.

John James Audubon
American, 1785–1851
*Carolina parrots*, from
*The Birds of America*,
London (published by the
author) 1827–38, plate 26
Engraving hand-colored
with watercolor
Plate size 84.1 x 59.7 cm
(33⅛ x 23½ in.)
Carnegie Museum of Natural
History, Pittsburgh

# Changing times

John James Audubon
American, 1785–1851
*Otter*, from *The Viviparous Quadrupeds
of North America*, New York
(published by the author) 1845–48,
plate 51
Lithograph hand-colored
with watercolor
Sheet size 55.9 x 71.1 cm (22 x 28 in.)
Carnegie Museum of Natural History,
Pittsburgh

John James Audubon's *The Birds of America* (1827–38) is widely acknowledged as one of the most beautiful books ever published. Its elegant compositions, superb execution, and appealing subjects ensure its fame even now, more than 170 years after publication. It is such a great work of art that we can easily forget that it is also a great work of natural history.

Audubon wanted to produce the most complete, accurate, beautiful, and informative book on American birds, and he spent most of his life bringing it about. Unlike many previous illustrators, Audubon was both a gifted and well-trained artist and a passionate naturalist, hunter, and explorer. He had observed many of the birds in the wild, and so could represent their characteristic poses, behaviors, and environments. He also shot his own specimens, dissected them to identify genders and learn their diets, and preserved and mounted them himself. The huge plates allowed him to show every bird at life-size and to depict multiple birds of different genders and ages interacting. One can almost hear his family of Carolina parakeets chattering away in their cockle burr bush. In Audubon's most dramatic plates, barn owls negotiate a meal

of dead squirrel, thrushes defend their nest from a predatory snake, and eagles fall on one another from the sky. These animal combats deserve comparison with the work of *animalier* artists such as Antoine Barye and Eugène Delacroix, Audubon's contemporaries (see pp. 90–91). Based on Audubon's observations of natural behavior, his combats equal the ferocity and tension of the others' imaginary battles of lions, tigers, crocodiles, and the like, and outdo them in realism and accuracy.

*The Birds of America* marks the beginning of modern ornithology. At the time of its publication in the 1820s and 30s, naturalists were struggling with different methods and standards for relating and classifying the countless new species turning up in America, Africa, and Asia. The eighteenth-century system had been based on analysis of preserved skins in European collections, with little or no attention devoted to a bird's physiology, behavior, or environment. Audubon's book demonstrated conclusively that systematic observation of birds in the field is as important as physical description.

Audubon's second great publication, *The Viviparous Quadrupeds of North America* (1845–48), is less famous today, but it deserves equal attention and respect. A catalog of mammals in the United States, Canada, and Mexico, it is illustrated with lithographs (a relatively new medium at the time, easier and cheaper than engraving) colored by hand with watercolor. While Audubon could not depict animals such as buffalo at life-size, he continued to emphasize environment, behavior, and interactions with other creatures in his plates. With the mammals, he introduces humans into the environment. A dog lives with an Indian tribe; a roe deer bleeds from a gunshot wound; an otter is caught in a cruel trap. Leafing through Audubon's brilliant elephant folio volumes today, it is sad to recognize that as a result of the westward expansion that began in Audubon's era, so many of his subjects are now extinct, endangered, or protected. The beautiful Carolina parakeet, once extremely common on the eastern seaboard, was gone by 1910.

**Anonymous**
French
*Giraffe*, c. 1785
Oil on canvas
165 x 122 cm (65 x 48 in.)
Bibliothèque Centrale du Muséum
National d'Histoire Naturelle, Paris

**Jacques-Laurent Agasse**
Swiss, 1767–1849
*The Nubian Giraffe*, 1827
Oil on canvas
127.3 x 102 cm (50⅛ x 40⅛ in.)
The Royal Collection, Her Majesty
Queen Elizabeth II

## Walking to the zoo

Before 1800, few Europeans had the chance to see a live giraffe. Skeletons and skins had arrived earlier, but the attempts to reconstruct the animal accurately from the material at hand and the occasional drawings were largely unsuccessful. The explorer François Levaillant (1753–1824) had presented evidence of the graceful African animal to the comte de Buffon, director of the Muséum d'Histoire Naturelle in Paris. By combining scientific and commercial interest, Levaillant was a typical example of an adventurer–scientist in the Age of Enlightenment. In 1781, he traveled to southern Africa, and he is now most famous for having published some of the most beautiful books on birds ever seen (see p. 21). When he returned to Paris in 1784, he brought more than one thousand stuffed birds and the skin of this giraffe. This skin and a few drawings formed the basis for the painting that the museum commissioned. The anonymous maker surely tried his best, but the animal shows serious anatomical flaws, because it is not painted from life. We may assume, though, that Levaillant, the man next to the giraffe, is represented more accurately.

The Parisians had to wait forty-three years before they could see the first living specimen. In 1827, Pasha Muhammad-Ali, the Ottoman Viceroy of Egypt, wanted to improve his relationship with the major European nations, namely France, Britain, and the Austrian Empire. The tokens in the service of diplomacy were giraffes. It is easy to imagine the wonder and excitement experienced by the citizens of Paris, London, and Vienna when a Nubian giraffe was put on public display in their respective cities.

The story of Zarafa, the giraffe that walked all the way from Marseille to the French capital, captured the public imagination. Thousands of people lined the streets to cheer the amazing creature on its journey through France, and it received a triumphal reception when it arrived. More than half a million visitors are said to have visited Zarafa in the first months at her new home, the Jardin des Plantes. Not only did the animal entertain the masses, but its presence broadened the horizon of many and inspired a fashion for natural history.

The Paris giraffe outlived its London and Vienna counterparts by many years. The London giraffe was first shipped to Malta to spend the winter there, and then continued by ship directly to the capital. It arrived on August 11, 1827, at Waterloo Bridge. From there the journey brought the giraffe to Windsor. This is where we see it in this work by the Swiss animal painter Agasse, who was the first choice of natural historians when it came to render hitherto seldom seen species accurately (see pp. 76–77). The giraffe is shown with the two Egyptians who accompanied it on its journey, as well as with a representative of the animal's host nation (whose identity is uncertain). In the background, two cows can just be distinguished. They would have provided the giraffe with milk, which was the only food the animal was given; it seems that this is the nourishment the Egyptians are offering her in a large bowl. The giraffe has to bend down to drink it, when it would no doubt much rather pick a few leaves from a tree. Agasse has made a harmonious composition and avoided any dramatization of the scene. The giraffe is seen in profile, the best position for us to see its shape and color, following the tradition of scientific illustration.

Today, a child growing up in a city may well see a living giraffe before he or she sees a deer or even a cow. Non-indigenous *artiodactyla* (even-toed ungulates) are more likely to be encountered than native ones. Thus has the whole notion of what is regarded as exotic changed over the last two hundred years. Some zoos answer to this new vision of animals by adding local cattle to their collections. That, however, may make a cow look even more exotic.

# Blood, no blood

Curious scientists would not stop at studying useful animals, exotic mammals, or pets. They also, quite literally, looked into frogs, snakes, and snails. With or without the microscope, researchers opened up bodies, looked inside, compared the inner organs, and recorded their finds for their students. The beauty of these images often stands in sharp contrast with the gruesome subject-matter. None of these creatures had any practical use for humans, neither as nourishment nor for labor. It is doubtful that people were interested in the organs of a frog in order to cure disease. What, then, were they looking for? Was it science for science's sake?

While illustrated books remained the most common medium to disseminate such information, another teaching tool was the three-dimensional model. The use of models saved many an animal's life. Not only did they prevent the messy killing of laboratory animals, but they also provided better study material than organs preserved in spirit, because the colors would not fade. The Frenchman Auzoux, who held a medical degree, excelled in employing a new material for this model-making: papier-mâché. Light yet surprisingly strong, and less fragile than wax or glass, papier-mâché permitted the model-maker to create a range of special effects. When Auzoux was thirty years old, he founded a factory where an ever-larger team of collaborators worked with him. Auzoux's models, like this one shown below, can often be opened up to allow viewers to see both the outside and the interior of an animal.

Auzoux invented a name for his special kind of model, the *anatomie clastique*. *Clastique* is derived from the Greek *klastos*, meaning "broken in pieces." Auzoux advertised by telling his potential clients—medical faculties—that his products would help students overcome the distasteful conditions of the dissecting room. His strategy proved very successful, and Auzoux's models were much sought-after in European and American universities.

**August Johann Rösel von Rosenhof**
German, 1705–1759
*Historia naturalis ranarum nostratium/ Die natürliche Historie der Frösche hiesigen Landes, etc.* (The natural history of native frogs), Nuremberg (Johann Joseph Fleischmann) 1758
Universiteit van Amsterdam, Artis Bibliotheek

**Louis-Thomas-Jérôme Auzoux**
French, 1797–1880
Anatomical model of an adder, after 1827
Papier-mâché
30 x 13.5 x 27 cm
(11⅞ x 5⅜ x 10⅝ in.)
Museum Boerhaave, Leiden

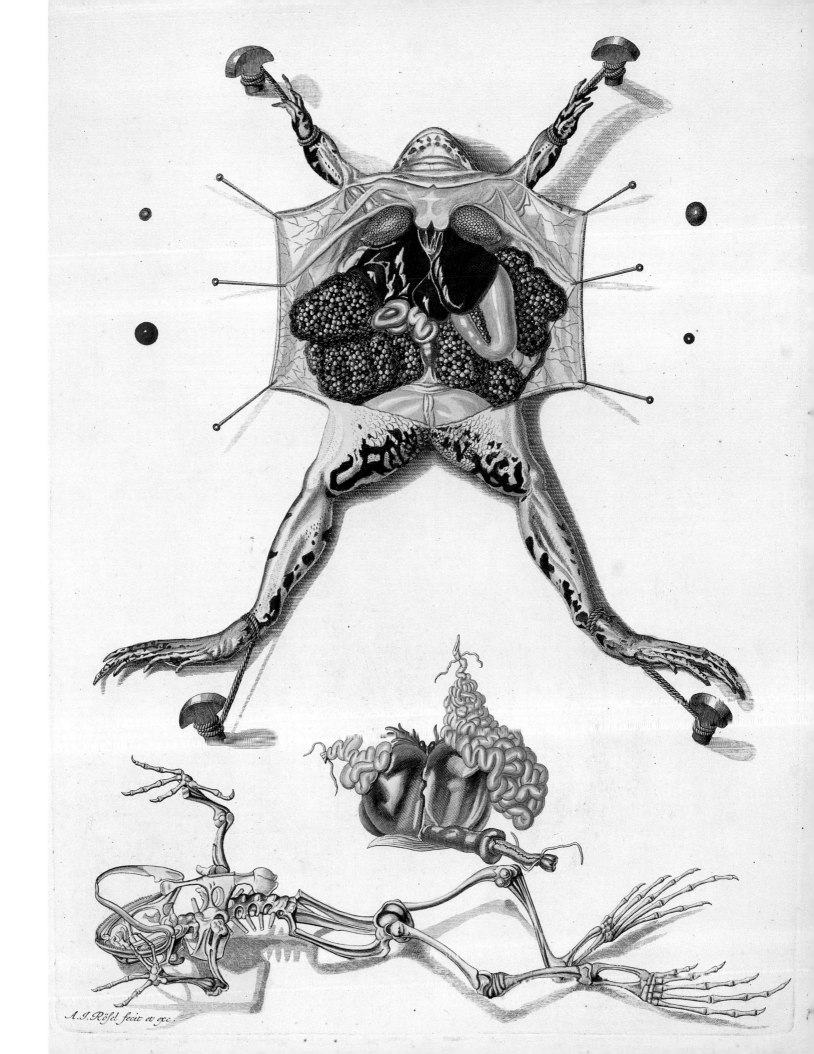

A.J.Röfel fecit et exc.

# Missing persons

Just what are these two paintings really about? Conceived as a pair, and framed as one, their titles encourage us to think of social contrasts. "Low," on the left: mongrel guard dog, butcher's block and knife, a simple workspace. "High," on the right: aristocrat's deerhound, the accoutrements of learning and chivalry, a richly furnished castle interior. Landseer presents us with well-ordered hierarchies of material goods, breeds of dog, and classes of men.

If Landseer's painting appears to support the traditional social order, it nevertheless subverts the traditional orders of art. Academic art of the eighteenth and nineteenth centuries was organized into a hierarchy of genres determined by subject-matter. History painting, concerned with human moral and ethical dilemmas, ranked highest; below it came genre painting (scenes of daily life), portrait painting, landscape, animal art, and still life (the lowest of the low, depicting only inanimate objects). One can argue that the two paintings that comprise *Low Life* and *High Life* are merely still lifes: are they not entirely filled with the possessions of the absent owners? One can also argue that they are animal paintings: the dogs are alive and painted from real animals, after all. Equally, one can argue that they are human portraits: everything is there to characterize the sitters except the sitters, who have unaccountably wandered away.

Landseer disorients us further with his point of view. Despite the Low–High contrast in the title, the two dogs' heads are on the same level; the shorter butcher's dog sits on a step that raises his head to the same height as that of the larger deerhound. And the perspective in each painting places the observer—us—on the same level as the dogs. We look right into their eyes as if we were dogs, too, and not down at them, as if we were humans. So this painting about hierarchies actually levels the field, by putting aristocrat and commoner, rich and poor, human and animal, on a single plane.

Looking dog-to-dog, so to speak, we recognize that these animals may be equals, but their characters differ. The terrier—burly, battle-scarred, lop-eared, and squint-eyed—relaxes in the sunshine even as he glares at a possible intruder. The deerhound—elegant, withdrawn, and tense—ignores us. Their attitudes mirror stereotypes of plebian and aristocratic human behaviors—aggressively straightforward in the former and neurotically aloof in the latter. Thus it is hard to see these dogs as individual animals; instead they serve as types that reinforce our reading of other objects in the scene as status symbols.

What kind of a dog are you?

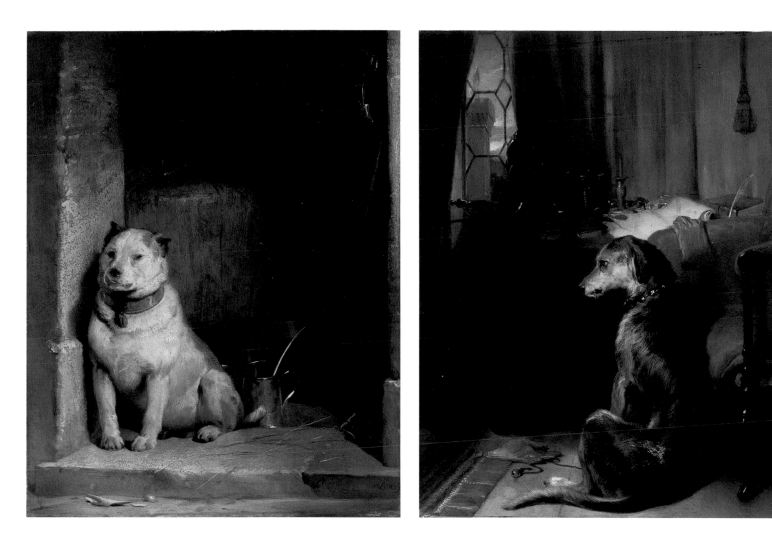

**Edwin Landseer**
British, 1802–1873
*Low Life* and *High Life*, 1829
Oil on panel
45.7 × 34.3 cm (18 × 13½ in.) each
Tate, London

# The year of the tiger

**1831**

It is not impossible that a tiger and a gavial should engage in a deadly fight. But you would have to be in northern India to see that, a place the French sculptor Antoine Barye never had visited. He could, however, see these animals in the Paris zoo, which was situated in the Jardin des Plantes. The first Bengal tiger arrived there in 1831, and Barye immediately created one of his most lively sculptures, which eventually gained him a medal at the annual Salon exhibition.

Tigers did not enjoy a good reputation. While lions were regarded as noble and served as a popular symbol for dynasties and nations, the big Asian cat was simply seen as bloodthirsty and cruel. Males would eat their cubs and even kill a female if she dared to defend them. This is how the great naturalist Buffon describes the tiger in a chapter full of prejudice in his *Histoire naturelle* (1749–88).

The Paris zoo was the first of its kind in Europe. It had exhibited exotic animals publicly since 1793, after the revolutionaries took over the royal menagerie. It was not until twenty-five years later that the next zoo would open, in London. French leadership in natural history collecting and research may explain the fact that the country could boast the most experienced animal sculptors and painters in Europe. In the Jardin des Plantes, the spirit of Enlightenment and the rage for natural history met with the curiosity and enthusiasm of young artists who were tired of seeing the same old stories painted over and over again. The Romantics were looking for fresh, even wild, subject-matter, motifs that were as untamable as they liked to imagine themselves to be.

The French even gave the artists working in the Jardin des Plantes a name: *animaliers*. The term initially was not meant to be flattering. At that time, animals were placed very low in the hierarchy of subject-matter: they usually served merely as attributes of royalty or to convey some symbolic meaning. As for hunting scenes, these served the glory of the hunters, not the hunted. Depicting animals in their own right, without the involvement of people, was virtually unknown. The *animaliers*, however, must have hit a nerve with their public, since they became enormously successful. Bronze groups like this appeared in great numbers over subsequent decades, bringing a bit of harmless wildlife into many homes.

Eugène Delacroix, the painter, and Antoine Barye, the sculptor, were friends. They visited the zoo together and studied each other's work. They not only observed surface appearances but

**Georges Gardet**
French, 1863–1939
*Tiger Family and Crocodile*, 1903
Yellow cipolin marble, Algerian onyx,
Lalique crystal, patinated bronze
44 x 58 x 35 cm (17½ x 22¾ x13¾ in.)
Univers du Bronze, Paris

■ This animal group is as perhaps more a bravura piece, showing off the sculptural skills of its maker, than a reflection on natural behavior. While Antoine Barye a generation earlier had excelled in bronze patination in order to evoke the colors of his tiger, Gardet uses different materials: marble for the tigers, onyx for the grass, crystal for the water, and bronze for the crocodile. The sculptor, a worthy follower of the French *animalier* school, was commissioned to make this work by the French Jockey Club for its Grand Prix of 1903. ■

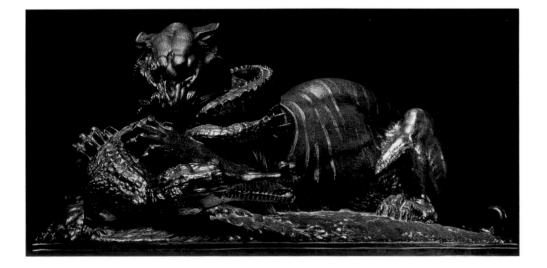

**Antoine-Louis Barye**
French, 1795–1875
*Tiger Devouring a Gavial*, 1831
(cast 1874)
Bronze
41 x 101 cm (16 x 39¾ in.)
Van Gogh Museum, Amsterdam

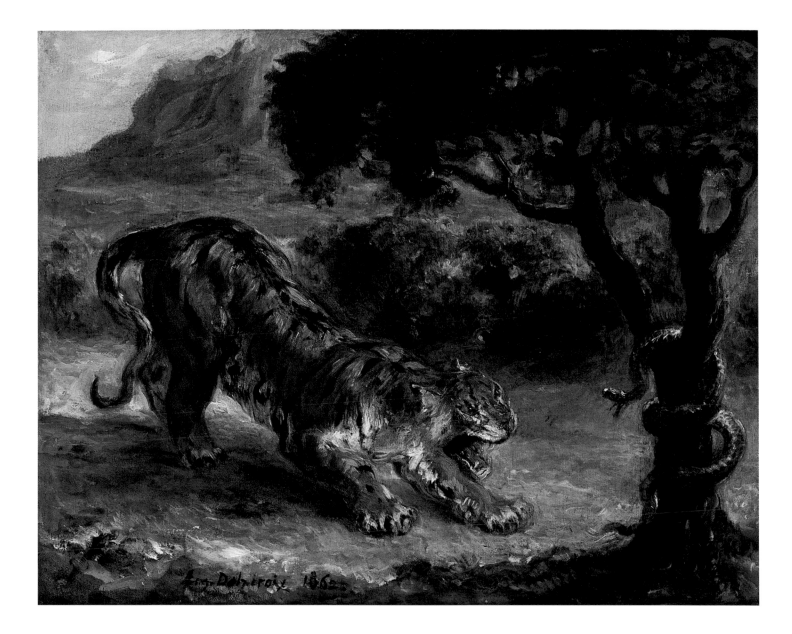

**Eugène Delacroix**
French, 1798–1863
*Tiger and Snake*, 1862
Oil on canvas
33 x 41.3 cm (13 x 16¼ in.)
The Corcoran Gallery of Art,
Washington, D.C., William A.
Clark Collection

also investigated the animals' anatomy, either by attending dissections or through the books of the leading scientists of their time, such as Georges Cuvier (see p. 21).

The fight between a tiger and a snake, which Delacroix painted three decades after the Barye work, must have been seen as the fight between two especially evil creatures. The snake has always been perceived as devious, and, as we have seen, tigers also suffered from a bad reputation. The outcome of the fight between tiger and snake is less certain than that between tiger and gavial: the gavial appears to have little chance of survival under the claws of the big cat.

As Barye had done earlier, Delacroix gives the illusion of observing a real event in nature, although the wild is the one place he could not have seen such a scene. He might have found inspiration in the Paris zoo, in a menagerie, in a circus, or even in old master paintings. Here, the big cat looks as if it is afraid of the reptile. We should not overestimate Delacroix's powers of observation, however. The painter is more interested in his creativity as a colorist than in a scientifically correct image of nature. As he put it, "Art consists not of copying nature but of re-creating it, and this is particularly true for the representation of animals."

# Whose side are you on?

Most pictures tend to lose their disturbing qualities with time, but in this case the opposite seems to be true. The more we know about what is going on in the scene, the worse it becomes. Under the watchful eyes of his students, a doctor cuts open a dog. The animal is alive: it is tied to the table and turns back its head in undisguised pain. Another dog is chained by its neck and looks at its comrade, most likely in horror.

Vivisection was not commonplace in 1832. It had only recently been introduced, as a way of finding cures for human diseases. As soon as vivisection began, the movement against it emerged. In 1824, a few years before this painting, the first animal protection movement had been founded in Britain: the Society for the Prevention of Cruelty to Animals. Other countries would follow the British example soon after.

Whatever purpose the doctor had in mind, then, his actions were not carried out in innocence. What is even more puzzling is why we, the viewers, are called to witness the scene. As far as we know, this is the only painting in the entire history of art—and certainly in the nineteenth century—to show a vivisection. Who is its author, Emile-Edouard Mouchy? We know hardly anything about him. He was certainly no great innovator in terms of style or technique. The composition is conventional, reminding us of many earlier group portraits, and the individuality of the faces leaves much to be desired. He could not be accused, however, of failing to put great care into the scene. The large format, too, is a clue to the seriousness of this enterprise.

And who is the doctor? He cannot be the famous French physiologist Claude Bernard, a pioneer of experimental medicine, because he was only nineteen years old when this painting was made. A better candidate might be Bernard's teacher, François Magendie (1783–1855). He is known to have experimented with dogs in public. An early case is reported to have taken place in England in 1824, and his practice initiated anti-vivisectionist campaigns. Interestingly, if we look at the room, we get the impression that the vivisection is not being held at a hospital or a medical school; it looks more like an anonymous attic room. Whoever the doctor is, did he need to hide this activity?

The room is crammed with people and also includes a few attributes of the medical profession. The cramped atmosphere may be a ruse on the part of the painter to convey a message with this humble environment. There is another element that may give a clue to the painter's intention, too. The number of students is twelve, and one of them seems to be leaning on the shoulder of the teacher. If this is not just an accident, Mouchy is making an allusion to Christ and his disciples gathering at the Last Supper.

Is the doctor thus portrayed as the savior of mankind? Many believed, as many still do, that experiments on animals are a legitimate means to advance medical science. Is Mouchy taking sides by painting a pro-vivisection propaganda piece? Whatever our conclusions, it is certain that the treatment of animals not only raised concerns but also deeply divided the public. In these terms, this painting is as relevant today as it was when it was created.

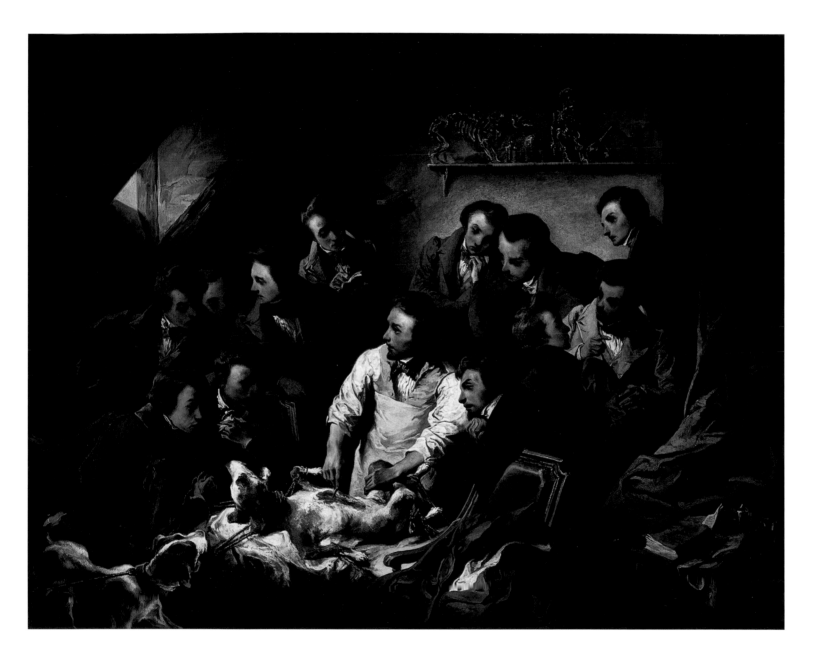

**Emile-Edouard Mouchy**
French, 1802–1870
*A Physiological Experiment with
Vivisection of a Dog*, 1832
Oil on canvas
112 x 143 cm (44⅛ x 56⅜ in.)
Wellcome Library, London

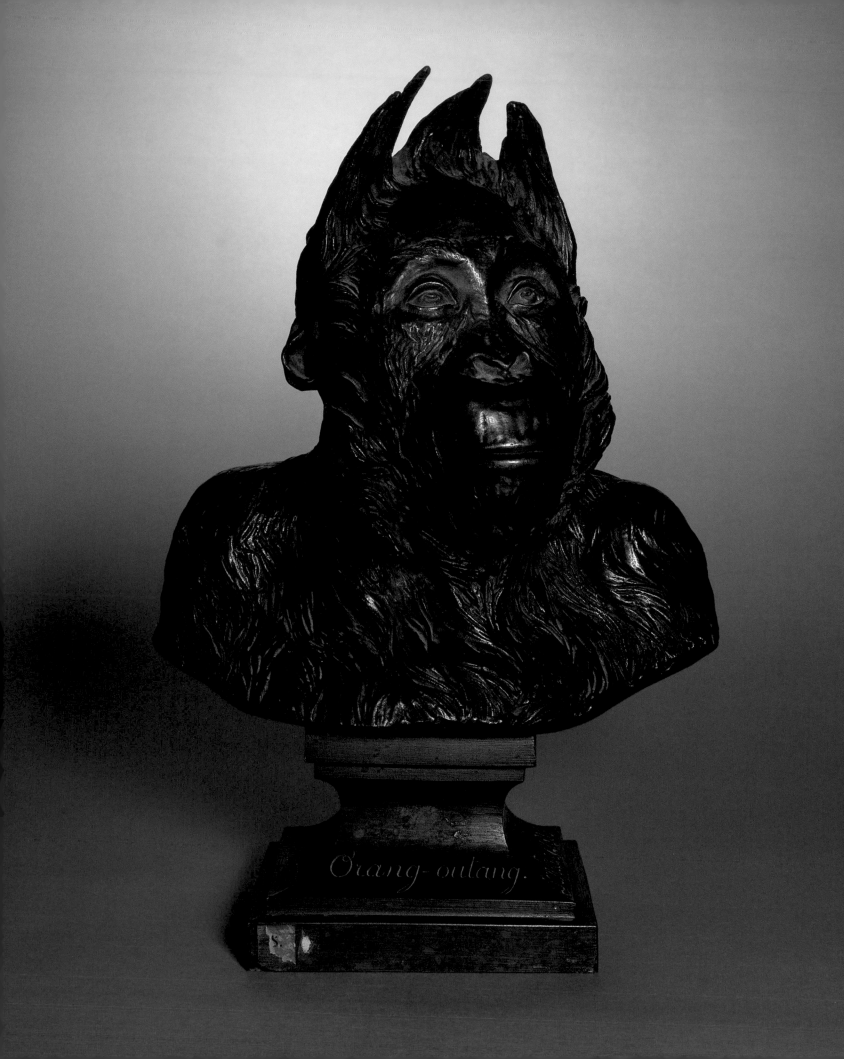

Orang-outang.

# Jack

This is Jack, an orangutan from the Paris zoo. Jean-Pierre Dantan, who made his bust, was a Romantic sculptor famous for his portraits of contemporary celebrities. With Victor Hugo, Alexandre Dumas, Franz Liszt, and Hector Berlioz having been among the artist's sitters, Jack is in good company. Dantan also made humorous sculptures, but this is not one of them. The ape is observed with great care. The convention of portrait busts tempts us to interpret his features and reflect on his character and state of mind. No matter what we think of him, Jack's portrait is one of a dignified individual. There had never been an animal portrait like this before.

Dantan's colleague Barye probably used the same model, but his approach is very different. Following the example of an English humorous print of 1832 (by Thomas Landseer, featured in Barrow's *Humorous Portraits of Animals*), Barye lets the orangutan mount a gnu. The sculptor has studied the animal's anatomy meticulously. The only "mistake" is that the ape is too large in relation to the antelope, but this is a *capriccio*, not a zoological study. Barye often combines different animals in his work, but usually in the form of a predator attacking a victim. This strange combination is unique among his œuvre.

Different as they are, both of these bronzes reflect the period's growing interest in primates. They stand on the threshold between the *singeries* of the eighteenth century and the very different perceptions of the late nineteenth century, when Darwin had narrowed the gap between humans and apes.

**Jean-Pierre Dantan Jeune**
French, 1800–1869
*An Orangutan called Jack—Study made in the Jardin des Plantes*, 1836
Bronze
Height 42 cm (16½ in.)
Musée Carnavalet—Histoire de Paris, Paris

**Antoine-Louis Barye**
French, 1795–1875
*Ape Riding a Gnu, c.* 1837–65
Bronze
23 x 25.4 x 9.7 cm (9 x 10 x 3¾ in.)
Van Gogh Museum, Amsterdam

# Fierce friends

Edward Hicks, the creator of over forty works with the title "Peaceable Kingdom," had little interest in animals. He had failed at farming, and as a deeply religious and provincial Quaker minister, it is highly unlikely that he would have visited a traveling menagerie where he might have seen a real lion, leopard, or tiger. As far as can be determined, the creatures in Hicks's Kingdoms, including the familiar domestic ones, are copied from print sources rather than life.

Hicks may have painted animals, but he also portrays the human soul. *The Peaceable Kingdom* is about a dream of a world where natural enemies can live together peacefully according to biblical prophecy, as set out in Isaiah 11:6–9:

> The wolf also shall dwell with the lamb, and the leopard shall lie down with the kid; and the calf and the young lion and the fatling together; and a little child shall lead them. And the cow and the bear shall feed; their young ones shall lie down together: and the lion shall eat straw like the ox. And the suckling child shall play in the hole of the asp, and the weaned child shall put his hand on the cockatrice's den. They shall not hurt nor destroy in all my holy mountain: for the earth shall be full of the knowledge of the LORD, as the waters cover the sea.

Hicks relates the prophecy to his own times in the scene on the far left of the picture, where William Penn, a leading figure in Quakerism, is seen concluding a treaty with Native Americans that was to enable peaceful coexistence for decades.

*The Peaceable Kingdom* is also about human character and spiritual conflict, and its meanings are deeply personal to the artist. Like many of his time, including Géricault, Rowlandson, and Landseer (see pp. 74, 81, 89, 103), Hicks perceived there to be a relationship between animal behavior and human character, and he intended his animals to symbolize human attributes. He differed from his contemporaries, however, in his clinging to the outmoded theory of the "four humors" (components of the blood thought to determine character). Thus he characterizes the "choleric" temperament with the fierce lion, the "sanguine" with the elegant but untrustworthy leopard, the "melancholy" with the mournful wolf, and the "phlegmatic" with a grouchy-looking bear. For Hicks, these were dangerous animals representing all that was wrong with humanity. They also symbolized the failings of orthodox Quakers, whose rejection of the unusual beliefs of Hicks and his allies had caused a painful schism within the Society of Friends.

Today, theories of the humors and the controversies of Hicksite Quakers are irrelevant to most of us, yet these paintings continue to fascinate. We still relate to the fierce, mournful, melancholic, placid, and gentle beasts that exemplify the worst and best aspects of human character. We yearn for the innocence of young children. We still wonder: how will the lion learn to eat straw, why would the asp fail to sting, and when will the wolf and the lamb dwell together?

Edward Hicks
American, 1780–1849
*The Peaceable Kingdom*, c. 1837
Oil on canvas
73.7 x 90.8 cm (29 x 35¾ in.)
Carnegie Museum of Art, Pittsburgh,
Bequest of Charles J. Rosenbloom

# Jurassic London

In 1852, long before Steven Spielberg filmed *Jurassic Park*, the Victorian author Charles Dickens asked, "And would it not be wonderful to meet a Megalosaurus, forty feet long or so, waddling like an elephantine lizard up Holborn Hill?"[1] The megalosaurus, now known to be a relative of Tyrannosaurus Rex but with longer forelegs, was discovered in 1824. It was the second creature to be identified as a dinosaur; the first was the iguanodon, which the geologist Gideon Mantell discovered and named from a single tooth in 1822. Using newly refined methods of comparative anatomy, Mantell made the breakthrough observation that his animal was a reptile of enormous antiquity and size. In 1841, the great anatomist Richard Owen named it and its fellow monsters "dinosaurs" (terrible lizards). These sensational discoveries aroused storms of excitement and controversy when neither science nor religion could explain their antiquity or appearance.

But what did dinosaurs look like? The early finds were fragmentary—a tooth here, a jaw there, a few disassociated bones elsewhere. The prevalence of large teeth among the early finds encouraged the assumption that these creatures were inordinately vicious. Anatomists inferred the rest from comparisons with reptiles they knew, such as the iguana for the iguanodon and the crocodile for the megalosaurus. The rest was up to artists.

Who better to paint the first iguanodon than John Martin, a visionary painter known for grandiose scenes of biblical disaster? Mantell commissioned Martin to paint a mural for his house, which he was turning into a public museum of fossils and natural history. Sadly, Martin's enormous composition has not survived, except in this tiny print, *The Land of the Iguanodon*, included in Mantell's 1838 publication *The Wonders of Geology*. Based on the most up-to-date geological and anatomical information, it is a scene of carnage observed by nervous turtles in the foreground and a bat-winged, birdlike animal perched on a rock. In the text Mantell compared his iguanodons to dragons and asserted that they had never coexisted with humans; their land was gone before God installed the present Creation.

From the very beginning, dinosaurs were a commercial success. Although Mantell's museum did not survive for long, there was almost immediately a solid market for books, prints, lectures, and the original fossils. Scholars might debate details of anatomy or argue about dinosaurs' place in a historical scheme still heavily dependent on the Bible, but ordinary people wanted to know what it would feel like to stand next to a monster of unimaginable ferocity. Thus it was that in 1854 Benjamin Waterhouse Hawkins produced life-size models of the iguanodon, the megalosaurus, and other members of the rapidly growing dinosaur class. Still viewable at Crystal Palace, near London, today, they look nothing like current reconstructions. Nor do the creatures in his large painting of Jurassic Europe, part of a set commissioned to teach Princeton undergraduates the principles of Darwinian evolution. Now that we have accustomed ourselves to warm-blooded, hyperactive, birdlike dinosaurs, these placid, lumpy animals with hippos' bodies and draggy tails, stars of many a Victorian nightmare, seem boring and highly unrealistic.

---

[1] Charles Dickens, *Bleak House* [1852], quoted in Tim Flannery, "Dinosaur Crazy," *Times Literary Supplement*, January 17, 2002, pp. 33–34.

**John Martin**
British, 1789–1854
*The Land of the Iguanodon*,
frontispiece to Gideon Mantell,
*The Wonders of Geology, or, a familiar
exposition of geological phenomena*,
London (Relfe and Fletcher) 1838
Mezzotint
9.5 x 14.9 cm (3¾ x 5⅞ in.)
University of Pittsburgh Library System,
Hillman Library Special Collections

**Benjamin Waterhouse Hawkins**
British, 1807–1889
*Life in the Jurassic Age*, c. 1871–77
Oil on canvas
79.7 x 233.4 cm (31⅜ x 91⅞ in.)
Princeton University, Princeton NJ

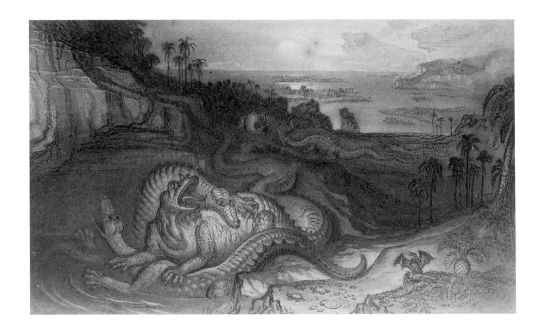

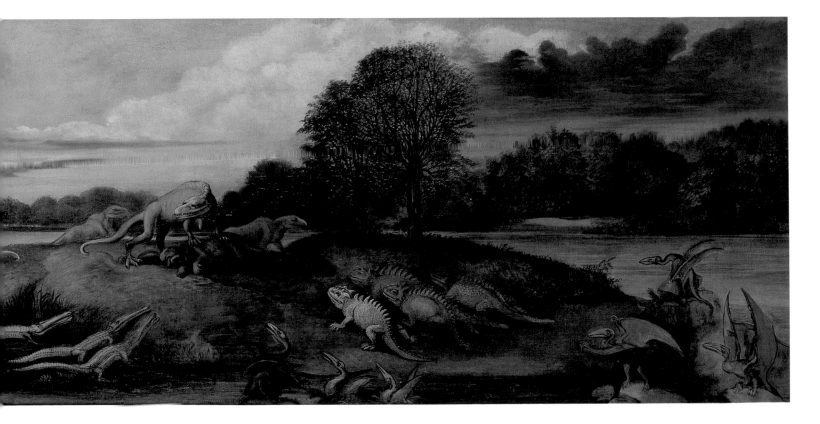

# Isaac in the lions' den

Spectacle and danger make great entertainment. The Romans knew this when they threw Christians to the lions or pitted gladiators against wild beasts in the Colosseum. Isaac van Amburgh knew this when he donned antique armor for his menagerie show as "Brute Conqueror of Pompeii" or, costumed as a biblical Daniel, entered a cage full of lions. And the British artist Edwin Landseer knew it also when he selected two tense moments in Van Amburgh's animal act as subjects for these large paintings.

Van Amburgh (died 1865), an American, invented the modern animal tamer act in 1833, when he performed tricks within menagerie animals' cages, and he is believed to be the first person to have placed his head between a lion's jaws voluntarily. He took London by storm in 1838. His success is recorded in prints, ceramic figurines, and popular songs: "Van Amburgh is the man who goes to all the shows, / He goes into the lions' den, and tells you all he knows, / He sticks his head into the lion's mouth, and keeps it there awhile, / And when he takes it out again he greets you with a smile."[1] Queen Victoria requested a command performance at Drury Lane Theatre in 1839 and a private view of feeding time.

**Edwin Landseer**
British, 1802–1873
*Portrait of Mr. Van Amburgh,
as he appeared with his animals
at the London theatres*, 1847
Oil on canvas
175.5 x 238.5 cm (69¼ x 94 in.)
Yale Center for British Art, Paul
Mellon Collection, New Haven CT

**Edwin Landseer**
British, 1802–1873
*Isaac van Amburgh and His Animals,*
1839
Oil on canvas
113.7 x 174.8 cm (44¾ x 68⅞ in.)
The Royal Collection, Her Majesty
Queen Elizabeth II

I Quoted from www.immortalia.com/html/
categorized-by-song/the-wild-west-show.html.
II www.thegalloper.com/menageries/
menwwamburgh.html.

Landseer's first Van Amburgh painting was made for the queen and records the culmination of the act, when the lion tamer and a lamb would lie down with the big cats in a biblical tableau depicting Isaiah's prophecy of all creation living peacefully together. Edwin Landseer was no Edward Hicks, however (see pp. 96–97); he delights in the theatricality and artifice of the moment, not its spirituality. We are standing *inside* the cage, while the lion tamer and a leopard gaze serenely at the audience, who are safe but nervous on the other side of the bars. And all hell is about to break loose. The lamb cringes; the leopard is staring at its vulnerable neck; the lioness has lifted her head to snarl at the tiger; and the tiger is restrained only by Van Amburgh's dominant hand. Will Van Amburgh prevail, or is the Peaceable Kingdom about to explode?

The second Van Amburgh painting is dated 1847, one year before his last recorded performance in England. The cast of characters is the same, but the mood is very different. Van Amburgh gestures imperiously with one hand and wields a metal crowbar with the other. The lion grimaces like a humiliated schoolboy in the corner, the lioness cowers, the tiger threatens, and the leopards wait in ambush. The painting exposes the cruelty behind the illusion, the animals' misery, and their hideously unnatural conditions of life—or so it appears today. To Victorians, the paintings exemplified mankind's moral superiority (1839 version) and physical power (1847 version) over all of nature. Van Amburgh's wooden countenance expresses the divinely mandated superiority of the human race.

The danger is always there, however. At Queen Victoria's viewing, the tiger and the lion both went for the lamb, but were beaten off by Van Amburgh. Van Amburgh's daughter was mauled to death in London in 1883.[II]

# Grafton and Scratch

Grafton, the bloodhound, and Scratch, the Scotch terrier, belonged to Jacob Bell, who commissioned their portrait from the animal painter Edwin Landseer sometime before 1839. That year, Landseer exhibited it at the British Institution under the title *Dogs*, thus protecting his sitters from the curiosity of the general public. This was also done for human subjects, who were usually listed by their initials; for example, *Miss S. as the Poetic Muse*.

In this as in many of his dog portraits, Landseer exploits the inherent human tendency to interpret others' expressions and behaviors on our own terms, even when the "others" are animals. For example, he paints only the dogs' heads and paws, as in the standard human head and shoulders portrait (emphasizing personality over physique). Moreover, he frames his dogs in an arched window, another convention of human portraiture. Then, at some point in its history, *Dogs* acquired its current title, *Dignity and Impudence*. As a result, it is now almost impossible to think of Grafton and Scratch as real dogs rather than as symbols of human characteristics.

Although it is customary to point out that Landseer paints animals as if they were human, he also treats humans as if they were dogs. We see Grafton and Scratch at dog's-eye level, as if we, the human observers, are also lying on the stone tile floor. Perhaps we are reclining in the opposite kennel? In fact, we look up at Grafton, which increases his stateliness. Scratch, on the other hand, is even closer to the floor than we are, and consequently appears less grand. If we are on the ground with the dogs, who or what are they looking at? Certainly not us. While we look at them, they are looking up and to their right at someone else outside the picture frame. Perhaps it is their master (and ours?), Mr. Bell. We cannot be sure, because Landseer depicts the moment before recognition; the bloodhound's weak eyes are unfocused, and his fine nose has not yet analyzed the scent, while the terrier seems too excited for coherent thought. If we were to title this painting according to the characters of the dogs (and not the emotional responses of human observers), it might be called "Nearsightedness and Excitability."

Whether we see Grafton and Scratch in human terms or doggy ones, Landseer succeeds admirably in capturing the essence of their respective types. Grafton is immediately recognizable as a bloodhound, a breed dating back to the tenth century; Scratch is a little more difficult because he does not resemble the modern Scottish terrier familiar from dog shows and whiskey ads. In his lifetime, any small dog with short legs, wiry hair, and an aggressive temperament was a Scotch terrier. That either animal can be classified at all in this era before breed standards were formally established is because each is a highly specialized working dog. Bloodhounds were bred and trained to track for rescue and hunting; terriers hunted vermin. Such dogs were kept as workers, not pets. Yet here they are in a commissioned portrait, as special and important as the humans posing in paintings around them or standing on the floor staring up at them. They are eloquent testimony indeed to the changing, and indeed confusing, relationships between animals and humans in the first half of the nineteenth century.

**Edwin Landseer**
British, 1802–1873
*Dignity and Impudence, c.* 1839
Oil on canvas
90.2 x 70 cm (35½ x 27½ in.)
Tate, London

**Joseph Mallord William Turner**
British, 1775–1851
*The Evening of the Deluge*, *c*. 1843
Oil on canvas
76 x 76 cm (30 x 30 in.)
National Gallery of Art, Washington, D.C.,
Timken Collection

# Missing the boat

Traditional images of Noah's Ark depict pairs of animals parading peacefully into the ark as Noah and his family make last-minute preparations and storm clouds threaten in the distance. As the biblical story recounts, Noah and his animals weathered forty days and forty nights of rain, and survived to repopulate a cleansed world. The moral of their story is that God punishes the wicked and ensures the survival of the morally fit. In the nineteenth century, however, more and more attention was given to the unfortunate creatures that Noah left behind.

Before eighteenth-century naturalists recognized that the strange shapes discovered in rocks were the fossilized remains of plants and animals, and before nineteenth-century zoologists realized that many of these fossil creatures were extinct, those who missed Noah's boat (and why, and how) had not been a weighty problem. God had defined the humans as unworthy sinners, and it was assumed that representatives of all animal species in Creation had been saved. But as more and more fossils turned up—seashells in the midst of deserts, fish skeletons on mountaintops, giant elks in Ireland, and hippopotami near Paris—it became clear that the surface of the earth had been scoured and rearranged at least once, and possibly many times. Debates over the place of the biblical Flood in earth's history began around 1770 and intensified as more and more fossil animals, in successive geological layers, were uncovered.

For Romantic artists with scientific interests, the combination of horrible prehistoric monsters and cataclysmic environmental disaster (in the mold of the movies *Jurassic Park* or *The Day After Tomorrow*) proved irresistible. The British artist John Martin (see p. 99)—who, not coincidentally, was the friend of an early paleontologist—was the first to incorporate geological evidence into a modern vision of the Flood. These Turner and Doré versions update the theme with the latest paleontological details. In the Turner, giraffes, elephants, and other sketchy beasts seem to evaporate in a cloud of mist, rain, and water as they rush to the distant Ark. The less mobile reptile in the right foreground will hear the door of the Ark slam shut. Its pointed snout identifies it as an ichthyosaur, a marine reptile whose nearly intact, fossilized skeleton had been discovered at a British seaside resort in 1824. Gustave Doré's melodramatic views of the Flood, created for a lavishly illustrated Bible, feature animals whose remains had been discovered in central France or elsewhere in continental Europe. In *The World Destroyed by Water*, giant snakes, a mammoth, some big cats, and two hippolike monsters compete with masses of naked sinners for a few patches of dry ground.[I] The next scene focuses on a mother tiger and the last sinners as the waters rise.[II] Finally, in the scene shown here (vol. 1, plate 8), the Ark comes to rest on Mount Ararat, Noah sends out his messenger dove, and we view a welter of dead bodies, including humans, horses, birds, and another ichthyosaur. In such a manner did conservative thinkers explain the masses of fossilized bones that were being discovered at this time, embedded in earth and rock all around the world.

But there were two major problems that could not be so easily explained away, the resolution of which would concern scientists, philosophers, and religious leaders for decades to come. First, if the earth was six thousand or so years old, as biblical chronologies suggested, how did that compute with the geological and fossil evidence, which suggested it was millions of years old? And second, if some species were dying out, and new ones were being created, how did this happen? Enter Darwin.

**Gustave Doré**
French, 1832–1883
*The Dove Sent Forth from the Ark*,
1865, from *The Holy Bible*, vol. I,
London (Cassell) 1866–70, plate 8
Wood engraving
Carnegie Library of Pittsburgh,
Music and Art Department

---

[I] *The Holy Bible*, 2 vols., London (Cassell) 1866–70, I, plate 6.
[II] *Ibid.*, plate 7.

# "Endless forms most beautiful and wonderful"

The secret of Palissy ware had died with its inventor, Bernard Palissy, in 1590. A Renaissance artisan, Palissy made the first ceramic objects decorated with three-dimensional, naturalistic snakes, fish, insects, lizards, and other repugnant creatures in their natural environments. His achievement required a bizarre imagination; extraordinary skill in modeling, glazing, and firing clay; and patrons who enjoyed the perversity of tableware that is unappetizing to look at and functionally useless. Charles-Jean Avisseau, a French potter, revived the method in the 1840s, more than a decade before Darwin elevated the lowest forms of life into the highest examples of natural law. Avisseau wanted to equal and surpass the greatest of all French potters and to exploit a growing taste in France for Renaissance revival styles that was already visible in costume, literature, and architecture.

There is no evidence that Avisseau, his friends, or competitors read Darwin, studied natural history, or viewed animals as anything but decoration for ceramic ware. But Darwin's famous last paragraph of *The Origin of Species* (1859) exemplifies a new attitude toward the creepy crawlies that may explain why the lower orders of nature appealed so much to later nineteenth-century taste and popular imagination. In Darwin's words:

> It is interesting to contemplate an entangled bank, clothed with many plants of many kinds, with birds singing on the bushes, with various insects flitting about, and with worms crawling through the damp earth, and to reflect that these elaborately constructed forms, so different from each other, and dependent on each other in so complex a manner, have all been produced by laws acting around us. … Thus, from the war of nature, from famine and death, the most exalted object which we are capable of conceiving, namely, the production of the higher animals, directly follows. There is grandeur in this view of life, with its several powers, having been originally breathed into a few forms or into one; and that, whilst this planet has gone cycling on according to the fixed law of gravity, from so simple a beginning endless forms most beautiful and most wonderful have been, and are being, evolved.[1]

Darwin was not the only fascinated observer of the lifestyles of bugs, worms, frogs, and snakes. There were thousands of amateur naturalists in Europe and the United States who, unable to excavate fossils or observe lions and tigers in the wild, turned to their own backyards and country roads for living illustrations of the laws of God and nature. Once they could cheaply acquire large glass bowls and boxes, they brought nature indoors with them. The craze for aquaria and terraria began in the 1850s; one can imagine a Victorian family gazing at spiders stalking their prey through the glass walls of their terrarium, just as we gaze at nature programs on cathode-ray tubes and plasma screens in our dens and family rooms.

Like television nature programs, nineteenth-century Palissy ware includes plenty of blood and gore (if you look carefully). The snake munching on a dead frog in the Langlais plate is a good example; the seafood laid out on the Brard platter is for us. Is this a continuation of the Romantic animal combats staged by Delacroix and Barye (see pp. 90–91)? Or would it be fair to say that, after Darwin, animal combats looked different? They seem to have lost their moral or symbolic meaning. Instead we see the amoral, appetite-driven struggle for survival, and a snake eating a frog is no different from a lion eating an antelope, or a human eating a fish. The Great Chain of Being, which had once organized life-forms according to their nearness to God, gave way to food chains that organized life-forms according to who ate whom.

---

[1] Charles Darwin, *The Origin of Species* [1859], New York (Random House) 1979, pp. 459–60.

**Charles-Jean Avisseau**
French, 1795–1861
Vase, *c.* 1850–55
Glazed earthenware
22.9 x 20.3 cm (9 x 8 in.)

**Léon Brard**
French, 1830–1902
Platter, *c.* 1865–95
Glazed earthenware
30.5 x 20.3 cm (12 x 8 in.)

**Thomas-Victor Sergent**
French, *c.* 1830–*c.* 1890
Large platter, *c.* 1870–80
Glazed earthenware
65.4 x 47.6 cm (25¾ x 18¾ in.)

Opposite (detail):
**Alexandre-Joseph Langlais**
French, 1860–1912
Platter, *c.* 1885–1905
Glazed earthenware
54.4 x 42 cm (21½ x 16½ in.)

All: Marshall and Wallis Katz, Pittsburgh

# Power supply

Rosa Bonheur painted this version of *The Horse Fair* with the assistance of her lifelong companion, Nathalie Micas. One quarter of the size of the first version (1853, Metropolitan Museum of Art, New York), it served as the model for a bestselling reproductive engraving by Thomas Landseer.

From its inception, Bonheur intended *The Horse Fair* to be a major statement. The original version, 16¹⁄₂ ft. (5 m) in width, dominated the walls of the Paris Salon of 1853 and astonished artists and critics alike with its energy, grace, and power. Her choice of subject also made a statement. In 1853, Bonheur had a reputation as a painter of placid rural scenes, and some people had doubted her ability to depict such massive animals in motion in a complex composition. This painting triumphantly proved them wrong.

The horses are Percherons, the largest, strongest, and most beautiful of the French breeds of draft horse, which were bred for power and endurance, warfare, and hard work. Percherons could be seen pulling plows in the countryside and heavy carts in the cities. Bonheur always preferred these massive French horses to the speedier but daintier Thoroughbred of English origin. And she shows them at their absolute best—in peak condition and bounding with energy. In no way would a Percheron be considered a suitable horse for a lady to own, to ride, or to paint. Bonheur depicts them on display and for sale at the weekly horse fair on the boulevard de l'Hôpital near the Salpetrière in Paris. She had dressed in men's clothing in order to visit the fair to make drawings and sketches for the big canvas.

Bonheur also challenged the conventions for women artists by depicting these animals in a

cavalcade. It is the least intimate or domestic subject imaginable. Her admitted model was the superb frieze of Greek horses and riders from the Parthenon, but she must also have drawn inspiration from Théodore Géricault's many paintings of "The Race of the Riderless Horses" (1817), showing heroic youths restraining plunging wild horses. Thus she takes on, and updates, the greatest treatments of the cavalcade from Classical antiquity and French Romanticism. In *The Horse Fair*, she asserts her mastery over the unruly beasts and her male competitors and detractors by painting herself as the rider of the chestnut horse in the center of the parade. Her easy confidence in the midst of this maelstrom of masculine energy is a remarkable feminist statement.

While at work on *The Horse Fair*, Bonheur may not have recognized that her painting celebrates the last great moment of the horse in Western culture. The steam engine was replacing horsepower in mills and factories, and the locomotive was proving itself faster and more efficient for long-distance hauling. The arrival of the internal combustion engine at the end of the nineteenth century would reduce these mighty animals to obscurity and pet food. Yet even now, these horses and this painting continue to symbolize motive power deep into the age of automobiles, bullet trains, and airplanes.

**Rosa Bonheur**
French, 1822–1899
and **Nathalie Micas**
French, 1824–1889
*The Horse Fair*, 1855
Oil on canvas
120 x 254.6 cm (47¼ x 100⅜ in.)
National Gallery, London

# Political animals

A hunted deer will seek water instinctively. Scent will not carry in water, so a deer that crosses a stream or lake will elude pursuing dogs. A deer unable to run further will also seek water, high rocks, or a dense thicket. Then it will turn to face the wolf, or the hounds and hunters, with antlers lowered in self-defense. It is the critical moment of the hunt. The stag in this painting is exhausted. Its gasping mouth and rolling eyes suggest that it has been running for hours to escape the pack in the distance. There is no rider in sight to sound the "*sonne à l'eau*" (gone to water) call that would bring the hunters rushing in, so perhaps this one will escape.

It would be tempting to interpret this dramatic scene as an expression of sympathy for the deer. Anti-blood sport activists have dramatized the agonies of hunted animals for over a century, and one can imagine that Courbet, a political radical, would empathize with the victim of this aristocratic pastime. But this is not the case. Raised in rural Franche-Comté, Courbet was an enthusiastic hunter who described shooting a twelve-point stag, like the one portrayed here, as a high moment in his life. When he wrote to his friends about his hunting scenes, he claimed to be capitalizing on the current French taste for English-style animal paintings in the vein of Edwin Landseer—another enthusiastic hunter, who had treated the same subject in a like manner (*Deer and Deerhounds in a Mountain Torrent*, before 1833, Tate, London).

Because Courbet knew deer hunting firsthand, the painting's inaccuracies raise the possibility that it may indeed carry some personal or political meaning, despite his disclaimers. One problem concerns the season and the stag's antlers. Courbet painted a spring landscape, but in spring, deer have no antlers. Antlers are shed each winter, bud in spring, grow and harden over the summer, and become weapons in the fall rutting battles. This animal is out of sync with its environment. Perhaps Courbet wanted an attractive backdrop for his stag, but his choice of a Franche-Comté setting lends a personal note. Symbolically, spring foliage suggests that the death of the animal is connected to a new beginning.

Another problem concerns the nature of the hunt portrayed. Courbet shot his twelve-point stag while hunting on foot, with a rifle, and assisted by beaters who flushed out the game. The hunt he depicts here is of an archaic aristocratic form, in which dogs and horsemen pursue the stag to the bitter end. Courbet had observed such a hunt, but never participated. Nevertheless, in an equally large painting entitled *The Huntsman Calls "Gone to Water,"* paired with *Stag Going to Water* in the Salon of 1861, Courbet portrayed himself in hunt livery dashing to the scene. In a way, this painting completes the story of the hunt; we know now that the stag will most likely die. But what did Courbet intend by it? Perhaps it is a dressed-up re-enactment of the glorious moment when he, a mere artist, bagged his stag under the noses of the hunt's aristocratic and wealthy patrons. Or, is he predicting a time when workers (including artists and hunt servants) will seize aristocratic privileges? Alternatively, is the doomed stag a symbol of the fate of the aristocracy itself, to be done in by ambitious revolutionaries like Courbet?

**Gustave Courbet**
French, 1819–1877
*Stag Going to Water*, 1859–61
Oil on canvas
220 x 275 cm (86⅝ x 108⅜ in.)
Musée des Beaux-Arts, Marseille

# Who's for dinner?

Mariner [to Antigonus]: Make your best haste, and go not
　　　　　　　　　　　Too far i' the land: 'tis like to be loud weather;
　　　　　　　　　　　Besides, this place is famous for the creatures
　　　　　　　　　　　Of prey that keep upon't.
　　　　　　　　　　　(Shakespeare, *The Winter's Tale*, Act III, Scene 3)

Like Antigonus in Shakespeare's play, the British mariner Sir John Franklin ignored this excellent advice—but came to a much worse end. In search of the Northwest Passage, Franklin's expedition disappeared in the snow and ice of the Canadian Arctic in 1847. Its fate was a mystery and a scandal for decades afterward. Search parties found no survivors. Inuit witnesses reported cannibalism, but such practices were unthinkable for civilized Englishmen. An American expedition sent north in the 1850s had little to report, although an artist on the voyage, Frederic Edwin Church, made some oil sketches for a future masterpiece. More would-be rescuers located some ghastly relics of Franklin in 1859, notably a lifeboat mounted on wooden runners that contained supplies and two skeletons. One skeleton was fully dressed,

seated, and armed with guns; the other was a jumbled wreck. The discoverers thought the broken skeleton might have been torn apart by wolves.

Frederic Church turned his oil sketches into a magnificent painting, *The Icebergs* (Dallas Museum of Art), which he displayed to critical acclaim in London in 1863. For the London showing he added some wreckage, alluding to the Franklin voyage and contrasting the British failure with the survival of the American expedition. Britain's foremost animal artist, Edwin Landseer, responded to this competitive challenge. *Man Proposes, God Disposes*, just as grand as Church's painting, concentrates on the enigmatic skeletons in the lifeboat. Landseer imagined the boat as an improvised shelter and added the faded tatters of a Union Jack, a blue jacket, and a telescope. Polar bears, drawn from animals in London zoo, tear into the scenery. Landseer may have been thinking of Shakespeare's famous stage direction from *The Winter's Tale* at the very end of the scene quoted from above: "Exit, pursued by a bear." Perhaps polar bears had mangled the bones. Dinner for two?

We now know that if wolves or bears had been there, they were cleaning up after the party. Subsequent investigators found more human bones as they retraced the paths of the doomed men. Modern forensic examiners identified knife marks on the bone and patterns of dismemberment indicating that the edible parts were kept, and the less nourishing bits (feet, for example) discarded. The jumbled skeleton in the lifeboat probably belonged to the next-to-last survivor, who provided a final meal for his well-dressed and well-armed companion. Dinner for one!

Today, this painting would seem to illustrate Darwin's principles of natural selection as laid out in *The Origin of Species* (1859). It clearly demonstrates the advantages of adaptation to the environment (polar bears do better than humans in the Arctic) and the deadly consequences of competition for limited resources (starvation and death). But *Man Proposes, God Disposes* is a strange title for a Darwinian subject. Landseer's title asserts that God, not natural selection, determined the outcome of the Franklin voyage. But if not a Darwinist himself, Landseer lived in Darwinian times. In the highly competitive London art world, only a major success against rivals like Church would ensure his survival on the top of the heap. Likewise, the American competition against Britain for new trade routes and territories, which spurred on Franklin in the first place, was a cold-blooded race for international dominance. Today, we casually describe the losers of these Darwinian struggles as "dinner."

**Edwin Landseer**
British, 1802–1873
*Man Proposes, God Disposes*,
1863–64
Oil on canvas
91.4 x 243.8 cm (36 x 96 in.)
From the Picture Collection, Royal Holloway, University of London, Egham, Surrey

# A walk on the bottom of the sea

**Edouard Lièvre**
French, 1828–1886
Fish bowl on stand, *c.* 1875
Bronze, glass
149 x 75 x 60 cm
(58¾ x 29½ x 23⅝ in.)
Private collection, Paris

■ In public aquariums, the fish tanks were generally put in the walls, lit from above, and sometimes even framed like paintings. Looking at an aquarium was like looking at a moving work of art. Some people were privileged enough to put a glimpse of this fascinating world into their homes. This fish bowl was made at a time when a goldfish was still a luxury item. The poor creature, however, would not have enjoyed the elaborate design of its support, which is clearly inspired by Asian art. The maker, Edouard Lièvre, was one of the most successful—and most expensive—decorative artists of his generation. Celebrities such as the actress Sarah Bernhardt were among his clients. ■

"And now, how can I retrace the impression left upon me by that walk under the waters? Words are impotent to relate such wonders!" So declares Jules Verne in his magisterial novel *Twenty Thousand Leagues Under the Sea*, published in 1869–71 as a series. The novel found a receptive audience for its evocative descriptions of underwater wonders:

> It was then ten in the morning; the rays of the sun struck the surface of the waves at rather an oblique angle, and at the touch of their light, decomposed by refraction as through a prism, flowers, rocks, plants, shells, and polypi were shaded at the edges by the seven solar colors. It was marvelous, a feast for the eyes, this complication of colored tints, a perfect kaleidoscope of green, yellow, orange, violet, indigo, and blue; in one word, the whole palette of an enthusiastic colorist!

Obviously, Verne needed the terminology of a painter to describe the fantastic, hitherto unseen, submarine world.

A visit to an aquarium is still one of the most popular family entertainments. The smooth movements of fish, their extraordinary colors, and the strange shapes of the many different kinds of invertebrate make us gaze in wonder at the miracles nature has designed. Imagine now a visit to the world's first aquarium, the "Fish House" at Regent's Park in London, on its opening in 1853, when none of these creatures had ever been seen alive and in public. Previously you could see only dead fish in the market, perhaps a few live ones in a pond and, if you were really privileged, colored illustrations in books.

One scientist made the daring attempt to paint an underwater landscape. The picture shown here is the first modern view of an underwater landscape ever made. The artist, Eugen Ransonnet-Villez, was an Austrian baron, diplomat, and traveler. After making some sketches in the Red Sea, he traveled to Ceylon (Sri Lanka) to make this study. But how did he do it? Museum sources relate that he made drawings directly from nature while sitting on a bench inside an underwater bell that was anchored to the ground. (The bell was of Ransonnet-Villez's own design.) Back in his studio, he made this painting, based on those drawings and others he had made in aquariums.

For a first try, the painting is a very convincing effort to render the scene realistically. The refraction of light under the sea, the shadows, and the small numbers of fish give a lifelike impression. It would seem that Ransonnet-Villez resisted the attempt to exaggerate what he saw. In this way, he acted more as a scientist making a painting than an artist attempting science.

**Eugen Ransonnet-Villez**
Austrian, 1838–1926
*Underwater Landscape*, 1864
Oil on canvas
50 x 70 cm (19¾ x 27½ in.)
Naturhistorisches Museum, Vienna

# Holy cow

Jean-François Millet grew up in a tiny village in Normandy and never lost his affinity with the rural environment. We may thus assume that his many pictures of rural life are based on direct observation. And indeed, this painting records a scene he saw in 1854, when he visited his home region. Millet by this time was living in the artists' colony of Barbizon, having fled the French capital.

Oddly enough, it took Millet ten years to finish the canvas. A number of surviving sketches underline the care with which he prepared the composition. When the painter finally presented the work to the 1864 Salon exhibition, reactions were mixed at best. Since Millet usually did more than just naturalistically record a scene, the critics did not believe that this one was based on real life. Some ridiculed the peasants, who walked as if in a procession. The calf is resting on a litter with a bunch of straw, evoking the humble birth of Christ. An interesting comparison can be made with Oudry's bitch and puppies of a century earlier (see p. 46). Here, too, the skinny mother (the cow) is showing her feelings, by licking her offspring lovingly. Since Millet's scenes of the countryside were peopled with pious farmers and loaded with suggestions of Christian allegory, why not here also?

When Millet was confronted with the negative reviews, he reacted in a letter to his friend and future biographer Alfred Sensier. Interestingly, he stresses the realism of the scene, blaming the critics for not knowing anything about life on a farm. Millet rejected the criticism of exaggeration and artificiality by pointing out that the posture of the farmers carrying the calf was based on the laws of gravity and nothing else.

Millet certainly had a point when he stated that the public had no idea about life in the country. How could they? Paris was a huge metropolis, and during the course of the nineteenth century the elements that linked city-dwellers to the countryside were slowly but surely

**Charles-François Daubigny**
French, 1817–1878
*Sunset, c.* 1871
Oil on canvas
103 x 203.5 cm (40½ x 80⅛ in.)
Museum Mesdag, The Hague

■ The sun goes down over fields that seem to stretch on forever. No human settlement is in sight. Two cows are silent witnesses of the ordinary yet extraordinary beauty of this natural phenomenon. The way Daubigny has placed the cow on the right—which is seen from the back and crossing the horizon—both heroizes the animal and invites the beholder to identify with it. It is an old compositional trick used by many painters before him, but not usually for cattle. As in the case of Rosa Bonheur's *Horse Fair* (see pp. 108–109), this canvas can be interpreted as a poignant evocation of the pleasures of rural life at a time of rapid industrialization. ■

**Jean-François Millet**
French, 1814–1875
*Peasants Bringing Home a Calf
Born in the Fields*, 1864
Oil on canvas
81.6 x 100 cm (32⅛ x 39½ in.)
The Art Institute of Chicago,
Henry Field Memorial Collection

Jan Stobbaerts
Belgian, 1839–1914
*The Butcher's Shop*, c. 1890–1900
Oil on canvas
104.5 x 151.5 cm (41¼ x 59½ in.)
Koninklijk Museum voor Schone
Kunsten, Antwerp

■ Artists often show us peaceful scenes with cows and calves living out their quiet lives, but they hardly ever confront the public with the fate of cattle dying under the butcher's knife. This is a rare example of a painting that shows the act of slaughter. When it was made, most slaughtering had already been (semi-) industrialized. We should remember that the assembly line that Henry Ford invented for the automobile was inspired by the "dis-assembly" lines of the Chicago slaughterhouses. Ford simply reversed the process in order to divide labor more efficiently. Here, the Belgian animal painter shows us a more primitive method. The animal seems to look at us with its last gaze, inviting us to sympathize with the poor creature. ■

disappearing. In 1810, a Napoleonic law decreed that abattoirs be moved outside the city. Private butchering was banned in 1838. Canned food had been developed even earlier, and by the 1860s Louis Pasteur was beginning to improve the hygiene of agricultural products. The smell of the stable was blown out of the towns.

It seems that Millet's success was at the same time his curse. Urban folks loved the countryside and bought paintings with representations of a pre-industrialized world. But they also lost the experience to judge the authenticity of the images. City people had always looked down at the apparently uncultured life of farmers. They found it repellent that they should not only care for their animals but live close by them, as is so clearly reflected in this work.

Another painter who grew up in a village was Vincent van Gogh. As one of the most ardent defenders of Millet and his sentimentality, he praised *Peasants Bringing Home a Calf Born in the Fields*, of which he had seen a sketch. In a letter to his friend Emile Bernard, Van Gogh spoke of Millet's power "that makes one tremble."

# Beauty is in the eye of the beholder

Thomas Couture, a celebrated painter in his time, presents us with an artist he calls a "Realist." According to him, a member of that movement prefers to study the head of a pig rather than the head of an Antique sculpture. For the Realist, the head of Jupiter better serves as an improvised seating opportunity than as a subject for painting.

In the eyes of Couture, it is an outrage to prefer a pig's head to the relics of antiquity. Sitting on Jupiter amounts to artistic blasphemy. Couture is commenting on the emerging movement of rebellious painters who focused on the banalities of real life. He had a point: many of his colleagues were becoming increasingly less interested in representing the glories of past ages. The evolutions and revolutions of early industrialization had directed attention toward much more pressing issues, such as the situation of the lower classes. The Realists also responded to market forces. A new class was interested in art. This class of practical people earned their money themselves and cared little for the triumphs of nobility or stories of ancient times that had limited relevance to the modern world.

Couture's comparison of a pig with Jupiter raises questions about definitions of beauty. For centuries, the gods and goddesses, idealized and eternalized by the Greeks and Romans, had served as the principal aesthetic models. A pig's physiognomy represented the extreme opposite and was associated with biblical abominations.

In order to criticize the Realists, Couture had to paint a pig's head realistically, a task in which he succeeded admirably. For a painter, the degree of difficulty involved in representing a human face or a pig's head is fairly similar, although conceivably it is more difficult to paint a pig because the subject-matter is less familiar than human portraiture.

It is possible that the ever-growing fashion for the natural sciences contributed to a change in public taste. The illustrations in Buffon's *Histoire naturelle* (1749–88) put every animal on a pedestal, from the noble lion to the modest hamster. Scientists cataloged all living creatures and taught us to look at each and every one of them with equal appreciation. In a way, they sanctioned the careful observation of what was considered ugly. The study of insects, reptiles, and micro-organisms radically broadened the spectrum of what is regarded as beautiful. Much to Couture's dismay, natural beauty had finally started to be in the eyes of the beholder.

**Thomas Couture**
French, 1815–1879
*A Realist*, 1865
Oil on canvas
46 x 38 cm (18⅛ x 15 in.)
Van Gogh Museum, Amsterdam

# Jealousy

"It is sunrise on the savanna. All the animals gather at Pride Rock to see Mufasa, the Lion King, and his queen, Sarabi, introduce their newborn son, Simba. Meanwhile, Mufasa's wicked brother, Scar, laments the unfairness of his life. He resents the new prince and the cub's status as next in line to be king—a job he covets for himself." Thus begins the plot outline for Walt Disney's *The Lion King*, on the corporation's official website. Jealousy in the animal world—surely this must be another fairy tale about four-legged creatures with a human touch. But before we start tracing the roots of such stories back to the fables of Aesop or La Fontaine, we should note that the existence of jealousy in the animal kingdom is a widely accepted fact. We are not merely interpreting animal behavior with human eyes: jealousy is something we inherited from our animal forebears, and it has helped to reinforce the process of natural selection that made us what we are.

This painting by the celebrated German animal painter Paul Meyerheim may thus be belittled as anecdotal, but it was most likely based on real observation. We can only guess, however, the identity of the woman who is causing distress to the lioness. A likely candidate is the female star among animal trainers in the late nineteenth century, Claire Heliot (1866–1953). Born Cläre Pleßke in Halle, Germany, the daughter of a postal worker, she was employed at Leipzig zoo and later became an international celebrity with her lion acts. We do not know whether she really is portrayed here, was employed as the model for the composition, or has nothing to do with the picture, but a well-known quotation by her at least fits the subject: "People have always disappointed me! My most faithful friends, they were my—lions."

The painting tells more than just the story of an intimate relationship between a human and two animals. The close-up view emphasizes the two areas of action, in front of and behind bars. Meyerheim allows us to get so near to the cage that the iron barrier is a comfort to us as well as to the trainer. It is interesting to compare this apparent non-composition with the theatricality of similar scenes in the paintings of Edwin Landseer (see pp. 112–13). Representations of big cats in the wild perhaps make an even more revealing comparison (see p. 124). With all of these paintings, we can ask ourselves whether they are based on the observation of nature, the observation of animals in captivity, or just on earlier paintings or photographs. In contrast to his predecessors, we can at least credit Meyerheim with trying to give us an unaffected view of a real scene. Although the action takes place within the confines of a narrow cage, it represents a significant move toward the current fashion for looking at animals as they exhibit their natural behavior.

Paul Meyerheim
German, 1846–1915
*The Jealous Lioness*, *c*. 1880
Oil on canvas
49.8 x 69 cm (19½ x 27¼ in.)
Das Städel. Städelsches Kunstinstitut
und Städtische Galerie, Frankfurt am Main

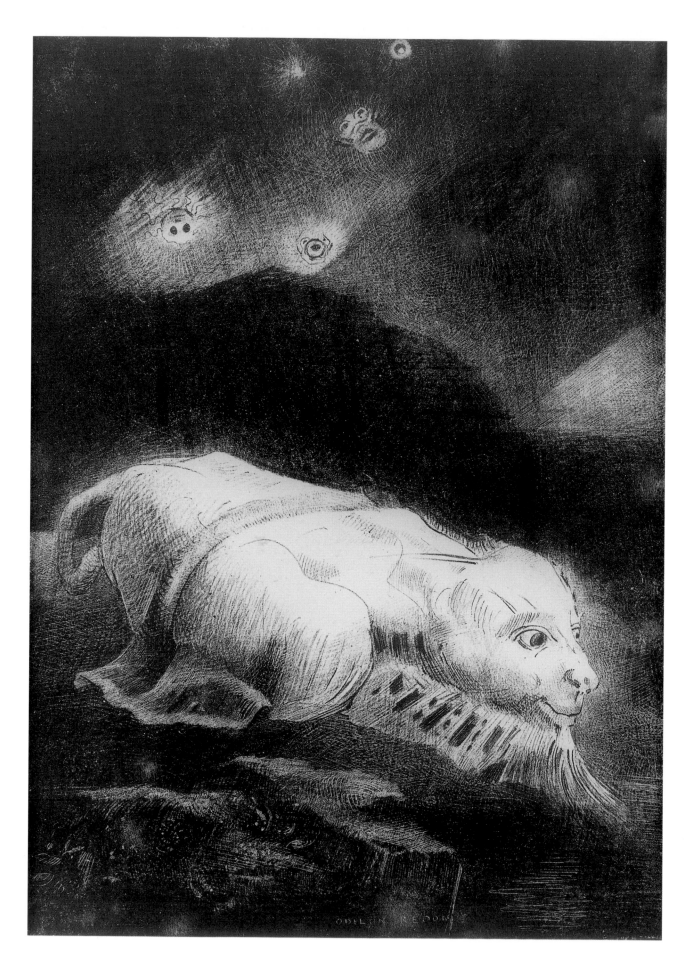

# Primeval slime

**Jean Carriès**
French, 1855–1894
Frog with rabbit ears, 1891
Stoneware
34.4 x 26.8 x 41 cm
(13½ x 10½ x 16⅝ in.)
Musée du Petit Palais, Paris

■ Jean Carriès is certainly one of the most original artists of the nineteenth century. He created an entire world of strange figures and beasts. Inspired perhaps in part by medieval bestiaries, his mixed-up animals really do not follow any tradition at all. The accuracy of the details found in his beasts is undermined by their bizarre combinations: a frog with the ears of a rabbit, or a toad with a fish tail. It is as though the taxidermists have taken a day off and decided to have fun. Carriès, however, was a serious artist, and it may be that he created these creatures in order to play a witty game with the theory of evolution. If natural selection is the cause of changes, why should a frog not have the ears of a rabbit in order to hear better? And would a toad not swim faster with a fish tail? Is Carriès merely suggesting improvements? What would his animals' chances of survival be? ■

**Odilon Redon**
French, 1840–1916
*When Life Was Awakening in the Depths of Obscure Matter*, 1883, from *Les Origines*
Lithograph
27.3 x 19.8 cm (10¾ x 7¾ in.)
Van Gogh Museum, Amsterdam

When it dawned on scientists—and in due course the general public—that evolution was not only a historic fact but also based on natural selection, many people realized that the Creation as narrated in the Bible could not have taken place. Another unsettling notion was the instability of evolution. All of a sudden, Creation was open-ended. This discovery was extremely disturbing and did not, of course, remain unchallenged. If true, the evolution of life on earth had neither a divine plan nor a fixed direction; indeed, anything could have happened. Following on from the encounter with exotic animals, the surfacing of strange underwater creatures, and the explanation of fossils, the theory of an evolution based on natural selection further undermined many cherished beliefs.

Open minds, however, took advantage of the new possibilities that these exciting revelations had to offer. Darwin's theories opened the door to a whole new view on nature, and a few artists dared to give their imagination free range. Odilon Redon was a friend of the botanist Armand Clavaud in Bordeaux, and visits to the local natural history museum intensified Redon's fascination with the great variety of plants and animals. The proposed instability of all living forms must have interested him greatly. Darwin's *The Origin of Species* was translated into French soon after its first publication in 1859. It took a while to gain acceptance, but sources indicate that Redon was deeply impressed by the findings of the English scientist. His reading of Darwin helped him go beyond the influence of the earlier writings by the great French naturalists le comte de Buffon and Georges Cuvier, who either believed in an evolution by successive catastrophes or remained faithful to the fixity of species.

In 1883, Redon published his own "origins," *Les Origines*, an album of eight lithographs. A highly original interpretation of the creation of life, Redon's album is one of the few direct artistic responses to Darwin. Before we look at the image, it may be worthwhile to reflect further on the impact the theory of natural selection would have had on the sensitive mind of an artist who was searching for both explanation and inspiration. Redon and his late nineteenth-century colleagues had witnessed profound changes in the world around them: the end of the ruling aristocracy; the struggle of the working classes; an enormous growth in general knowledge; the increase in speed of transportation and information; rapid urbanization; and certainly the end of the belief in any fixed rules in art. Evolutionary theories were the last blow to an already crumbling world. Decadence, drugs, occultism, and travel to exotic places were only some of many ways to escape from the confusion and to find a niche that might provide some spiritual comfort. Redon's interests crystallize many of these tendencies. His work is a cosmos of creative inventions that are all his own.

If we now take a closer look at the beast in Redon's lithograph, we see it is a highly original mixture of existing animal features. The friendly face recalls that of a lion, but with human lips. The beard may be that of a goat. It has no legs but seems to move forward on the ground like a ray fish. Does he or she have wings as well? There is also a strange separation of the main body, as if of an insect. Finally, the tail could be that of a lion again. But debate as we might about the sources of this creature, this is not what Redon intended us to do. He carefully avoids similarities with fantasy animals of earlier ages. Instead he wants his creature to be as original as possible, to look, as the title implies, like something that has awakened "in the depths of obscure matter." This, of course, is not to be taken literally. As the artist himself said, "I am not at all a Darwinist, because I make art not science." But thanks to Redon's inventions, we may be grateful to Darwin, too, for having opened our imaginations as well as our minds.

# Domesticated cats

From painters to cinematographers, all animal artists want to persuade us that their images are real. Disguising their artistry and hiding their technical limitations, they focus on a creature's most important characteristics so that we will accept the image more readily. It is easy to think of these "important characteristics" as timeless. But definitions of what is "important" have changed according to what can be seen and represented, just as notions of what is "characteristic" of humans and animals have also changed over the last three centuries. And each change exposes anew the artificiality of all animal art.

Eighteenth-century artists worked mostly from a stuffed model or from another image, so they were limited to featuring basic physical traits. Nineteenth-century painters observed sedentary animals in zoos or menageries. Rosa Bonheur studied Pierrette, a lioness residing in a Paris dwelling (Pierrette liked to hide under beds to surprise people), and later the artist kept lions at her chateau, releasing them in the courtyard when she wished to draw them. The painting on her easel may represent Nero and Fathma, her two favorite pets. Both Bonheur and Jean-Léon Gérôme frequented the Jardin des Plantes, Paris's zoo, where animals in small cages could only sleep or pace. Because lions and tigers do sleep much of the time, even today we can accept as "natural" scenes that have been concocted from studies of caged beasts. However, careful examination of "wild" animals in nineteenth-century art will almost always reveal poses and behavior typical of the zoo exhibit or the domestic pet. Placing the right animal in a natural setting can also enhance a picture's realism if done well. Gérôme's *Night in the Desert*

**Jean-Léon Gérôme**
French, 1824–1904
*Night in the Desert*, 1884
Oil on canvas
55.9 x 100.3 cm (22 x 39½ in.)
Carnegie Museum of Art, Pittsburgh,
Gift of the Thomas H. Nimick, Jr.
Family in memory of Florence
Lockhart Nimick

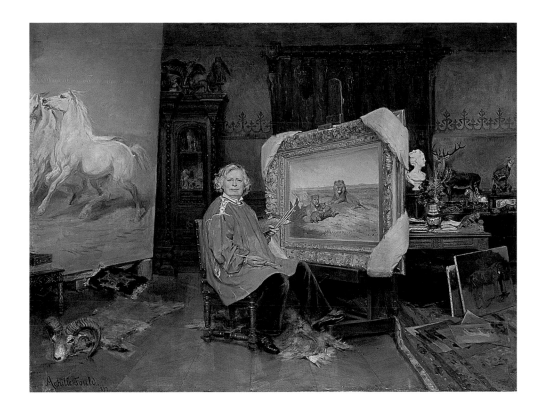

is a most beautiful painting, and the tiger is convincing. But the cubs lack stripes, and these jungle creatures rest near a desert water hole, an impossible scene. Bonheur's lions recline in terrain that is meant to be African but might just as well be French.

A subtle change has taken place, however, in the portrayal of wild animals as social beings. Darwinism (by emphasizing animals' competition for survival) and psychology (by analyzing animal emotions and social relationships) encouraged this important trend in science and art. There are no faked combats for Gérôme or Bonheur, instead we see a majestic lion and his mate, and a mother tiger contemplating her frolicking cubs. At first these groupings seem normal, but in nature, lions live in large groups, not mated pairs, and a tiger would not so expose her cubs. Our painters have substituted new sentimental fantasies (carnivores as domestic paragons) for the old romantic ones (carnivores as unbridled forces of primitive violence).

Artists led the way in creating this late nineteenth-century vision of animal life and psychology. Taxidermists followed suit with displays now known as "happy families." In these, animals enact the traditional human ideal, in which a fiercely protective or providing male and a gentle, complacent female nurture the young, all presented in a transparent glass case to enhance the illusion that we are observing a real scene. Fortunately, this more human/humane conception of animal behavior also inspired zoo reform. Carl Hagenbeck's innovative animal park in Stellingen, near Hamburg (1907), consisted of large, open-air displays in which animals isolated by moats seemed to roam and interact freely. The cage bars were finally gone, replaced by ever more subtle and believable artifice.

# Prehistory painting

Paul-Joseph Jamin's vision of prehistoric hunters fleeing from a mammoth may be unique in nineteenth-century art. What other nineteenth-century painting of men and animals shows the animal with the upper hand? While the end result is comical, Jamin's defiance of the heroic conventions of history painting is grounded in the paleontological and evolutionary science of his time.

In 1799, a frozen mammoth with skin, hair, and some of its flesh intact was discovered in Siberia and widely reported in Europe. Charles Willson Peale discovered his mastodon in 1801 (see pp. 68–69), and Georges Cuvier identified both as extinct elephants. Then in 1825 human bones were found with mammoth remains in Britain, and in the Dordogne (France) a piece of mammoth ivory engraved with an image of a mammoth turned up in 1864. There could be no doubt that humans and mammoths once coexisted, and that human history predated Genesis by many thousands of years. Charles Darwin published *The Origin of Species* (1859) and *The Descent of Man* (1871), and the controversy over human evolution took off.

Artists gave form to this controversy. At first in illustrations for popular periodicals and didactic books, and later in major paintings such as this, they attempted to imagine life in a prehistoric world suddenly full of people. Jamin consulted experts on prehistory for details of dress, weapons, environment, and local fauna. He got some important details right: the snowy, Ice Age landscape, and the hunters' fur clothing and primitive clubs and axes, for example. But others are wrong. Jamin modeled his mammoth's head on the broad, flat skull of the modern elephant, not the high-domed shape of the mammoth. And the great tusks curve outward, not inward, because mammoth experts would not get the tusks right until around 1899.

Jamin's mammoth shows no fear of the tiny bipedal creatures: it seems more curious than aggressive. The humans, by contrast, are terrified. Perhaps this is their first encounter with the shaggy monster; their facial expressions and headlong flight suggest panic. The effect is a comic reversal of our expectation that mankind will dominate. But even here Jamin may be attempting to depict the primitive character of prehistoric peoples realistically. Like many students of early humans, including Darwin, he insinuates that these lowly types lack the courage and the technology for confronting a mammoth. Today we think differently, and the idea of human perfection seems dated and optimistic. Looking back over the mass extinctions for which we are responsible, it appears likely that the mammoth may have been one of our first victims.

**Paul-Joseph Jamin**
French, 1853–1903
*Flight from the Mammoth*,
1885
Oil on canvas
125 x 93.5 cm
(49¼ x 36¾ in.)
Muséum National d'Histoire
Naturelle, Paris

# Funny bones

When anatomists started to compare bones, they found out that most vertebrates had a lot in common, indeed almost everything. All that was needed was to distinguish the forms and put everything in the right place, and then most bones could be given the same name. In order to clarify this for their students, teachers of anatomy found a way of coloring certain bones so that the position and the shape could easily be compared in different animals. This striking example is the skull of a hippo, painted for the faculty of veterinary science in Alfort near Paris.

In this book, we have seen all sorts of ways of visualizing the animal world: skeletons and stuffed animals; paintings, sculptures, and photographs; glass and papier-mâché models; illustrated books; and more. Eugène Petitcolin developed yet another manner of representing animals or their parts. Working also for the faculty of veterinary science at Alfort, he conceived a stable and instructive way to preserve animal organs.

Take this example of a lion's liver. The anatomist would dissect the organ, which would then be prepared with fat and put into liquid plaster. After the plaster had hardened, the organ would be taken away, leaving behind the mold for later casts. Petitcolin painted the final cast in natural colors. The result was a polychrome bas-relief model.

Petitcolin was obviously proud of his achievements: he not only framed his organic sculptures but signed and dated them as well. A hundred years later, they look rather like three-dimensional abstract paintings—something of which their maker could not, of course, have conceived. What is interesting, however, is that the scientist proudly turned the anatomical model into an artwork—or, at least, something that should be admired as one.

**Eugène Petitcolin**
French, 1855–1928
Model of a lion's liver, *c.* 1883–1910
Plaster
68 x 55 x 7 cm
(26¾ x 21¾ x 2¾ in.)
Musée Fragonard, Ecole Nationale
Vétérinaire d'Alfort, Maisons Alfort

**Colored skull of a hippopotamus**
19th century
Musée Fragonard, Ecole Nationale
Vétérinaire d'Alfort, Maisons Alfort

# Van Gogh on animals

Landscapes, flowers, and peasants may come to mind when we think about Vincent van Gogh's favorite motifs, but animals also played a major role in his œuvre. When starting out as an artist, he consulted the standard treatises, which recommended the study of animal anatomy. Horses, in particular, were needed for history paintings, traditionally the most important genre. Although largely self-taught, Van Gogh received some training in the atelier of Fernand Cormon in Paris. From this period, the Van Gogh Museum possesses the plaster cast of a horse and the oil sketch that Van Gogh made after it. (The cast, incidentally, is based on a horse painting by the leading academic painter Jean-Léon Gérôme.)

Van Gogh often used whatever models and objects were to hand to create color studies. This was probably the case with both *Kingfisher* and *Crab on Its Back* (see p. 130). The coloration of the bird was a welcome starting point for the Dutchman, who had only recently been exposed to the experiments of the Impressionists. The painter worked from a stuffed bird, which explains the kingfisher's unnatural position and incorrect colors. The crab, meanwhile, is depicted in striking hues of red and blue.

Some time later, during his stay at the asylum in Saint-Rémy, Van Gogh became fascinated by a moth (see p. 131). On May 23/24, 1889, he wrote to his brother Theo about the "wonderfully fine colors, black, gray, a nuanced shade of white with a red sheen that, instead, sometimes seems to be olive green; it is very large. To be able to paint it, I had to kill it, and that was a pity with such a beautiful beast." A minor problem is that Van Gogh thought it was a Death's head hawk moth (*Acherontia atropos*). Art historians, not always known for their

**Model of a horse**
*c.* 1870–80
Plaster
10 x 25 x 26 cm (4 x 9¾ x 10¼ in.)
Van Gogh Museum, Amsterdam
(Vincent van Gogh Foundation)

**Vincent van Gogh**
Dutch, 1853–1890
*Plaster Figure of a Horse*, 1886
Oil on cardboard
33 x 41 cm (13 x 16⅛ in.)
Van Gogh Museum, Amsterdam
(Vincent van Gogh Foundation)

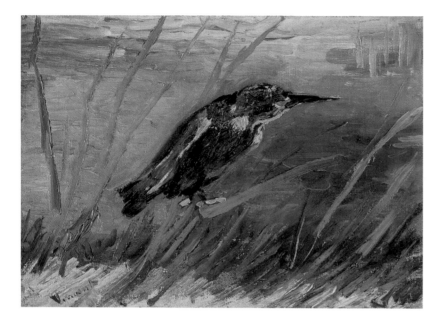

Vincent van Gogh
Dutch, 1853–1890
*Kingfisher*, 1887
Oil on canvas
19 x 26.5 cm (7½ x 10½ in.)
Van Gogh Museum, Amsterdam
(Vincent van Gogh Foundation)

**Stuffed kingfisher**
Van Gogh Museum, Amsterdam
(Vincent van Gogh Foundation)

Vincent van Gogh
Dutch, 1853–1890
*Crab on Its Back*, 1889
Oil on canvas
38 x 46.5 cm (15 x 18⅜ in.)
Van Gogh Museum, Amsterdam
(Vincent van Gogh Foundation)

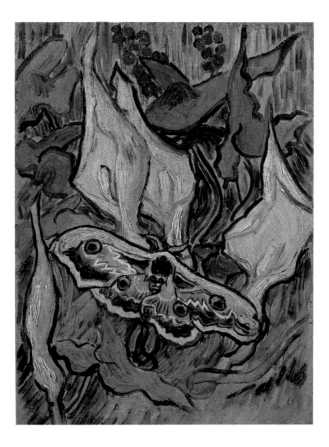

zoological skills, have sometimes corrected him, claiming that it is an Emperor moth (*Pavonia pavonia*). Close examination and probability, however, would seem to favor its identification as a Great peacock moth (*Saturnia pyri*).

In one of his last works, perhaps even his very last, Van Gogh returned to the subject of animals. In *Crows in a Wheat Field*, a flock of black birds rises into the sky. Each bird is rendered with only two strokes, the most minimal way of representing an animal. After studying animals in natural history cabinets or in nature, and after using them as a pretext for color experiments, Van Gogh now reduces the bird to its very essence. Two brushstrokes suffice to "be" a living animal.

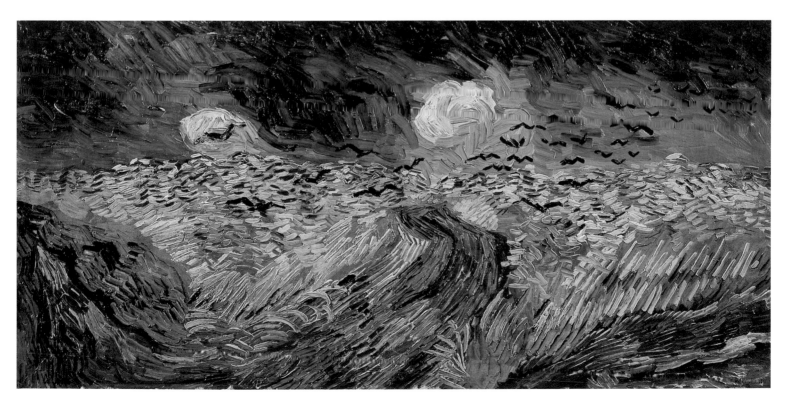

# Fast machines

Before the twentieth century, transportation on land depended almost entirely on the speed and strength of horses. For this reason, analysis of the motion of the horse preoccupied everyone from governments to racehorse owners. Artists were given the impossible task of representing actions that occurred too fast for the unaided eye to see. Then in the 1870s, Eadweard Muybridge and his French contemporary Etienne-Jules Marey (1830–1903) solved the problem almost simultaneously. By inventing new chemical processes and extremely fast camera shutters, they were able to photograph horses, humans, birds, and other creatures in motion. Today, historians view Muybridge's 1872 photographs of a trotting horse with all four feet off the ground as the technical breakthrough that led to moving pictures. Marey's images of athletes, animals, and birds inspired twentieth-century artists to portray the dynamism of modern life in segmented, time-sequenced images; these were the origins of Cubism, Futurism, and Dada. Photographs of animal motion became the foundation stones of modern culture.

It is surprising, therefore, to realize that the sponsors of these projects supported ideas about animals that dated back to the eighteenth century or earlier. In 1882, J.D.B. Stillman, a physician and friend of Muybridge's patron Leland Stanford, wrote the introduction to *The Horse in Motion as Shown by Instantaneous Photography*, the first comprehensive publication of Muybridge's work. Stanford paid for the publication, and it seems to reflect his ideas about animals and nature. A chapter entitled "The Horse Considered as a Machine" looks at the horse's bones and muscles as moving mechanisms—a way of thinking about animals that had died out in the eighteenth century, but which seemed to be undergoing a revival at the onset of the machine age. In his introduction, Stillman asserts his belief that an intelligent divine creator, whose fixed laws governed the organic world, has designed this "complicated mechanism" (the horse, not the camera). There are no deistic "laws of nature" or, even worse, atheistical "laws of evolution" for Dr. Stillman. In the end, these nineteenth-century animal motion studies are even more old-fashioned in intent than George Stubbs's eighteenth-century comparative anatomies (see pp. 64–65). Only the technology was modern.

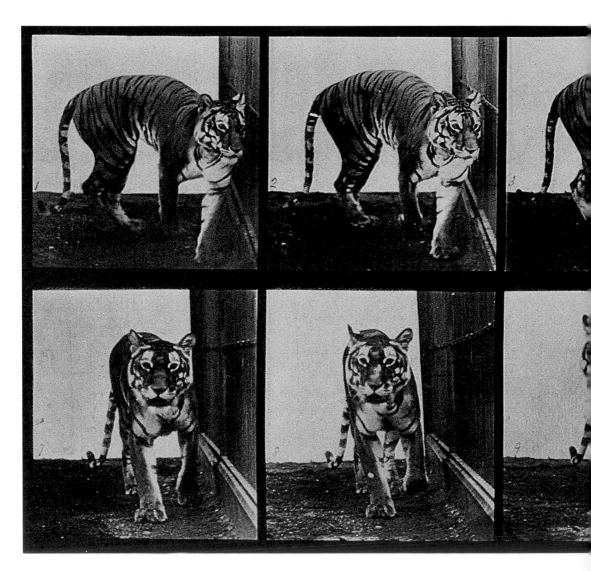

We can only guess at Muybridge's views, because Stanford rejected his introduction to the 1882 publication in favor of Stillman's. After splitting with Stanford, Muybridge pursued commercial prospects for his work. As he built on his achievement with a vast new project, *Animal Locomotion* (1887), he promised to reform painters' representations of animal movement. Like Stubbs, Muybridge expanded his project to encompass more animals, including exotics such as this tiger, birds, and many humans. He was less concerned with scientifically exact comparisons between species, however, and more interested in producing an encyclopedic source of images. Sadly, the high cost of the published work prevented its widespread use, although contemporary realist artists Thomas Eakins, Jean-Louis-Ernest Meissonier, and Edgar Degas studied it with care. In the end, Muybridge's obsession with the details of animal and human motion would matter less than the unintended radicalism of his invention of a single work of art that could depict change and motion over time.

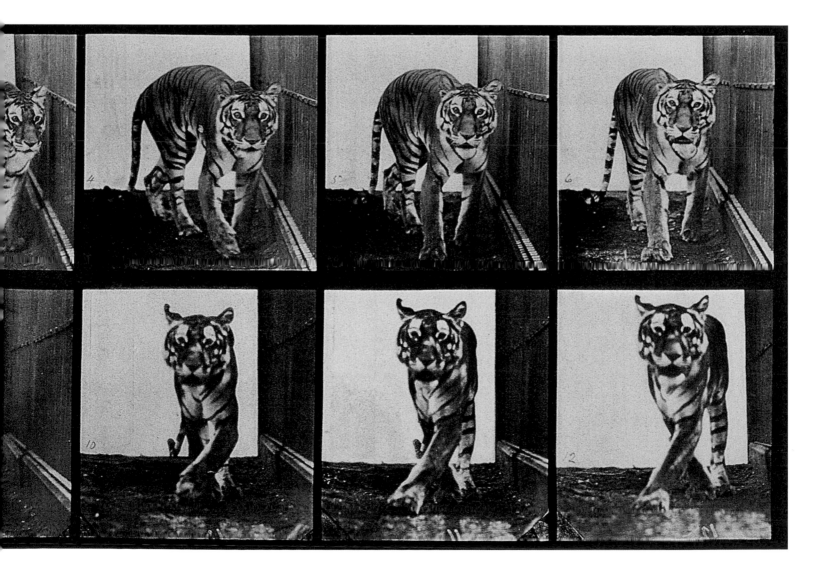

# Modern apes, modern artists

In 1840, the American author Edgar Allan Poe wrote what is widely regarded as the first detective story, "The Murders in the Rue Morgue." Somehow, a murderous assailant has entered and departed from a locked Paris apartment, leaving bloody corpses behind. The detective eventually identifies the criminal as an orangutan kept nearby as a pet; it had climbed through a window inaccessible to humans and, blindly mimicking its master's morning shave, slashed its victims' throats with a razor. The Rue Morgue orangutan had no conscience, no awareness of killing, or moral sense of its crime. Driven by the instinct to imitate, and unable to suppress that instinct through reasoning or moral judgment, Poe's orangutan was not responsible for its actions. The crime was a tragic accident, as if a machine or force of nature had killed the victims.

Poe's view of the ape as a mindless imitator of human behavior has a long history in Western culture. An ape or monkey traditionally served as a symbol of imitation in sixteenth- and seventeenth-century emblem books, for example. The concept lends its meaning to the English verb "to ape," as well as to the long series of ambivalent images of monkey artists "aping nature" by painting that date back to the early eighteenth century (see pp. 36, 55). Like Poe's orangutan, artists were credited with mindless mechanical skills instead of conscious achievements.

Frémiet's sculpture depicts another criminal ape, this time a gorilla. Information about gorillas reached Europe in the 1850s, and they were soon competing with orangutans for the title of "scariest living anthropoid" in the human imagination. Frémiet made his first sculpture of a gorilla dragging off the body of a woman in 1859. In this later version, the gorilla has captured a live female, and the mystery is not "whodunit" but "why?" The sculptor provides some ambiguous clues. The wounded gorilla carries a rock, so it may be fleeing a conflict. The woman is young, naked, and struggles ineffectively in the creature's grasp. A snake slithers out of a crack in the rock of the base. It might suggest the jungle environment, or a fall from innocence.

Contemporary critics interpreted the scene as a rape. This reading—the King Kong version—gained strength from ideas about race and gender that we find abhorrent today, but which were widely accepted as "scientific" in the late nineteenth century and beyond. Some interpreters of Darwin's evolutionary theories argued that some races (whites) were more highly evolved than others (everyone else). A maturing individual of any species was thought to evolve from lower developmental levels to higher ones, so highly educated human males were deemed biologically and culturally superior to females, and children were closest to animals. Thus the notion of a gorilla consumed with passion for an African woman (just one step away on this hideous evolutionary ladder) seemed feasible.

Frémiet himself countered the rape story by stating that his gorilla is female. If so, her motivation is hunger, and murder and cannibalism would be her crimes. Ironically, either interpretation would represent an advance in human understandings of primate psychology, by acknowledging that such animals were capable of feeling and independent action, and (think of the gorilla's rock) were intelligent enough to use tools or weapons deliberately.

So, as our understanding of primate behavior shifted, what happened to meanings of the verb "to ape" and the traditional idea of artists "aping nature"? These changed, too. "To ape" has been replaced by a new colloquialism, "to go ape," meaning violently to lose control of oneself. And the job of "aping nature" was given to photography, a truly mechanical imitator of the visible world, invented in 1839. Many artists in the later nineteenth century abandoned literal imitations of nature in favor of work that expressed emotions or inner drives. In other words, they continued to paint like apes, but more modern ones.

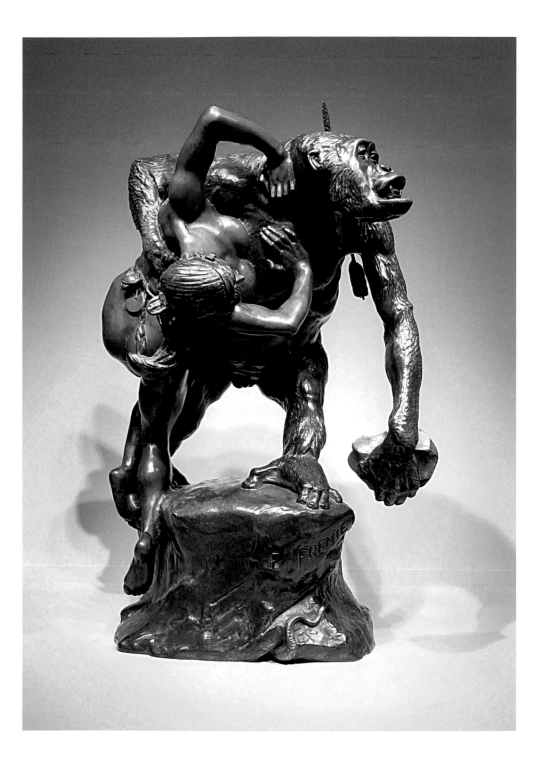

Emmanuel Frémiet
French, 1824–1910
*Gorilla Carrying Off a Woman*, 1887
Bronze
Height 44 cm (17¾ in.)
Private collection

# Monkey business II

Both of the paintings opposite show monkeys looking at a painting. There is a gap of about fifty years between them. Right in the middle of this period Darwin's *The Origin of Species* was published (1859). The profound effect that this book had on human perception of animals, and on the position of our species in the animal kingdom, makes it essential to reflect on a pre-Darwin and a post-Darwin approach to painting monkeys.

Alexandre-Gabriel Decamps started his career as a caricaturist. He developed into an established genre painter of fashionable Orientalist subjects, but throughout his career he also followed the tradition of *singeries*, the painting of monkeys acting like humans, a famous example of which (by Chardin) is featured earlier in this book (see p. 36). Decamps showed monkeys as painters, bakers, and butchers, or looking into a mirror. Here, four apes, probably based on chimpanzees, are visiting an artist's studio. The painter himself—is he another ape?—is not present. The animals are dressed in contemporary fashions and gaze intensely at a brownish landscape in the Romantic style. Géricault comes to mind or, perhaps more logically, Decamps himself. We do not know if the painter wanted to make a statement about some item of current affairs, if he was insulted by yet another negative review, or if he was expressing his general attitude toward the art critics of his time.

Max's monkeys could not behave more differently. They are not dressed up, they are clustered together, they are of many different species, and at least half of them are not really looking at the painting. Moreover, we do not know what the canvas shows, since we are only allowed to see a part of its frame and a label on its back, presumably giving the title of the work: "Tristan und Isolde." It also gives the price of the work, a staggering 100,000 marks. The monkeys are sitting on a crate bearing the inscription "*Vorsicht*" (attention). That crate must have contained either the painting or another fragile artwork.

It is said that Max wanted to express his discontent with the jury of the first annual art exhibition in Munich in 1889. The painter was unhappy with the exhibition, the selection of the works, and the development of art in general. Although he uses monkeys to criticize the critics, he does so in a very different way from the traditionalist Decamps. Max was a staunch Darwinist and well versed in the latest research on animals. He corresponded with Ernst Haeckel (see pp. 146–47), one of the most radical promoters of the evolutionary theory. Darwin and Darwinism offered a scientific foundation for a close relationship between humans and apes. Max answered these new investigations with a strong emotional bonding with his monkeys. The painter kept a number of monkeys at his home near Lake Starnberg in the vicinity of Munich, and the quality of this painting suggests he knew the animals well. In fact, he became so fond of one of them that he requested in his will that it should be buried with him when it died.

Why would the painter make fun of the monkeys when he loved them so much? Unlike those in Decamps's painting, Max's monkeys are not exaggerated, dressed up, or otherwise caricatured. They are behaving quite naturally, albeit in a non-natural environment. Each of them is painted carefully and respectfully. Experts can identify the different species with ease. It may well be true that Max intended a slur against the jurors, but he is not saying that the jurors are as stupid as monkeys—rather, that the critics have lost their natural instinct when looking at art. According to Max, monkeys are the better jurors.

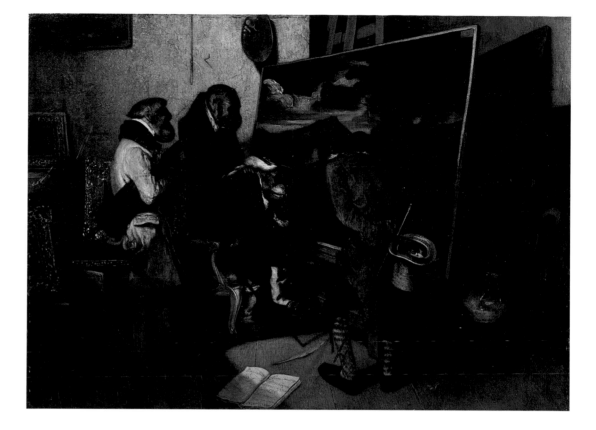

**Alexandre-Gabriel Decamps**
French, 1803–1860
*The Experts*, 1837
Oil on canvas
46.4 x 64.1 cm (18¼ x 25¼ in.)
The Metropolitan Museum of Art,
New York, H.O. Havemeyer Collection

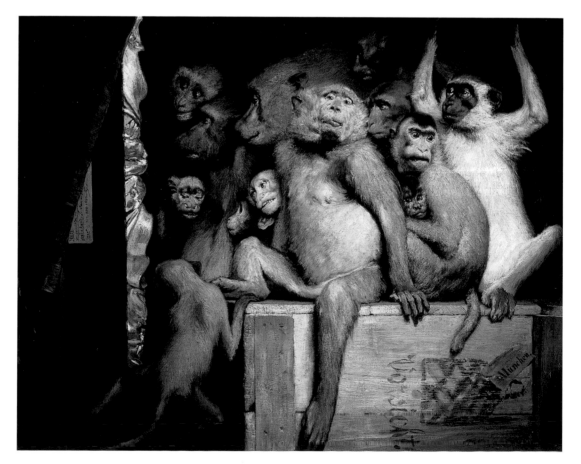

**Gabriel Max**
Austrian, 1840–1915
*The Jury of Apes*, 1889
Oil on canvas
81.5 x 107.6 cm (33¼ x 42⅜ in.)
Bayerische Staatsgemäldesammlungen,
Neue Pinakothek, Munich

# Blood relatives

We have to look carefully before we can understand what is going on in this picture. A young woman is lying on a hospital bed, looking pale, with her eyes closed. A doctor is putting a tube into the vein of her left arm. The other end of the tube is connected to a goat lying on a table at the back. The doctor transfuses the blood of the goat into the body of the girl, obviously in an attempt to cure her from an illness.

Until pigs' hearts were transplanted into humans, the exchange of blood must have been the closest connection between man and animal. Experiments with such transfusions date back at least to the seventeenth century, when doctors in England and France tried to heal patients by giving them animal blood. These experiments were often based on contemporary thinking about animal characteristics. In the late 1660s, a doctor gave the blood of a lamb to a young feverish boy in order to calm him down. Sheep were "sheepish," thus their blood should mellow the boy's temper, but the only thing he reportedly felt was "a very great heat." At least he survived. Most other patients did not.

Anecdotes relate that it was harder to find the model for the goat than for the girl. The man standing in the center is Dr. Simon Bernheim, who practiced in Paris and specialized in vaccination. He commissioned the painting and had offered Jules Adler 1200 francs for it. Adler would receive an additional 300 francs if the painting was accepted at the annual Salon. Bernheim hoped that the work would be seen by hundreds of thousands of people, which would bring much publicity and be well worth the extra investment. The Salon jury accepted the painting, but it is doubtful if it found Bernheim the recognition he so desired.

Bernheim was not so much an innovator as the last in line to try to save humanity with this dangerous method. He could not yet know why it was doomed to fail: it was not until a dozen years later, in 1901, that Karl Landsteiner would discover the existence of blood groups, and along with it the compatibility—or rather, incompatibility—of different blood types. From then on, nobody would ever reasonably try this experiment again. The Paris Ecole de Médecine, somewhat embarrassed by this chapter in its otherwise glorious past, put the painting in the stairway leading to its museum, although historical failures can be just as valuable to posterity as its successes.

**Jules Adler**
French, 1865–1952
*The Transfusion of a Goat's Blood*,
1890
Oil on canvas
129 x 195 cm (50⅞ x 76⅞ in.)
Musée d'Histoire de la Médecine, Paris

# Working-class heroes

Many thousands of people and horses moved from the countryside to cities, mines, and factories during the nineteenth century. They provided the raw labor that fueled the Industrial Revolution. Horses pulled wagons, carts, buses, and cabs in the cities; they turned windlasses for power in the factories and for lifting coal and ore out of the mines; and when they were too old to work, they were slaughtered to feed the people whom they had also served in life.

Coal mining was especially dangerous, dirty, and degrading. In Britain in 1842, investigators discovered miners treated like animals; reform laws forced mine owners to replace women and children with real animals—pit ponies that lived underground and hauled coal through tunnels in perpetual darkness. One such animal is portrayed in Meunier's bronze. The pony had survived a disastrous 1887 Belgian mine explosion that killed 113 workers; it had been trapped underground for a week and was near starvation when it was rescued. Meunier was present, and his portrayals of the suffering miners, including this horse, are still harrowing to look at today. In 1896, viewing *Old Mine Horse* at a Paris exhibition, the French art critic Octave Mirbeau wrote of the feeling of "deep depression from tortured beast to martyred man."[I] The carthorse in Anton Mauve's *Weary* probably belonged to a team that pulled fishing boats on and off the beaches of Holland. Like the creature depicted in *Old Mine Horse*, it has been worked to a state of stubborn exhaustion and emaciation. Van Gogh described these animals as being "resigned to living and working a little longer, but if they have to go to the knacker tomorrow, so be it, they are ready."[II]

The practice of slaughtering old workhorses for food also originated as a nineteenth-century reform aimed at improving the lot of human workers. It solved two pressing problems: the disposal of old animals unfit for work, and the provision of cheap, nutritious protein for working-class people who could not afford expensive beef and mutton. A well-publicized "*banquet hippophagique*" to promote horsemeat was staged in Paris in 1865, and another occurred in London in 1867. Composed entirely of foods derived from horsemeat, they failed as gourmet events. But in France and Belgium especially, specialized butcheries began to sell horsemeat to the urban working classes, as they still do today.

Meunier's starving mine horse and Mauve's exhausted carthorse are a far cry from the robust animals celebrated by Rosa Bonheur in *The Horse Fair* (see pp. 108–109). While her Percherons exemplify optimism, power, and strength, these workers embody the brute sufferings of industrial laborers both human and animal. But by the 1880s, such abuses had become too horrific and too widespread to ignore. Political and social reforms benefiting people came first, as labor unions and radical politics threatened social and economic stability. Kindness to work animals was an expensive luxury, however, for most of the nineteenth century. Although critics such as Octave Mirbeau and artists like Van Gogh empathized with the miserable animals depicted in these works of art, it would be the steam engine and the internal combustion engine that would finally free them from slavery.

[I] Quoted in *Hommage à Constantin Meunier 1831–1905*, exhib. cat. by Sura Levine and Françoise Urban, Antwerp, Galerie Maurice Tzwerin-Pandora, 1998, p. 29.
[II] Quoted in *Van Gogh's Imaginary Museum: Exploring the Artist's Inner World*, ed. Chris Stolwijk *et al.*, New York (Abrams) 2003, p. 209.

**Anton Mauve**
Dutch, 1838–1888
*Weary, c.* 1880–82
Graphite
28.9 x 38.3 cm (11⅜ x 15⅟₁₆ in.)
Carnegie Museum of Art,
Pittsburgh, Purchase

Constantin Meunier
Belgian, 1831–1905
*Old Mine Horse*, 1890
Bronze
36.5 x 49 x 14.5 cm
(14⅜ x 19¼ x 5¾ in.)
Musées Royaux des Beaux-Arts
de Belgique, Brussels

# God 0, Darwin 1

The poet Charles Baudelaire once famously asked, "Why is sculpture boring?" Humor in sculpture is indeed rare. The reason may be that creating sculpture is hard manual work, and highly complex to boot. You either have to hack the form out of stone or mold it and cast it in bronze, techniques that are both far too tedious for jokes. Nevertheless, looking at a monkey regarding a human skull, one is tempted to treat this as a sort of caricature. The monkey sits on a pile of books, one of them inscribed "DARWIN," and we are likely to put it among the large group of anti-Darwinian slurs that were produced in the decades after the first publication of *The Origin of Species* (1859). But things are a bit more complicated with this work.

Hugo Rheinhold, the creator of this small bronze, is hardly known as a joker. He was a member of a group of freethinkers who hoped to improve the world through ethics. Rheinhold wrote articles in the magazine *Ethische Kultur* (Ethical culture), published and edited by Georg von Gizycki and his wife Lily, who later became a leading German socialist and feminist (as Lily Braun). In 1876, Gizycki wrote a book entitled *Philosophische Consequenzen der Lamarck-Darwin'schen Entwicklungstheorie* (Philosophical consequences of Lamarck's and Darwin's theories of evolution), in which he outlined the impact that evolutionary theory could have, or should have, on society. This was also a very serious enterprise, which tried to apply a general theory of continuous development to philosophy, ethics, and religion. The goal of Gizycki's movement was to promote ethical behavior without religion—or at least above the existing religions, without being atheist or materialist. The movement's founder was Felix Adler, a German émigré in the United States, where the movement was called "Ethical Culture."

What does all this tell us about the monkey? Another engraved text on the pile of books may give the clue: ERITIS SICUT DEUS from Genesis 3:5: "For God doth know that in the day ye eat thereof, then your eyes shall be opened, and YE SHALL BE AS GODS, knowing good and evil." The ape assumes a typical pensive position. He is regarding a skull, reminding us of the famous scene in which Hamlet stands at the grave of the court jester Yorick, pondering about what remains of life after death. There is another hint, mostly overlooked: in his right foot, no less, the monkey carries a pair of compasses, symbol of God as the "architect of the universe." (It is also known from William Blake's anti-Newtonian print, *The Personification of Man Limited by Reason*, 1795; Tate, London.)

For Gizycki and perhaps also for Rheinhold, Darwin replaced God. In this sculpture, the ape is man's equal.

**August Allebé**
Dutch, 1838–1927
*Escaped Monkeys*, 1873
Watercolor
45 x 67.6 cm (17¾ x 26⅝ in.)
Amsterdams Historisch Museum

■ Two monkeys—actually young orangutans—are dressed in the old-fashioned manner as in an eighteenth-century *singerie*. They have "escaped" to a library, where they study a book with schematic drawings of skulls. What they are looking at with growing concern are the diagrams in Petrus Camper's posthumously published book, *Über den natürlichen Unterschied der Gesichtszüge* (On the natural differences in facial features) of 1792. The influential Dutch anatomist shows how a simple method could differentiate the physiognomy of monkeys, apes, humans, and idealized Greek statues. These plates were often misunderstood as racist theories, as they seem to indicate a hierarchy. In fact the opposite is true: Camper tried to undermine values assigned to certain physiognomies. We do not know what Allebé's stand was, but the drawing is proof that Camper's theories were still much debated even after Darwin had made his pronouncements on the subject. ■

**Paul Jouve**
French, 1878–1978
*Monkey Regarding an Egyptian Sculpture, c.* 1910–20
Plaster
14 x 33 x 34.5 cm (5½ x 13 x 13½ in.)
Collection Dominique Suisse, Paris

■ This monkey, a baboon, is looking at another sculpture, a statuette of the Egyptian god Thoth. The god of wisdom and learning, Thoth is mostly given the head of an ibis. In the form of a baboon, he is a creature of the night and greets the sun in the morning. Paul Jouve was one of the twentieth century's most prolific *animaliers* in sculpture, painting, and printmaking. His work rarely tells a story; instead it usually concentrates on the surface beauty of animals. However, a baboon regarding a baboon statuette that represents divine wisdom must surely be a comment on the question of whether animals can see, reflect, and understand. ■

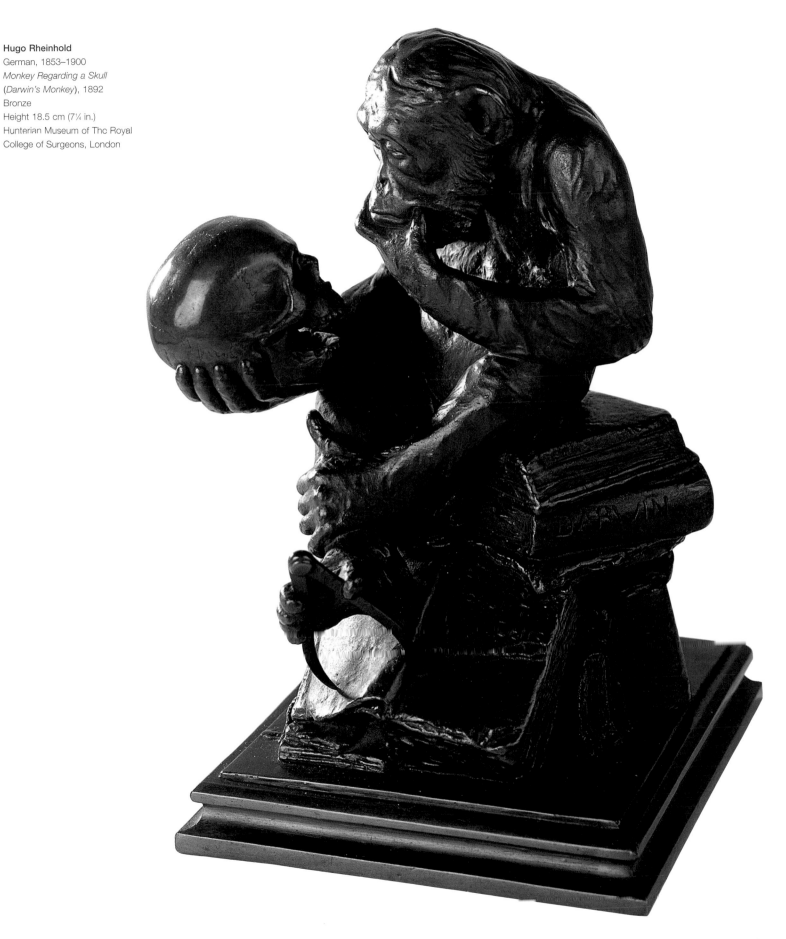

**Hugo Rheinhold**
German, 1853–1900
*Monkey Regarding a Skull*
(*Darwin's Monkey*), 1892
Bronze
Height 18.5 cm (7¼ in.)
Hunterian Museum of Thc Royal
College of Surgeons, London

# The lives of animals

Late nineteenth-century animal painters used a new strategy when representing the natural world. They responded to—and perhaps in part inspired—a new tendency in research. Scientists were no longer simply interested in taxonomy and comparative anatomy. Influenced by travel writing and explorers' tales, they started to become interested in the behavior and the environment of animals. The isolation of individual species in natural history books, museums, and zoos did not correspond with the new understanding that fauna and flora are part of an interrelated whole. In the second half of the nineteenth century, animals were shown increasingly in groups and families as well as in their natural habitat.

Perhaps the most widely read natural history book of the period was the multi-volume *Thierleben* (The lives of animals; 1864–69), by the German naturalist Alfred Brehm (1829–1884). Brehm employed the leading German animal painters to illustrate his work, among them Richard Friese. The painter shares the fate of many of his colleagues who specialized in animal painting, in having been left out of the art history canon. Their paintings decorate natural history museums, but are rarely seen in an art gallery. In their time, however, they were celebrated mainstream artists who received many honors. Friese took part in hunting campaigns with Wilhelm II and was asked to make drawings of deer shot by the emperor. In 1896, the date of his *Fighting Moose*, he was awarded a professorship at the Prussian Art Academy in Berlin.

Friese's fighting moose are positioned slightly away from the center of the composition, and a large part of the canvas is devoted to the trees of the forest. There is no visible human presence. We are given the illusion of being the accidental witnesses to a fight for dominance between two adult animals. In the background, female moose curiously watch the combat. The winner will have a better chance of gaining even more of their interest later. This is no less than the story of natural selection taking place right in front of our eyes. It is doubtful that a scene like this would have been the subject of a large academic painting before the publication of Charles Darwin's *The Origin of Species* (1859). In the end, Friese is not just giving us a glance of the natural world. He is telling a story, a very old one indeed, but one in which humans had only recently become interested.

Together with dioramas, paintings such as this link the Romantic empathy for wild animals with modern-day nature documentaries. In 1896, when this canvas was finished, modern art had already taken an entirely different direction. Impressionists and Post-Impressionists—and soon the Cubists and Expressionists—took the animal subject as a pretext to work on the liberation of art from naturalistic representation. The success of illusionistic media such as the diorama and photography allowed artists to pursue other goals, leading them toward abstraction. Friese and his fellow realists, however, went on painting in the old style. Their modernity lies in their choice of subject-matter and the way it reflects contemporary science. Around 1900, artists had a choice when painting animals. The two directions—abstraction and scientific realism—represent extreme stylistic opposites, but both, nevertheless, are testimonies of their age. The way animals are represented, in paintings, zoos, and film, will always tell us more about how we look at animals than about the animals themselves.

**Bruno Andreas Liljefors**
Swedish, 1860–1939
*A Fox Leaves a Forest in the Snow,*
1904
Oil on canvas
71 x 90.5 cm (28 x 35⅝ in.)
Rijksmuseum Twenthe, Enschede

■ One of the most popular animal painters of all time, Bruno Liljefors managed to combine an apparently realistic view of the natural world with a stunning painterly technique. Critics then and now have commented on Liljefors's passion for the close observation of animal behavior. His works often focus on the struggle for survival, on predators and their prey, and on the beauty of fooling the enemy by blending into the environment. Camouflage interested Liljefors more than bright contrasting colors. As a painter, however, he followed the typical career path of his time, starting at the Royal Academy of Art in Stockholm and then traveling through Europe, ending up in Paris. In the French capital, Liljefors was exposed to the influence of Impressionism. It is interesting to ponder whether it was the style of the French avant-garde painters, or the latest research on animals, that had the greater effect on his art. Are his paintings natural history impressions? Were his colors more inspired by the canvases of the great masters or the camouflage of his subjects? ■

**Richard Friese**
German, 1854–1918
*Fighting Moose*, 1896
Oil on canvas
124.4 x 226 cm (49 x 89 in.)
Rijksmuseum Twentho, Enschede

**Rudolf Blaschka**
Austrian, 1858–1930
A member of the species *Siphonophora*,
c. 1900
Glass, wax, and pigment
19 x 21.6 x 21.6 cm (7½ x 8½ x 8½ in.)
Carnegie Museum of Art, Pittsburgh,
transferred from Carnegie Museum of
Natural History

■ Bohemia's world-famous glassmaking tradition is mostly associated with the decorative arts: vases, chandeliers, and so on. But when father-and-son glassmaking team Leopold and Rudolf Blaschka began specializing in botanical and zoological model-making, they found a lucrative market for their trade. Combining keen observation with astonishing skill, they managed to export their glass menagerie all over the world. One of the techniques they employed was the "spinning" of glass, which made possible the modeling of the finest details, such as the tentacles of jellyfish. Leopold had become interested in marine life during a journey to the USA in 1853. By 1885, the company had on offer seven hundred different models, mostly of underwater creatures and other invertebrates. Universities and natural history museums loved them because they provided better teaching materials than the faded animals preserved in spirit or the two-dimensional illustrations in books. Alongside their pedagogical use, the Blaschka models were also recognized for their decorative qualities—indeed they were advertised as such. The nineteenth-century obsession with natural history brought with it a taste for advanced technical skills and strange animal forms.    ■

# Darwin and design

If there is one publication that epitomizes the connection between art and science, it is Ernst Haeckel's *Kunstformen der Natur* (Art forms in nature; 1899–1904). This series of one hundred plates is the summary of a lifetime preoccupation with zoology. Haeckel was a respected scientist whose research on invertebrates is still considered groundbreaking. His fame is also based on his firm stand in favor of Darwin's theory of evolution. Haeckel even radicalized the views of the great scientist, always looking for a single answer to all mysteries of nature.

As early as the 1860s, Haeckel's taxonomic works on jellyfish, mollusks, and other "lower" life-forms were richly illustrated with beautiful and highly ornamental designs. The scientist was trying to solve the mystery of what he called a "general morphology of organisms," some kind of common denominator shared by all living creatures. His images were very persuasive; indeed, many critics blamed Haeckel for manipulating the truth in order to prove a preconceived view of the world. Haeckel was looking for perfection in nature, and if he did not find it, he would give nature a little hand in achieving it. According to him, the basis of beauty is symmetry, and if you look the right way you can find symmetry almost everywhere.

We can certainly credit Haeckel with hitting a public nerve with the plates in *Kunstformen der Natur*. The images were immensely popular, and soon were widely disseminated by being reproduced in general encyclopedias. They even found resonance in the decoration of many stylish Art Nouveau homes.

Do Haeckel's plates show the influence of the current fashion, or did they contribute to this fashion's formation? By forcing animal forms—from microscopically small creatures to antelopes—into an almost obsessive symmetrical scheme, *Kunstformen der Natur* still fascinates the modern viewer. We may wonder, however, whether these images really were as progressive as they seem, or whether they in fact represented a quite outdated look at the animal world. Haeckel's contemporaries were becoming more and more interested in the behavior of animals. In a way, Haeckel is repeating what the taxonomists of the eighteenth century did, namely, taking the animals out of their environmental context and isolating them. The straightjacket into which Haeckel forces his creatures could hardly stand in greater contrast to the freedom that animals were gaining at the time, both in their artistic representation in nature and in the confinements of the zoo. Painters and sculptors now stood at a crossroads. The choice of abstraction versus realism was never more stark. More than anyone else, Haeckel helped define these choices.

**Ernst Haeckel**
German, 1834–1919
*Siphonophorae—Staatsquallen*,
from *Kunstformen der Natur*
(Art forms in nature), 1899–1904,
plate 17
Chromolithograph
36.3 x 27.3 cm (14¼ x 10¾ in.)
Van Gogh Museum, Amsterdam,
Library

Siphonophorae. — Staatsquallen.

# Resurrections

Is taxidermy an art, a science, or a craft? It began as a craft in the eighteenth century. Preserving and stuffing bird or animal skins was a dangerous and lowly job related to leather tanning. Early taxidermists sewed up the tanned skins, filled them with straw, and were done. Their specimens lasted about a decade before they succumbed to fading, insects, mold, or compressed stuffing; as a result, paintings, prints, and drawings remained the best method of preserving and disseminating visual information about animals until well into the nineteenth century.

Taxidermy took a step forward in 1803, with the publication of a new preservation technique employing arsenic. Specimens treated with arsenical soaps two hundred years ago are still on display in natural history museums today; it was the taxidermists who succumbed prematurely to arsenic poisoning. Nevertheless, the growing popularity of exhibitions of taxidermied animals encouraged more lifelike products. Taxidermied menageries functioned primarily as public entertainment, so taxidermists looked to popular art for inspiration and models. The greatest piece of taxidermy in this mode that survives today is the famous *Arab Courier Attacked by Lions* made by the French firm of Jules Verreaux for exhibition at the Paris International Exposition of 1867. It is modeled on the sensational animal combats of Baroque and Romantic art, such as the Barye sculpture and Delacroix painting included here (see pp. 90, 91).

However, the very drama of that human-versus-animal conflict nearly led to the composition's destruction at the end of the nineteenth century. By then, natural history museums had discovered the didactic value of taxidermy, but they wanted up-to-date, scientific displays. Sensational dramas gave way to more naturalistic presentations of animals in pristine environments apparently free from human interference. So, in 1899, the American Museum of Natural History, about to destroy its outmoded *Arab Courier*, instead shipped it off to the newly founded Carnegie Institute, which was seeking crowd-pleasing displays. It has terrified and enthralled generations of Pittsburgh children ever since.

Taxidermists' methods improved in the later nineteenth century. It was no longer a fatal occupation, and it even enjoyed a brief craze as an amateur craft. Henri Coeylas's depiction of an ideal taxidermy lab includes every phase of the process, from preservation of skins in the right foreground, to the creation of lifelike sculptures for the stretching of skins (background), to the integration of preserved specimen and mount (far right). In the left foreground, the blue-smocked artisan, bookish scientist, and palette-wielding painter exemplify the perfect collaboration of science, art, and craft in "modern" taxidermy. But look at the animal they are fabricating. It is the famous dodo, extinguished in the seventeenth century and known only from old paintings and prints and a few original parts preserved in museums. Coeylas and the taxidermists must have been proud that, through their craft, they could resurrect animals that had been extinct for centuries.

Today, we know increasing numbers of animals only through such man-made replicas, because all that remains of many extinct species are the hides and occasional bones stuffed and preserved in museum glass cases around the world. The Carnegie's *Arab Courier* has new life as a great scientific treasure, because its ferocious Barbary lions are long gone from Africa and everywhere else. The preservation of DNA in some of these remains means that someday we may able to resurrect these creatures for real. But for now, we look at Coeylas's taxidermy laboratory with a peculiar sense of irony and sadness. In this era of mass extinctions, it seems more than bizarre to kill rare animals in order to make lifelike replicas.

**Jules Verreaux**
French, active 19th century
*Arab Courier Attacked by Lions*, 1867
Taxidermy group, life size: metal, straw, plaster, animal skins, leather, textiles
Carnegie Museum of Natural History, Pittsburgh

Henri Coeylas
French, active *c.* 1880–1910
*Reconstruction of a Dodo in the Taxidermy Laboratory of Emile Oustalet*, 1903
Oil on canvas
127 x 163 cm (53 x 64¼ in.)
Muséum National d'Histoire Naturelle, Paris

# Horsepower

We have seen a horse frightened before in Géricault's painting of 1813–14 (see p. 74). In Max Francis Klepper's painting the cause of the excitement is not a natural phenomenon but a De Dion-Bouton type Q, a French automobile built in 1903. It had a single cylinder engine of 698 cc, producing the power of six horses. The French car manufacturer had changed the position of the motor from the rear to the front in 1902, giving its vehicles a more modern look. This is not a horseless carriage anymore.

The proud owner of this car scares the horses of a two-in-hand on Riverside Drive along the Hudson River in New York. The artist is painting a scene of what was then modern urban life. Today, it reminds us of the days when cars were replacing the horse as the most common means of transportation. This development took a while. Early automobiles were objects of extreme luxury, more often used for the races, social events, and other leisure activities than for getting to work. We are not looking at Manhattan's rush hour. Klepper's scene depicts a holiday atmosphere, with wealthy New Yorkers showing off the latest fashions. Riverside Park was one of the favorite promenades for Manhattan's upper class.

Klepper was a painter of moderate talent who specialized in animals, horses in particular. He is one of the large number of artists who eschewed the new Impressionist tendencies in favor of painting the life of well-to-do city-dwellers. Painting within the established "academic" tradition, these artists catered to a clientele who preferred to recognize everything in detail rather than admire a blurry cityscape. In the end, however, it was the Impressionists who won the aesthetic battle against the academics, just as the car has won the battle against the horse. Why, then, do we hardly ever see cars in the work of the Impressionists? It is not that they did not live and work long enough. Were automobiles considered vulgar, the province only of the nouveaux riches? Among the true modernists, only the Italian Futurists seem to have embraced the accumulation of horsepower in a machine.

**International Benz 3.5-HP**, 1899
Louwman Collection, Nationaal
Automobielmuseum, Raamsdonksveer,
The Netherlands

■ As in the case of many other technological inventions, the designers of automobiles were compelled to adapt older forms before they could find an adequate new design. Early automobiles depended heavily on the shape of horse-drawn carriages. This example still has the steering wheel in the center and also provides two hooks for the times when a horse would be required to move the still very unreliable vehicle. ■

**Max Francis Klepper**
German, active in the United States,
1861–1907
*Carriage and Automobile on
Riverside Drive, New York,* 1904
Oil on canvas
68.5 x 99 cm (27 x 39 in.)
Private collection, Paris

# Building a better dinosaur

Without art, dinosaurs would just be big heaps of fossilized bones, and paleontology would not exist. And Pittsburgh's "Dippy," the enormous sauropod formally known as *Diplodocus carnegii hatcher*, would not have been an international celebrity at the turn of the twentieth century. Dippy is as much a product of art as of science.

Drawings, photographs, and sculptures document the creation of Dippy. The story began in Sheeps Creek, Wyoming, in 1899. Excavators working for Carnegie Institute found an unusually complete set of large fossilized dinosaur bones embedded in rock. The first image of Dippy is a hand-drawn site map showing the distribution of the bones in Quarry C. The drawing, later published in *Memoirs of the Carnegie Museum*, would serve as a useful guide in reconstructing the dinosaur, because it recorded the relative positions of major bones, such as the sequence of vertebrae in the spine.

The bones were excavated, coated in protective plaster, and shipped back to Pittsburgh on the train. Although remarkably complete, the dinosaur was not all there; most of the skull, the forelegs, and other parts were missing. Curator J.B. Hatcher would also have to determine the relationship of his new dinosaur to other recently discovered sauropods in collections in New York and New Haven, Connecticut. Using drawings and photographs of individual bones, Hatcher meticulously compared details of the Pittsburgh dinosaur with comparable bits and pieces from the others. This was a straightforward exercise in comparative anatomy, but closely analogous to the visual comparisons that art connoisseurs employed when identifying makers of works of art. By 1900, Hatcher had determined that his dinosaur belonged to the same genus as the others—Diplodocus—but differed enough to merit its own species name, "carnegii" after the sponsor of his museum and of the excavations in Wyoming.

Between the Pittsburgh find and the bones in other collections, it was just possible to reconstruct the entire skeleton. This was done first with drawings. Hatcher had worked out the arrangement of the skeleton based on his site map, clues about muscle attachments and limb articulation from the bones themselves, and current theories about dinosaur anatomy and lifestyle based primarily on living reptiles. He supplied the missing parts by carefully scaling to correct proportions the comparable parts from other specimens. He composed the skull from fragments from four different dinosaurs. The end result was a meticulous drawing by the draughtsman R. Weber, published in the *Memoirs*, of the largest dinosaur in the world. A copy of the original sheet was sent to Andrew Carnegie to congratulate him on the success of his project and encourage further support.

Below left:
**R. Weber**
American, active *c.* 1900
**J.B. Hatcher**
American, d. 1904
*Restoration of the skeleton of Diplodocus carnegii* [scale], from J.B. Hatcher, "Diplodocus (Marsh): Its osteology, taxonomy and probable habits," *Memoirs of the Carnegie Museum*, vol. I (1901), plate xiii
Photolithograph
Carnegie Museum of Natural History, Pittsburgh

Below right:
**American, early 20th century**
*W.J. Holland with others assembling the first Diplodocus skeleton at Carnegie Institute, c.* 1906
Gelatin silver print
11.4 x 20.3 cm (4½ x 8 in.)
Carnegie Museum of Art, Pittsburgh, Gift of Carnegie Library of Pittsburgh

T.A. Mills
American, active *c.* 1908
**W.J. Holland**
American, d. 1932
*Diplodocus carnegii hatcher*, 1908
Painted plaster
30.5 x 137.8 x 19.7 cm
(12 x 54¼ x 7¾ in.)
Carnegie Museum of Natural
History, Pittsburgh

Once the blueprint for Dippy's skeleton had been drawn, the art of sculpture took over. So did W.J. Holland, who became museum director following Hatcher's unexpected death from typhoid fever in 1904. Assembling the fossilized bones into a complete skeleton called for an extremely sturdy metal armature analogous to the metal armatures that stiffen and strengthen clay and plaster models. Scaled-to-fit plaster facsimiles of bones from other animals supplied the missing portions. The solution was borrowed from art restorers' centuries-old practice of replacing lost bits of marble sculptures with plaster substitutes; it was not a big step from the missing arms of the *Venus de Milo* to the missing leg of *Diplodocus carnegii*. The imposing skeleton, which has dominated Carnegie Museum's Dinosaur Hall since 1907, is both a scientific prize and an impressive work of art.

The final stage in bringing Dippy to life also involved sculpture. Working with the artist T.A. Mills, Holland created a small-scale plaster model of Dippy as he/she would have appeared in life. Basically, they have put flesh onto the great skeleton—the pose is unchanged—although somehow Dippy has acquired a slightly quizzical expression and an elegant, almost Art Nouveau, sinuosity in its tail. Plaster is not only a creative medium but a favorite material for reproductions. Once the mold is made, endless copies can be easily and cheaply produced. Andrew Carnegie, however, did not work on a small scale. A chance remark inspired him to commission full-size plaster replicas of the entire skeleton and to offer them as diplomatic gifts to the crowned heads of Europe. Dippy became an international star, making sensational appearances (in plaster) in London, Berlin, Paris, Vienna, and St. Petersburg, all before World War I.

# Further Reading

Allin, Michael, *Zarafa: The True Story of a Giraffe's Journey from the Plains of Africa to the Heart of Post-Napoleonic France*, London (Headline) 1998

*Animaux d'Oudry: Collection des ducs de Mecklenbourg-Schwerin*, exhib. cat. by Vincent Droguet *et al.*, Fontainebleau, Musée National du Château, and Versailles, Musée National des Châteaux de Versailles et Trianon, 2004

Artinger, Kai, *Von der Tierbude zum Turm der blauen Pferde: Die künstlerische Wahrnehmung der wilden Tiere im Zeitalter der zoologischen Gärten*, Berlin (Dietrich Reimer Verlag) 1995

Ashton, Dore, and Denise Brown Hare, *Rosa Bonheur: A Life and a Legend*, New York (Viking Press) 1981

Asma, Stephen T., *Stuffed Animals and Pickled Heads: The Culture and Evolution of Natural History Museums*, Oxford (Oxford University Press) 2001

Baker, Steve, *Picturing the Beast: Animals, Identity, and Representation*, Urbana and Chicago (University of Illinois Press) 1993

Baratay, Eric, and Elisabeth Hardouin-Fugier, *Zoos: Histoire des jardins zoologiques en Occident (XVIe-XXe siècle)*, Paris (Editions la Découverte) 1999

Barber, Lynn, *The Heyday of Natural History, 1820–1870*, Garden City NY (Doubleday) 1980

Bayertz, Kurt, *Glanz und Elend des aufrechten Ganges: Eine anthropologische Kontroverse des 18. Jahrhunderts und ihre ethischen Implikationen*, Jahrbuch für Recht und Ethik 8, 2000, pp. 344–69

Beattie, Owen, and John Geiger, *Frozen in Time: The Fate of the Franklin Expedition*, Vancouver (Greystone Books) 1998

Belden, Louise Conway, *The Festive Tradition: Table Decoration and Deserts in America, 1650–1900*, New York and London (Winterthur Museum and W.W. Norton & Company) 1983

Belmonte, Brenda, *The Pug Handbook*, New York (Barron's Pet Handbooks) 2004

Berger, John, "Why Look at Animals?" [1977], in *About Looking*, New York (Vintage Books) 1991

Berger, Roland, and Dietmar Winkler, *Künstler, Clowns und Akrobaten: Der Zirkus in der bildenden Kunst*, Berlin (Henschelverlag) 1983

Blum, Ann Shelby, *Picturing Nature: American Nineteenth-Century Zoological Illustration*, Princeton NJ (Princeton University Press) 1993

Braun, Marta, *Picturing Time: The Work of Etienne-Jules Marey (1830–1904)*, Chicago and London (University of Chicago Press) 1992

Cadbury, Deborah, *The Dinosaur Hunters: A True Story of Scientific Rivalry and the Discovery of the Prehistoric World*, London (Fourth Estate) 2000

Cassidy-Geiger, Maureen, "Fabled Beasts: Augustus the Strong's Meissen menagerie," *Antiques*, CLXIV, no. 4 (October 2003), pp. 152–61

Clark, Kenneth, *Animals and Men: Their Relationship as Reflected in Western Art from Prehistory to the Present Day*, London (Thames & Hudson) 1977

Clarke, T.H., *The Rhinoceros from Dürer to Stubbs, 1515–1799*, London (Sotheby's Publications) 1986

Clutton-Brock, Juliet, *Horse Power: A History of the Horse and the Donkey in Human Society*, Cambridge MA (Harvard University Press) 1992

Cohen, Claudine, *The Fate of the Mammoth: Fossils, Myth, and History*, Chicago and London (University of Chicago Press) 2002

Conn, Steven, *Museums and American Intellectual Life, 1876–1926*, Chicago and London (University of Chicago Press) 1998

*Courbet und Deutschland*, exhib. cat. by Werner Hofmann and Klaus Herding, Hamburger Kunsthalle and Städtische Galerie im Städelschen Kunstinstitut, Frankfurt am Main, 1978–79

Dance, S. Peter, *The Art of Natural History: Animal Illustrators and Their Work*, Woodstock NY (The Overlook Press) 1978

Darwin, Charles, *Voyage of the Beagle* [1839], London (Penguin) 1989

Darwin, Charles, *The Origin of Species* [1859], New York (Gramercy Books) 1979

*Darwin und Darwinismus: Eine Ausstellung zur Kultur- und Naturgeschichte*, exhib. cat., ed. Bodo-Michael Baumunk and Jürgen Rieß, Dresden, Deutsches Hygiene-Museum, 1994

*Das Tier in mir. Die animalischen Ebenbilder des Menschen*, exhib. cat. by Johannes Bilstein and Matthias Winzen, Baden-Baden, Staatliche Kunsthalle, 2002

Davidson, Alan, *The Oxford Companion to Food*, Oxford (Oxford University Press) 1999

Dean, Dennis R., *Gideon Mantell and the Discovery of Dinosaurs*, Cambridge (Cambridge University Press) 1999

Deuchar, Stephen, *Sporting Art in Eighteenth-Century England: A Social and Political History*, New Haven CT and London (Yale University Press) 1988

Doherty, Terence, *George Stubbs: Anatomical Works*, Boston (David R. Godine) 1974

Driesch, Angela von den, *Geschichte der Tiermedizin*, 3rd edn, Stuttgart (Callwey) 1989

Eekhoud, Georges, *Les Peintres animaliers belges*, Brussels (Librairie Nationale d'Art et d'Histoire) 1911

Farber, Paul Lawrence, *Discovering Birds: The Emergence of Ornithology as a Scientific Discipline, 1760–1850*, Baltimore and London (The Johns Hopkins University Press) 1982

Ford, Alice, *Edward Hicks, His Life and Art*, New York (Abbeville) 1985

Foucart-Walter, Elisabeth, and Pierre Rosenberg, *Le Chat et la palette: Le Chat dans la peinture occidentale du XVe au XXe siècle*, Paris (Adam Biro) 1987

Foucault, Michel, *The Order of Things: An Archaeology of Human Sciences*, New York (Random House) 1970

Freedberg, David, *The Eye of the Lynx: Galileo, His Friends, and the Beginnings of Modern Natural History*, Chicago and London (University of Chicago Press) 2002

*George Stubbs 1724–1806*, exhib. cat. by Judy Egerton, London, Tate Gallery, 1984

Gindhart, Maria P., *The Art and Science of Late Nineteenth-Century Images of Human Prehistory at the National Museum of Natural History in Paris*, PhD diss., University of Pennsylvania 2002

Gould, Stephen Jay, *The Mismeasure of Man*, rev. edn, New York and London (W.W. Norton & Company) 1996

Gould, Stephen Jay, *The Hedgehog, the Fox, and the Magister's Pox: Mending and Minding the Misconceived Gap between Science and the Humanities*, London (Jonathan Cape) 2003

Grob, Bart, *De wereld van Auzoux: Modellen van mens en dier in papiermaché*, Leiden (Museum Boerhaave) 2000

Hackenbroch, Yvonne, *Chelsea and Other English Porcelain, Pottery and Enamel in the Irwin Untermyer Collection*, Cambridge MA (Harvard University Press) 1957

Hancocks, David, *A Different Nature: The Paradoxical World of Zoos and Their Uncertain Future*, Berkeley CA, Los Angeles, and London (University of California Press) 2001

Haraway, Donna J., *Primate Visions: Gender, Race and Nature in the World of Modern Science*, New York and London (Routledge) 1990

Hardouin-Fugier, Elisabeth, *Le Peintre et l'animal en France au XIXe siècle*, Paris (Editions de l'Amateur) 2001

Hearne, Vickie, *Adam's Task: Calling Animals by Name*, New York (Alfred A. Knopf) 1987

*Het verdwenen museum: Natuurhistorische verzamelingen 1750–1850*, exhib. cat., ed. B.C. Sliggers and M.H. Besselink, Haarlem, Teylers Museum, 2002

Hoage, R.J., and William A. Diess (eds.), *New Worlds, New Animals: From Menagerie to Zoological Park in the Nineteenth Century*, Baltimore and London (The Johns Hopkins University Press) 1996

*Hommage à Constantin Meunier 1831–1905*, exhib. cat. by Sura Levine and Françoise Urban, Antwerp (Galerie Maurice Tzwern-Pandora) 1998

*Hommeanimal: Histoires d'un face à face*, exhib. cat., Strasbourg, Musée Archéologique, 2004

*Jacques-Laurent Agasse (1767–1849)*, exhib. cat., London, Tate Gallery, 1988

*Jean-Baptiste Greuze/1725–1805*, exhib. cat. by Edgar Munhall, Hartford CT, Wadsworth Atheneum Museum of Art, and others, 1976–77

*J.-B. Oudry 1685–1755*, exhib. cat. by Hal Opperman, Fort Worth TX, Kimbell Art Museum, 1983

Kaselow, Gerhild, *Die Schaulust am exotischen Tier: Studien zur Darstellung des Zoologischen Gartens in der Malerei des 19. und 20. Jahrhunderts*, Hildesheim, Zurich, and New York (Georg Olms) 1999

Katz, Marshall P., and Robert Lehr, *Palissy Ware: Nineteenth-Century French Ceramists from Avisseau to Renoleau*, London and Atlantic Highlands NJ (Athlone Press) 1996

Kete, Kathleen, *The Beast in the Boudoir: Petkeeping in Nineteenth-Century Paris*, Berkeley CA, Los Angeles, and London (University of California Press) 1994

Klumpke, Anna, *Rosa Bonheur: The Artist's (Auto) Biography*, Ann Arbor MI (University of Michigan Press) 1997

Köhler, Wolfgang, *The Mentality of Apes* [1925], London and New York (Routledge) 1999

Köstering, Susanne, *Natur zum Anschauen: Das Naturkundemuseum im Kaiserreich 1871–1914*, Wiesbaden (Böhlau-Verlag) 2003

Lambton, Lucinda, *Beastly Buildings: The National Trust Book of Architecture for Animals*, London (Jonathan Cape) 1985

*L'Âme au corps: Arts et sciences 1793–1993*, exhib. cat., ed. Jean Clair, Paris, Galeries Nationales du Grand Palais, 1993–94

*L'Animal miroir de l'homme: Petit bestiaire du XVIII siècle*, exhib. cat., Paris, Musée Cognacq-Jay, 1996

Lenain, Thierry, *Monkey Painting*, London (Reaktion Books) 1997

*Leopold & Rudolf Blaschka*, exhib. cat., ed. James Peto and Angie Hudson, London, Design Museum, 2002

Lepenies, Wolf, *Das Ende der Naturgeschichte*, Frankfurt am Main (Suhrkamp) 1978

Loffredo, François-Raphael, "Des recherches communes de Barye et de Delacroix au Laboratoire d'anatomie comparée du Muséum d'Histoire Naturelle," *Bulletin de la Société d'Histoire de l'Art Français*, 1982, pp. 147–57

Marret, Bertrand, *Portraits de l'artiste en singe: Les singeries dans la peinture*, Paris (Somogy) 2001

Mauries, Patrick, *Cabinets of Curiosities*, London (Thames & Hudson) 2002

McGowan, Christopher, *The Dragon Seekers: How an Extraordinary Circle of Fossilists Discovered the Dinosaurs and Paved the Way for Darwin*, Cambridge MA (Perseus Publishing) 2001

M'Clintock, Francis Leopold, *The Voyage of the "Fox" in the Arctic Seas: A Narrative of the Discovery of the Fate of Sir John Franklin and His Companions*, Boston (Ticknor & Fields) 1860

*Mensch und Tier. Eine paradoxe Beziehung*, exhib. cat., Dresden, Deutsches Hygiene-Museum, 2002

Montagu, Jennifer, *The Expression of the Passions: The Origin and Influence of Charles LeBrun's Conférence sur l'expression générale et particulière*, New Haven CT and London (Yale University Press) 1994

Myers, Amy (ed.), *Art and Science in America: Issues of Representation*, San Marino CA (The Huntington Library) 1994

Nochlin, Linda, and Martha Lucy (eds.), "The Darwin Effect: Evolution and Nineteenth-Century Visual Culture," *Nineteenth-Century Art Worldwide* II, no. 2 (Spring 2003) (www.19thc-artworldwide.org)

Pinette, Matthieu, *From the Sun King to the Royal Twilight: Painting in Eighteenth-Century France from the Musée de Picardie, Amiens*, New York (American Federation of Arts) 2000

Piper, Reinhard, *Das Tier in der Kunst*, Munich (Piper Verlag) 1921

Poe, Edgar Allan, *The Unabridged Edgar Allen Poe*, Philadelphia (Running Press) 1983

Potts, Alex, "Natural Order and the Call of the Wild: The Politics of Animal Picturing," *Oxford Art Journal* XIII, no. 1 (1990), pp. 12–33

Prince, Sue Ann (ed.), "Stuffing Birds, Pressing Plants, Shaping Knowledge: Natural History in North America, 1730–1860," *Transactions of the American Philosophical Society* XCIII, part 4 (2003)

Rae, Tom, *Bone Wars: The Excavation and Celebrity of Andrew Carnegie's Dinosaur*, Pittsburgh (University of Pittsburgh Press) 2001

Riedl-Dorn, Christa, *Das Haus der Wunder: Zur Geschichte des Naturhistorischen Museums in Wien*, Vienna (Holzhausen) 1998

Ritvo, Harriet, *The Animal Estate: The English and Other Creatures in the Victorian Age*, Cambridge MA and London (Harvard University Press) 1987

Ritvo, Harriet, *The Platypus and the Mermaid and Other Figments of the Classifying Imagination*, Cambridge MA and London (Harvard University Press) 1997

Robbins, Louise E., *Elephant Slaves and Pampered Parrots: Exotic Animals in Eighteenth-Century Paris*, Baltimore and London (The Johns Hopkins University Press) 2002

Rosenblum, Robert, *The Dog in Art: From Rococo to Post-Modernism*, New York (John Murray) 1988

Rothfels, Nigel, *Savages and Beasts: The Birth of the Modern Zoo*, Baltimore and London (The Johns Hopkins University Press) 2002

Rudwick, Martin J.S., *The Meaning of Fossils: Episodes in the History of Palaeontology*, 2nd edn, Chicago and London (University of Chicago Press) 1976

Rudwick, Martin J.S., *Scenes From Deep Time: Early Pictorial Representations of the Prehistoric World*, Chicago and London (University of Chicago Press) 1992

Rudwick, Martin J.S., *Georges Cuvier, Fossil Bones, and Geological Catastrophes: New Translations & Interpretations of the Primary Texts*, Chicago and London (University of Chicago Press) 1997

Sacco, Janis C., and Duane A. Schlitter, "The Return of the Arab Courier: 19th-Century Drama in the North African Desert," *Breakthrough*, no. 65 (Fall 2001), pp. 65–68

Schupbach, William, "A Select Iconography of Animal Experiment,"

in Nicolaas A. Rupke (ed.), *Vivisection in Historical Perspective*, London and New York (Routledge) 1990, pp. 340–60

Sellers, Charles Coleman, *Mr. Peale's Museum: Charles Willson Peale and the First Popular Museum of Natural Science and Art*, New York (W.W. Norton and Company) 1980

Semonin, Paul, *American Monster: How the Nation's First Prehistoric Creature Became a Symbol of National Identity*, New York and London (New York University Press) 2000

*Sir Edwin Landseer*, exhib. cat. by Richard Ormond, Philadelphia, Philadelphia Museum of Art, and London, Tate, 1981

Sliggers, B.C., and A.A. Wertheim (eds.), *Een vorstelijke dierentuin. De menagerie van Willem V/Le Zoo du prince: La Ménagerie du stathouder Guillaume V*, Haarlem (Teylers Museum) 1994

Solnit, Rebecca, *River of Shadows: Eadweard Muybridge and the Technological Wild West*, New York (Viking) 2003

Stanton, Theodore (ed.), *Reminiscences of Rosa Bonheur*, New York (Hacker Art Books) 1976

Stephens, Frederic G., *Sir Edwin Landseer*, 3rd edn, London (Sampson Low, Marston, Searle, & Rivington) 1883

*Theater der Natur und Kunst*, 2 vols., exhib. cat., ed. Horst Bredekamp *et al.*, Berlin, Martin-Gropius-Bau, 2000–01

Thomas, Keith, *Man and the Natural World: A History of the Modern Sensibility*, New York (Pantheon) 1983

Thomson, Richard, "Les Quat' Pattes': The Image of the Dog in Late Nineteenth-Century French Art," *Art History* V, no. 3 (September 1982), pp. 323–37

Turner, James, *Reckoning with the Beast: Animal, Pain, and Humanity in the Victorian Mind*, Baltimore and London (The Johns Hopkins University Press) 1980

*Vies de chiens*, exhib. cat. by Claude d'Anthenaise *et al.*, Paris, Maison de la Chasse et de la Nature, 2000–01

Viola, Jerome, "Redon, Darwin and the Ascent of Man," *Marsyas*, II (1962–63), pp. 42–57

Waal, Frans de, *The Ape and the Sushi Master: Cultural Reflections by a Primatologist*, London (Penguin Books) 2001

Walcha, Otto, *Meissen Porcelain*, New York (G.P. Putnam's Sons) 1981

Weekley, Carolyn J., *The Kingdoms of Edward Hicks*, Colonial Williamsburg Foundation and New York (Harry N. Abrams) 1999

Wendt, Herbert, *Out of Noah's Ark: The Story of Man's Discovery of the Animal Kingdom*, London (Weidenfeld & Nicolson) 1956

*Wer hat das Thierreich so in seines Pinsels Macht? … Die Tierdarstellungen von Johann Elias Ridinger*, exhib. cat., ed. Stefan Morét, Darmstadt, Museum Jagdschloss Kranichstein/Stiftung Hessischer Jägerhof, 1999

Wilson, Edward O., and Nancy Pick, *The Rarest of the Rare: Stories behind the Treasures at the Harvard Museum of Natural History*, New York (HarperCollins) 2004

Wonders, Karen, *Habitat Dioramas: Illusions of Wilderness in Museums of Natural History*, PhD diss., Uppsala University 1993

*Wunderkammer des Abendlandes: Museum und Sammlung im Spiegel der Zeit*, exhib. cat., Bonn, Kunst- und Ausstellungshalle der Bundesrepublik Deutschland, 1994–95

Wynne, Clive D.L., *Do Animals Think?*, Princeton NJ and Oxford (Princeton University Press) 2004

Yanni, Carla, *Nature's Museums: Victorian Science and the Architecture of Display*, Baltimore and London (The Johns Hopkins University Press) 1999

*Zirkus, Circus, Cirque*, exhib. cat., ed. Jörn Merkert, Berlin, Nationalgalerie, 1978

# Index

## Lenders to the Exhibition

AUSTRIA
Naturhistorisches Museum, Vienna

BELGIUM
Koninklijk Museum voor Schone Kunsten,
   Antwerp
Musées Royaux des Beaux-Arts de Belgique,
   Brussels

FRANCE
Musée de Picardie, Amiens
Musée des Beaux-Arts, Bordeaux
Musée des Beaux-Arts, Chartres
Musée des Beaux-Arts, Lyons
Musée Fragonard—Ecole Nationale
   Vétérinaire d'Alfort, Maisons Alfort
Musée des Beaux-Arts, Marseille
Musée Girodet, Montargis
Musée-Site-Buffon, Montbard
Galerie André Lemaire, Paris
Musée Carnavalet—Histoire de Paris
Musée d'Histoire de la Médecine, Paris
Musée de la Chasse et de la Nature, Paris
Muséum National d'Histoire Naturelle,
   Paris
Petit Palais, Musée des Beaux-Arts de la
   Ville de Paris
Univers du Bronze, Paris
Collection Dominique Suisse, Paris

GERMANY
Museum Folkwang, Essen
Das Städel. Städelsches Kunstinstitut und
   Städtische Galerie, Frankfurt am Main
Bayerische Staatsgemäldesammlungen,
   Neue Pinakothek, Munich
Staatliches Museum Schwerin

THE NETHERLANDS
Amsterdams Historisch Museum
Kattenkabinet, Amsterdam
Rijksacademie voor Beeldende Kunsten,
   Amsterdam
Rijksmuseum, Amsterdam
Universiteit van Amsterdam, Artis
   Bibliotheek
Universiteit van Amsterdam,
   Universiteitsmuseum
Van Gogh Museum, Amsterdam
Zoölogisch Museum, Amsterdam
Paleis Het Loo National Museum, Apeldoorn
Rijksmuseum Twenthe, Enschede
Teylers Museum, Haarlem
Museum Mesdag, The Hague
Nederlandse Vereniging tot Bescherming
   van Dieren, The Hague
Royal Cabinet of Paintings Mauritshuis,
   The Hague

Museum Boerhaave, Leiden
Naturalis—Nationaal Natuurhistorisch
   Museum, Leiden
Zeeuws Museum, Eigendom van het
   Koninklijk Zeeuwsch Genootschap der
   Wetenschappen, Middelburg
Louwman Collection—Nationaal
   Automobiel Museum, Raamsdonksveer
Universiteit Utrecht, Faculteit
   Diergeneeskunde
Universiteit Utrecht, Museum
   Diergeneeskunde
Universiteit Utrecht,
   Universiteitsbibliotheek
Universiteit Utrecht, Universiteitsmuseum

UNITED KINGDOM
National Gallery of Scotland, Edinburgh
The Picture Collection, Royal Holloway
   College, University of London, Egham,
   Surrey
College of Surgeons, London
The National Gallery, London
Her Majesty Queen Elizabeth II
Hunterian Museum at The Royal
   Collection of Surgeons of England,
   London
Tate, London
Wellcome Library, London
Collection Desmond Morris, Oxford

UNITED STATES OF AMERICA
The Maryland Historical Society, Baltimore
Museum of Fine Arts, Boston
The Art Institute of Chicago
The Cleveland Museum of Art
The Stephen White Collection II,
   Los Angeles
Yale Center for British Art, New Haven,
   Connecticut
The Metropolitan Museum of Art,
   New York
Duane Michals, New York
Carnegie Library of Pittsburgh
Carnegie Museum of Art, Pittsburgh
Carnegie Museum of Natural History,
   Pittsburgh
Falk Library of the Health Sciences,
   University of Pittsburgh
Hillman Library, Special Collections
   Department, University of Pittsburgh
Marshall and Wallis Katz, Pittsburgh
Princeton University
The Corcoran Gallery of Art, Washington,
   D.C.
National Gallery of Art, Washington, D.C.

## Picture Credits

Photographic material for reproduction was provided by lenders unless otherwise mentioned:

Andréani/Photothéque des musées de la ville de Paris, p. 94
Bayer & Mitko, Artothek, Neue Pinakothek, München, p. 137
A.C. Cooper Ltd., p. 84
Lysiane Gauthier, Musée des Beaux-Arts, Bordeaux, p. 125
Gillmann, Amiens, Musée de Picardie, p. 33
Christine Guest, The Museum of Fine Arts, Montreal, p. 29
Tom Haartsen, Leiden, Museum Boerhaave, p. 86
Peter Harholdt, pp. 38, 40, 49, 81, 82, 83, 97, 106, 107, 124, 132–133, 140, 146, 148, 152
David Hall, Artothek, Das Städel, Frankfurt am Main, p. 121, cover
Erik & Petra Hesmerg, Sneek, p. 90
R. Klein Gotink, Rijksmuseum Twenthe, Enschede, pp. 144, 145
Ladet/Photothéque des musées de la ville de Paris, p. 122
Nicolas Mathéus, Musée de la Chasse et de la Nature, Paris, p. 51
Karin Maucotel, p. 151
A.A.W. Meine Jansen, Apeldoorn, Paleis Het Loo, p. 54
Thijs Quispel, Amsterdam, pp. 12, 15, 21, 22, 23, 26, 58, 59, 86, 95
Patrice Schmidt, pp. 50, 128
Richard A. Stoner, Pittsburgh, pp. 17, 18, 20, 124, 152, 153
Studio Basset, Musée des Beaux-Arts, Lyons, pp. 73, 80
Rodney Todd-White, p. 101
Elke Walford, Staatliches Museum Schwerin, pp. 34, 35
Ivo Wennekes, Zeeuws Museum, Middelburg, pp. 56, 57

# Acknowledgments

It has been a pleasure for us to continue the personal and institutional partnerships that began in 2000–2001 with the exhibition *Light! The Industrial Age, 1750–1900, Art & Science, Technology & Society*. As always when we venture into new fields and experiment with new ways to look at art, we have relied heavily on the generosity, skill, knowledge, and imaginations of many other people, who have helped shape our vision and make it a reality.

These projects inevitably consume the time and energy of the staffs of our respective museums. In Amsterdam, we wish to specially thank the Van Gogh Museum Animal Team: Arda van Dam, Martine Kilburn, Adrie Kok, Sara Verboven, Melanie Verhoeven, and Berber Vinckemöller. We are also grateful for the contributions of Edwin Becker, Suzanne Bogman, René Boitelle, Maartje de Haan, Ella Hendriks, Sjraar van Heugten, Hanneke Hueber, Ellen Jansen, Leo Jansen, Agnieszka Juszczak, John Leighton, Hans Luijten, Jantien Luttikhuizen, Heleen Naterop, Rianne Norbart, Patricia Schuil, Chris Stolwijk, Marion Wolff, Anita Vriend, and Roelie Zwikker. In Pittsburgh, Carnegie Museum of Art colleagues who shared their time, their collections, and their expertise include Elizabeth Agro, Richard Armstrong, Ellen Baxter, Erica DiBenedetto, Amber Morgan, Sarah Nichols, Chris Rauhoff, Maureen Rolla, Marilyn Russell, Arlene Sanderson, Tey Stiteler, Monika Tomko, Craig Uram, and Rhonda Wozniak. We are also greatly indebted to Carnegie Museum of Art's neighbor, Carnegie Museum of Natural History. We offer special thanks to Chris Beard and Bernadette Callery for their wise advice during the planning, research, and writing phases of the project. In addition, Sandra Budd, Mary Dawson, Bill DeWalt, Deborah Harding, Suzanne McClaren, Sandra Olsen, Robin Panza, John Rawlins, James Richardson, Stephen P. Rogers, John Wible, and Norman Wuerthele have responded enthusiastically to any number of unusual and very unscientific requests from us.

We are grateful to the many lenders and the staff of lending institutions for making this exhibition possible. In addition to those who wish to remain anonymous, we should like to thank Claude Allemand-Cosneau, Claude d'Anthenaise, Charles Aston, Nadine Berthelier, Heather Birchall, Robert Bowman, Louise T. Brownell, Georges Brunel, David Burnhauser, Valentijn Byvanck, D.A.S. Cannegieter, Gilles Chazal, Michael Clarke, Marie-Véronique Clin, Mary Cowling, Richard Dagorne, Jan Debbaut, Yvonne Deckers, Christophe Degueurce, Marrietta Dirker, Hesther van den Donk, Douglas Druick, Andrew Edmunds, Malgorzata Fort, Bertrand-Pierre Galey, Beatrice B. Garvan, Timothy Goodhue, Roos Goverde, Henny Greven, Anthony Griffiths, Bart Grob, Peter de Haan, Willemijn van Helberg, Lars van den Hoek Ostende, Frans van den Hoven, Jeff Husted, Paul Huvenne, Annemiek de Jong, Jacoba de Jonge, Marianne Jonker, Joachim Kaak, Marshall and Wallis Katz, Tinie Kerseboom, Paul Knolle, Peter A. Koolmees, Ronald A. Kooyman, Pauline Kruseman, Paul Lambers, Olivier Le Bihan, Frederik Leen, André Lemaire, Jean-Marc Léri, Christophe Leribault, Sylvaine Lestable, Christopher Lloyd, Kathy Logan, Bernhard Lötsch, Mario-Andreas von Lüttichau, Dominique Marechal, Stella Mason, Bob Meijer, Amy Meyers, Duane Michals, J.R. ter Molen, Philippe de Montebello, Desmond Morris, Hans Mulder, Andrew Murray, François Nédellec, Tiziana Nespoli, Julia Nurse, Philippe Péricault, Matthieu Pinette, Michel Poletti, Roberto Polo, Earl A. Powell III, Greg Priori, Sylvie Ramond, Katharine Lee Reid, Hans-Jörg Rheinberger, Alain Richarme, Christa Riedl-Dorn, Joseph Rishel, Betsy Rosasco, Caroline van Santen, Charles Saumarez-Smith, M. Scharloo, Marian Schilder, Jan Willem Schrofer, Sabine Schulze, William Schupbach, Françoise Serre, Jacquelyn Days Serwer, John Shulman, Peter Sigmond, Amélie Simier, Maria Catharina Sitniakowsky, Bert Sliggers, Marieke Spliethoff, Iveta Stanislavová, Susan Alyson Stein, Dominique Suisse, G.A.C. Veeneman, Frank van der Velden, Arthur Verdoorn, Marie-Paule Vial, Jaap de Visser, John de Vos, René van Weeren, Stephen White, Scott Wilcox, Annemarie de Wildt, and James N. Wood.

We should also like to thank many helpful people—both scholars and laypeople—whose advice and contribution were essential: Percy Adlon, Alberto Althoff, Joep Bartels, Geoffrey Batchen, Josine van den Berg, Gerard van der Bijl, Jim Bobick, Mattie Boom, Dorothee Brantz, Rachel M. Burlingame, Bart Deputter, Thierry W. Despont, Sally Duensing, Rachel Esner, Maarten Frankenhuis, Thomas W. Gaehtgens, Dario Gamboni, Ben Gammon, Ursula Harter, Emmanuelle Héran, Annemarie Hürlimann, Elvire Jansen, Andrea Kirsh, Rudy Kousbroek, Barbara Krulik, Wijbren Landman, Nicola Lepp, Martha Lucy, Laurent Mignonneau, Barbara Mirecki, Bianca du Mortier, Larry Nichols, Linda Nochlin, Suzanne Penn, Maria de Peverelli, Henriëtte Plantenga, Jelle Post, Tineke G. Prins, Carel Richter, Hans Rooseboom, Robert Rosenblum, Susan Rossen, Devorah Slavin, Lisa Small, Frans Smits, Abigail Solomon-Godeau, Christa Sommerer, Inge Specht, Gary Steiner, Harm Stevens, Andrea Sullivan, Nicolette Talboom, Jan Teeuwisse, Frances Terpak, Richard Thomson, Ivy Trent, Robert Upstone, Roel Valenteijn, Frans de Waal, and Thomas Zaunschirm.

Our publishers have risen brilliantly to the challenge of working with authors in different continents, time zones, language groups, and computer systems. We are especially indebted to Hugh Merrell, Julian Honer, Nicola Bailey, Anthea Snow, Michelle Draycott, Sadie Butler, Helen Miles, and Sam Wythe for their skill, patience, and persistence in the production of this book.

Our thanks to all.

Louise Lippincott
Andreas Blühm